THE ART OF
STEPHEN HICKMAN

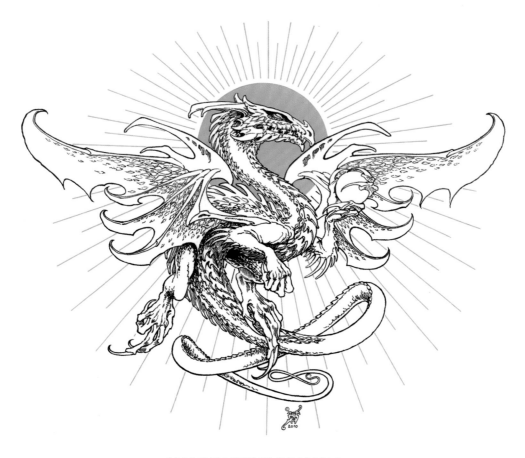

IMAGINATIVE REALISM:
A BEAUTIFULLY CAPTURED IMAGE OF SOMETHING
THAT NEVER EXISTED, BUT SHOULD HAVE.

THE ART OF STEPHEN HICKMAN
ISBN: 9781783298457
Limited edition ISBN: 9781783299478

Published by
Titan Books
A division of Titan Publishing Group Ltd.
144 Southwark St.
London
SE1 0UP

First edition: November 2015
10 9 8 7 6 5 4 3 2 1

What did you think of this book?
We love to hear from our readers. Please email us at:
readerfeedback@titanemail.com,
or write to us at the above address.

To receive advance information, news, competitions,
and exclusive offers online, please sign up for the
Titan newsletter on our website: www.titanbooks.com

A CIP catalogue record for this title is available from the British Library.

Printed and bound in China.

THE ART OF
STEPHEN HICKMAN

WRITTEN BY
STEPHEN HICKMAN

INTRODUCTION BY DAVID DRAKE

FOREWORD BY RICK BERRY

TITAN BOOKS

TO THE MEMORY OF JIM BAEN,
THE ONLY MAN I'VE EVER CALLED BOSS.

AND TO HANK REINHARDT, MY
WOLF-BROTHER WHO LOOKS DOWN
ON US FROM VALHALLA.

CONTENTS

STEPHEN HICKMAN, ME, AND ART

INTRODUCTION
BY DAVID DRAKE

I was flattered but bemused when Steve asked me to do an intro for this volume, because I am one of the least artistic people I know. If I try to draw a straight line with a ruler, the ruler generally slips. Obviously, I will not be discussing the sorts of things that an art director or a fellow artist might say. Steve and I go back a ways. The first book of mine he did a cover for was the 1987 collection, *Lacey and His Friends* (see page 115). That was a heck of a good meeting point. I've had many, many good covers over the years, but I've never had one which I think is better or which I like more than the *Lacey* cover. It hangs on my wall now, thanks to Baen Books (and Steve himself kicking in the framing).

Steve and I didn't meet till many years later, however. What we had in common was Jim Baen: editor, later publisher, and always his own art director. I don't know anybody who was neutral about Jim. Steve and I were two of the people who really liked him, for all that he regularly drove us (me at least, but I'm sure us) nuts. Jim had a personality and we have personalities. It worked out. Because Jim and I were friends, he would chat to me about art, stuff that normally a writer would never hear. He mentioned that the *Lacey* cover was Steve's conception with one exception: the original showed Lacey playing with a pen. Jim (wearing his art director hat) told Steve to replace the pen with a knife.

The combination of Jim and Steve was hard to beat. In that particular case, I think Jim also talked about the cover to *Cthuhu: the Mythos and Kindred Horrors*, a collection of Robert E Howard stories which I wound up editing by the back door. Jim was always boss—note the dedication to this book—but when he wasn't in any doubt about his power, he didn't shove his weight around. I suspect that most art directors would have required a lot of persuading before they allowed an artist to sculpt a statuette and photograph it for a book cover. Jim simply agreed with Steve's proposal.

The next I heard about the cover was that the photographer couldn't get a usable image because of highlights from the surface. Jim said he'd told Steve to do a cover painting of the statuette instead (and added $500 to the fee for the extra work). And finally, Jim said that if he'd been thinking, he would have suggested that Steve blow talcum powder over the statuette to kill the highlights; but he didn't really mind, because the painting was so good.

This volume has a photograph of the statuette (with wings added, as Steve describes in his text). As you can see, it's a great job; I bought a copy of it myself. But I'm with Jim on this one: the painting is even better.

Those are covers from the '80s. I'm now going to discuss current work for both Steve and myself: my ongoing RCN series, for which he's done all the covers save that of Writers—and more often wannabes—talk about cover control: that is, the right to tell the artist what to paint and how to paint it. I've seen senior writers not only demand cover control but also tell other writers that they must demand cover control of their own works. I've never once seen that work out in a good way for any of the parties concerned.

It is true—it's true for me at least—that the writer knows his own book better than anybody else does. However, it isn't true that the writer knows best what would make the best scene for the cover of his book. Indeed, most of the writers I've talked to don't have a clue as to the purpose of a cover painting.

The purpose of a cover painting is to sell the book to a potential customer. It's really that simple. There are various design factors useful for getting the book noticed (because if the potential customer doesn't see the book, she won't buy it), but nothing except selling the book to the right person should matter to the writer.

What writers universally seem to want on the cover, however, is an illustration with all the details in keeping with their text. "The hero should be younger." "The heroine's hair should be brunette." "The piping on the epaulets should be red because he's on the staff in this volume." (No, I'm not making that up.)

Quite apart from anything else, covers controlled by writers tend to be cluttered with detail. That loses the strong central image which is one of those useful design factors I don't think that even a writer who understands and agrees with what I've said above should be giving an artist cover direction. At any rate, I personally shouldn't be giving the artist direction, and I've learned to resolutely refuse to get involved even when the editor or the artist himself is pressing me to do so.

I'll use my most recent cover, Steve's painting for *What Distant Deeps* (an RCN space opera) as an example. If I had been forced to choose a subject, I probably would have picked a large, angry Plesiosaur charging down onto a small human figure with her

That's a good scene. It's the one I go to when I'm asked to do a reading from the book, and I think you could do a good cover from it.

But what Steve did, as he has generally done for the series, was to focus on the two central characters with peripherals which show that the book is exotic SF. Those are perhaps the two most important factors in the RCN series.

There are other things in the novel—for example: space battles, heroic derring-do, political intrigue—which another artist might have painted and gotten a suitable cover. (Thomas Hart Benton really did do a great painting of political intrigue.) The cover of *What Distant Deeps* is also right for Steve, however. He picked a subject that fitted his skill set and which he could be passionate about.

Skill and passion are the constants of all the art—the wonderful art—in this book. I'm privileged to be allowed to write this introduction, and I'm lucky beyond words to have Steve Hickman doing covers for my books.

Dave Drake
Chatham County, NC

FOREWORD

The pleasure of the forms:
The foil and carapace of a brilliant drake, or
A scallop of rocks and reefs surrounding a mystery,
Maybe fabrics personal to a princess,
Or is it a mermaid's undulating frill racing her arched ribs?
Then there's the finials defending cardinal points
of a pavilion in some faraway Shangrilah
And a ship perhaps, wrought by a culture that thinks beauty
a necessary engine for stepping to the stars
—it goes on and on.

It's the shape and path of the artist's hand doing its work
and so it's in some manner the shape of his mind.

I've known this artist for quite some time now; we have both endeavored in the same arenas of book covers, magazine illustration, concepting— the gamut, I think. I've always been aware of his work and for good reason: inspiration is always welcome. And I'd like to be clear on this in that it's not just a "gosh, how'd he do that?" sort of thing. No, it's far more important that you see art that makes you feel like you're going somewhere, transported as it were. That's why spotting one of Hickman's efforts is always memorable. I don't follow his work, I don't have to; once encountered, it follows you around, carries you a while to a new place. I like that.

The root of Sci-Fi-Fantasy is freedom of mind, not simple obeisance to received wisdom. Our artist enjoys this as license and does so fearlessly (in publishing, this can be risky). Instead of simply pleasing his masters (mind you, he's very pleasant) his desire is room to move, opportunity to design worlds unfolding in some lovely way—a way that must have as its base unit something called the "Hickman Fractal"—no matter which direction you go, infinitely small, cosmically large, you'll find this lyric math informing every single pass of the brush.

From this internal riddle, this real thing in the artist, wondrous architectures unfold. And when I say architecture, certainly I mean buildings, avenues, "engineering" but you also find it in the braids of a witch's hair, the arc of tree branch dotting blossoms across a distant wrack of clouds, as if they were notes from Pan's pipe. That music from this artist's mind is everywhere in the picture. Not a thing goes unconsidered, a grace note left behind.

They are pictures to dream upon
To return you that freedom of mind and possibility
With this artist's efforts as clear proof it can be done.

That's just fine. Inspiration to believe in wonders is just a fine thing.

Dive in.
Perhaps a mermaid will show you the way.

Rick Berry, Boston - 2015

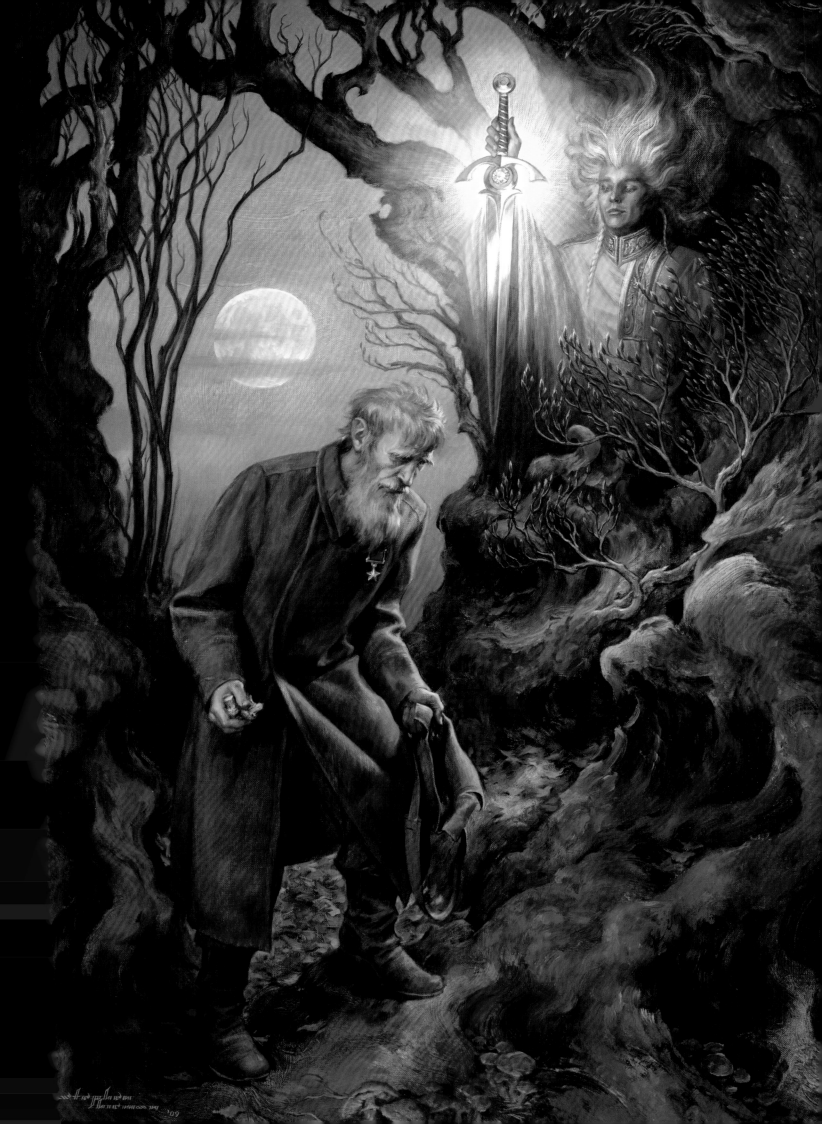

FANTASY

Here is the field of art that is, to my way of thinking, the richest of all, in terms of possible imagery. It is, by definition, limitless—the very essence of Imaginative Realism.

This in itself presents a challenge: think of the thousand years of accumulated cliché our imaginations have to work past—yet all mythos, visual or otherwise, is a work in progress. And buried within the ages of traditional imagery live the icons, visual archetypes that grow from year to year, requiring constant upgrades as the course of human progress accelerates.

For me, fantasy imagery is simply my favorite place to work and live, and nature, particularly in my native Hudson Valley region, is a wellspring of ideas. To paraphrase Auguste Rodin "nature is the great teacher." Personal imagery, much of it inspired or informed by nature, is becoming more important to me the more painting I do, and fantasy is my direction of choice.

Left: Apotheosis

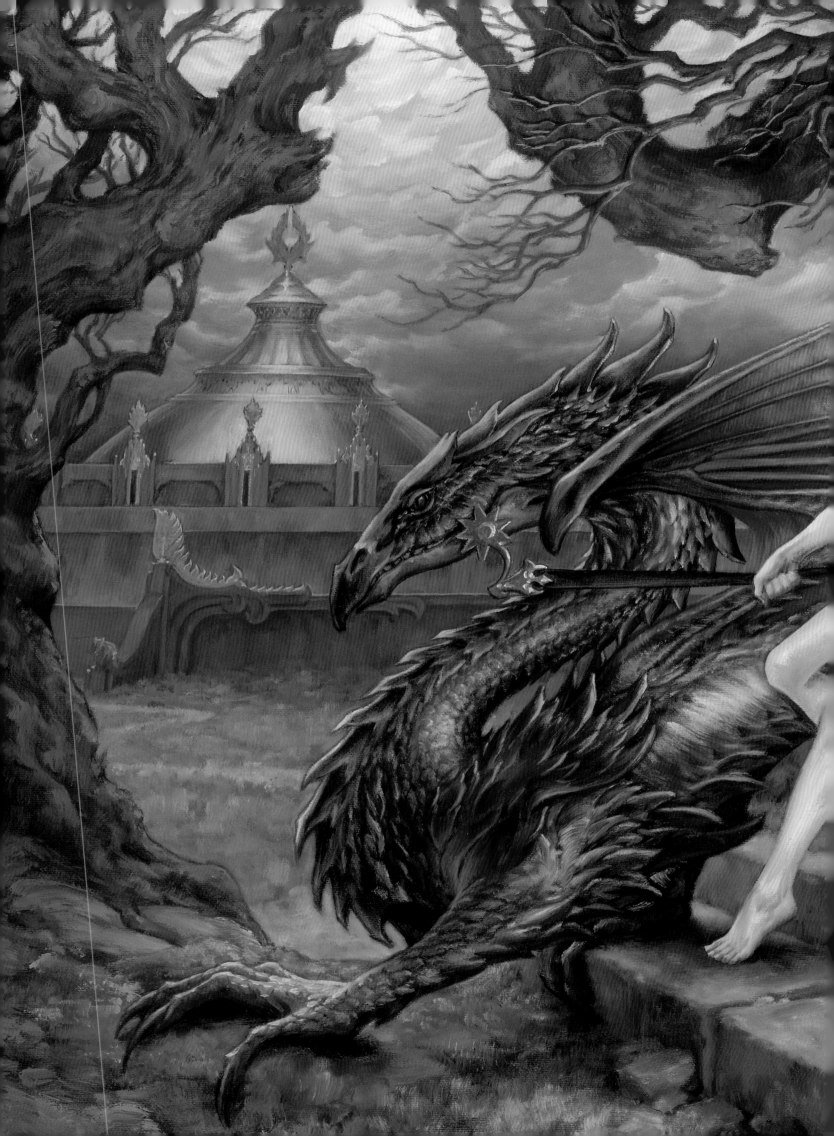

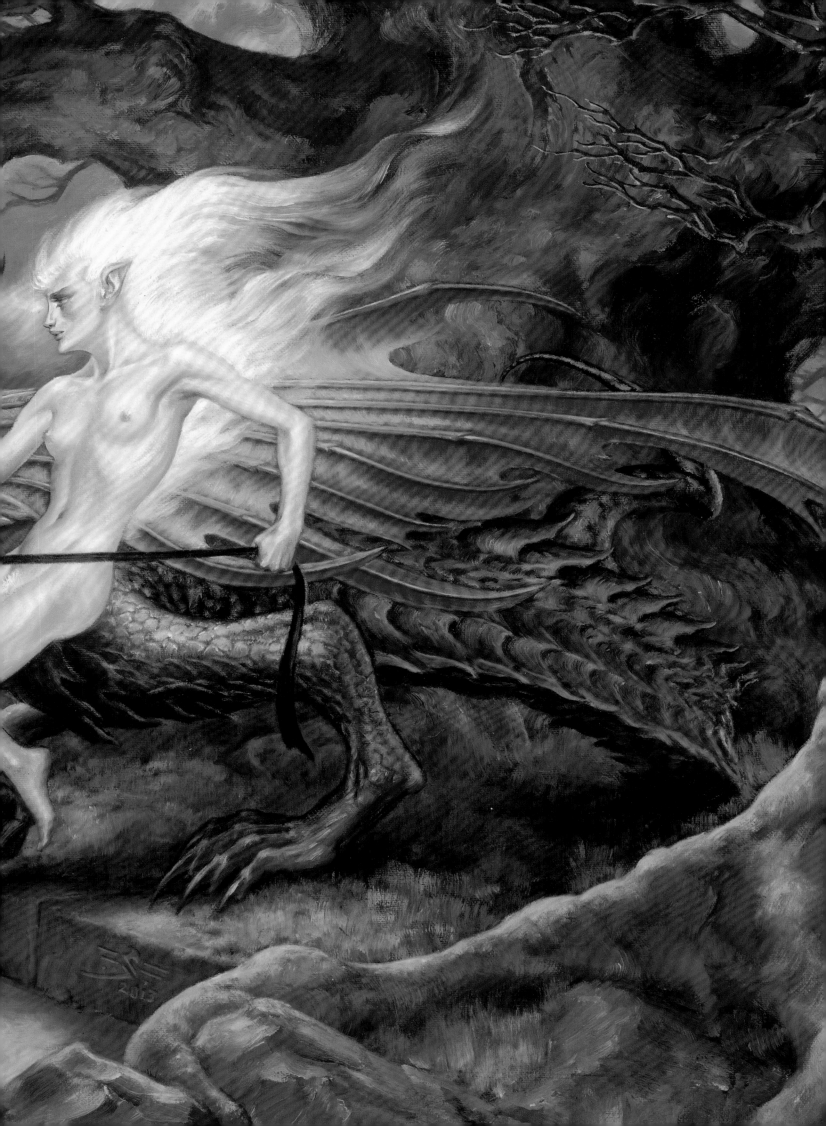

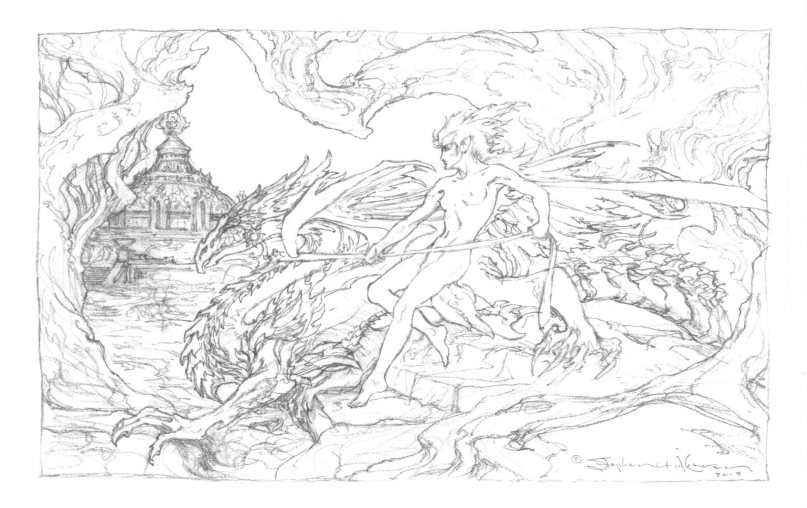

THE DRAGONBINDER *(previous spread)* - The initial idea for this commission painting probably came to me while walking our high-energy Belgian Malinois; I know I found myself reminded of similar-themed statuettes. So when I was speaking to my client and friend Mr. Daniel Fowlkes about possible subjects for a painting, this notion fell nicely into the list of things that we were both interested in putting into a picture: dragons and nude ladies in exotic settings.

To plausibly manage a dragon, I felt a lady of supernatural aspect would be called for—this in turn suggested the strange and vaguely nightmarish setting. This approach I developed in two sketch versions, and a detailed color sketch.

When Daniel asked me what I intended to call this painting, I was at a loss. After some thought, *White Flame* was the best I could come up with; a bit weak. So I put the title problem up to social media, and my friend Fiona Campbell came up with the current title, *The Dragonbinder,* on a Facebook comment thread—a blessing on your Celtic genius, Fiona.

Technical notes: This is painted in oil color on linen canvas mounted on cabinet-grade birch plywood. The plywood was treated with three coats of polyurethane varnish, and the canvas was folded around this and secured with a waterproof carpenter's glue. It was then sized with the traditional hide glue, and layered with tinted gesso to reduce the canvas grain. Over a monochrome of raw umber, I painted in the color using the Venice turpentine medium.

THE DEMON HARP *(right)* - Here is the first version of the *Demon Harp* painting, the second version of which was printed in my previous art book—rather than reprint that one, here is the one that Archie Goodwin (then editor of *Epic* magazine) saw, and said he would print if I did another version with the right configuration for a magazine cover.

Every artist doing fantastic subjects, especially horror subjects, is familiar with the question "How do you come up with the *ideas* for this stuff?" Of course, most of the time the ideas are a natural product of my dark and fevered brain, but this time I had at least a partial alibi: I saw a harp something like this in a book of odd musical instruments. I only saw it once, but I had to use the idea—a sorceress, playing on a harp of power made from the skull of a great magician, and using the music to control some sort of creatures.

I like to think of this as an homage to the work of the immortal Frank Frazetta, particularly the sort of covers he did for *Creepy* and *Eerie* magazines. Of course Frank's work has always been in a class by itself, and admits no imitations. The greatest challenge in my early years, in fact, was to do work that didn't look like his, and the thing I'm happiest about in this painting was that I could come back to this type of picture without swiping a single thing from Frank Frazetta.

Technical Notes: This is an oil painting on canvas, using a raw umber monochrome over a gray-toned gesso ground. I was using the linseed-oil/stand-oil/turpentine medium then, so that's probably what I did this painting with.

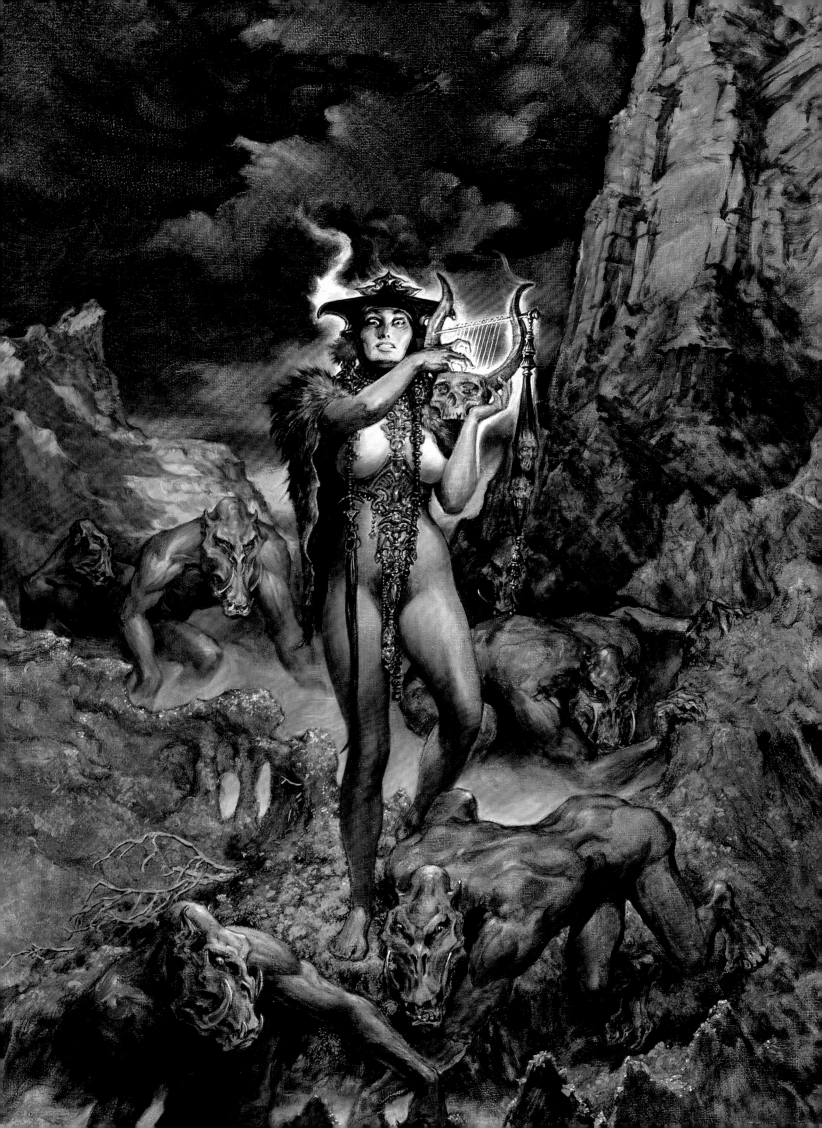

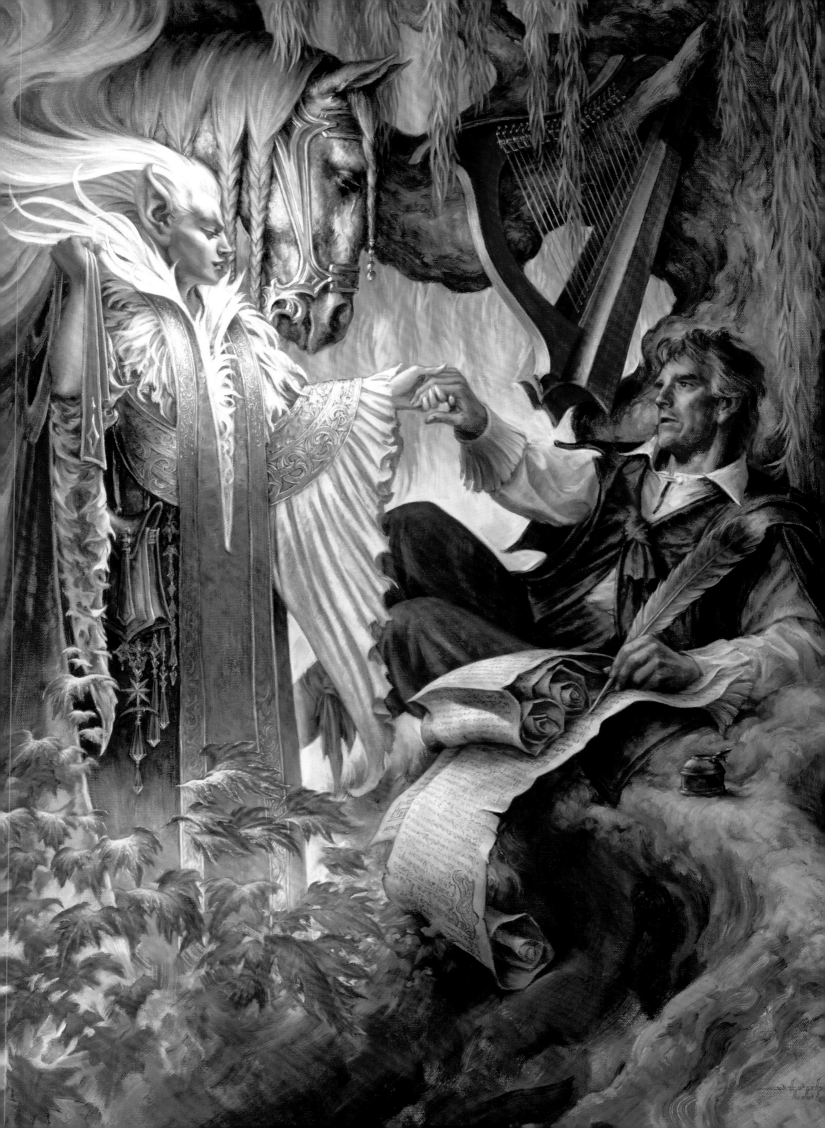

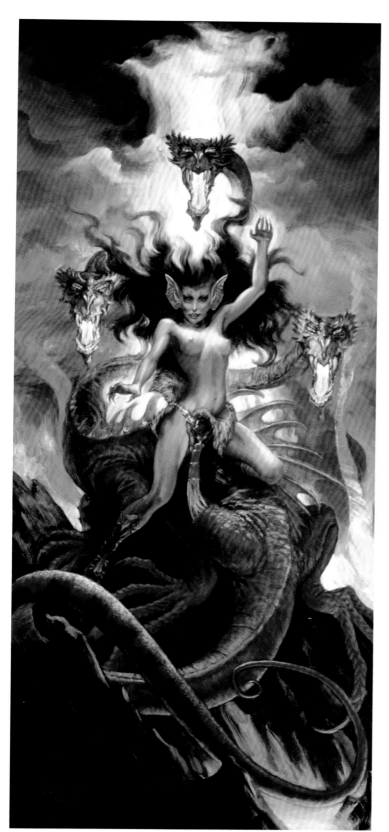

THOMAS THE RHYMER AND THE QUEEN OF ELFLAND *(far left)* - Based on the thirteenth-century Scottish poet Thomas of Earlston, who wrote the most celebrated version of Tristan and Isolde of his time. Scots legend built a myth around this romantic figure, evolving over time, as myths will, into its present form as Thomas the Rhymer.

To my way of thinking, the most fascinating version is the one as told by Robin Williamson, a modern Celtic Bard, and the greatest storyteller of our age. And certainly the inspiration for this painting.

As Robin tells it, Thomas of Earlston was seated one day beside the Bogleburn, the haunted stream deep in the Eildon Forest, "... the very spot a poet would choose to write his verses." And there came to Thomas, as he sat under the Eildon tree, the Queen of Elfland, and called Thomas to follow her to the Blessed Realm, there to serve her for seven years—this he did, though it seemed to him but a day. And when seven years in mortal lands had passed, the Queen sent him back, for every seven years the devil took his tithe to Hell, and the Queen feared that Thomas would be the devil's choice. The Queen sent Thomas back with this left-handed gift: from that day forth, Thomas could speak only truth, and so he gained the gift of prophecy, and was known as True Thomas.

For me, the final touch was to have my friend Richmond Johnston, a talented piper and teacher, as the model for Thomas.

Technical notes: I worked out my scene with a charcoal tonal drawing beforehand—then projected this onto a gray-toned gesso-surfaced canvas, refining my drawing in charcoal. The underpainting was done in mars violet, and the colors laid in according to my mental image of the scene. I think I was using W&N Artist's Painting Medium at the time.

NAGHAL THE SORCERESS *(left)* - I started this picture in some downtime after minor surgery, just to keep occupied. The picture developed to what you might call state one, and stayed there for a while.

The background wasn't doing anything for me, but then late one night I seemed to see in the amorphous fog a kind of psychic storm. So I painted in a spiral of storm, and it still didn't make it. There wasn't enough character. So I took a palette knife and repainted the background yet again, and there it was.

One thing about a palette knife is that you never know what you'll get, except that it will have personality. There is really a surprising range of effects you can get with one of these.

The lady's face evolved a bit, too—only to get more disturbing.

Technical notes: I think the underpainting was raw umber, but it should have been mars violet instead. The medium was Liquin.

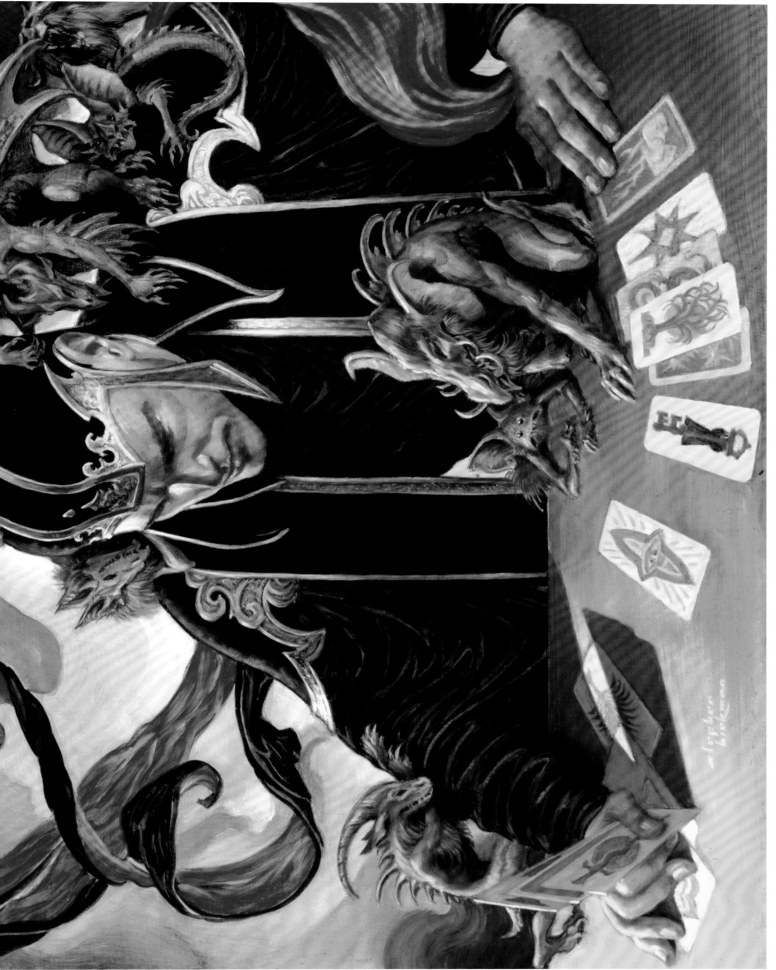

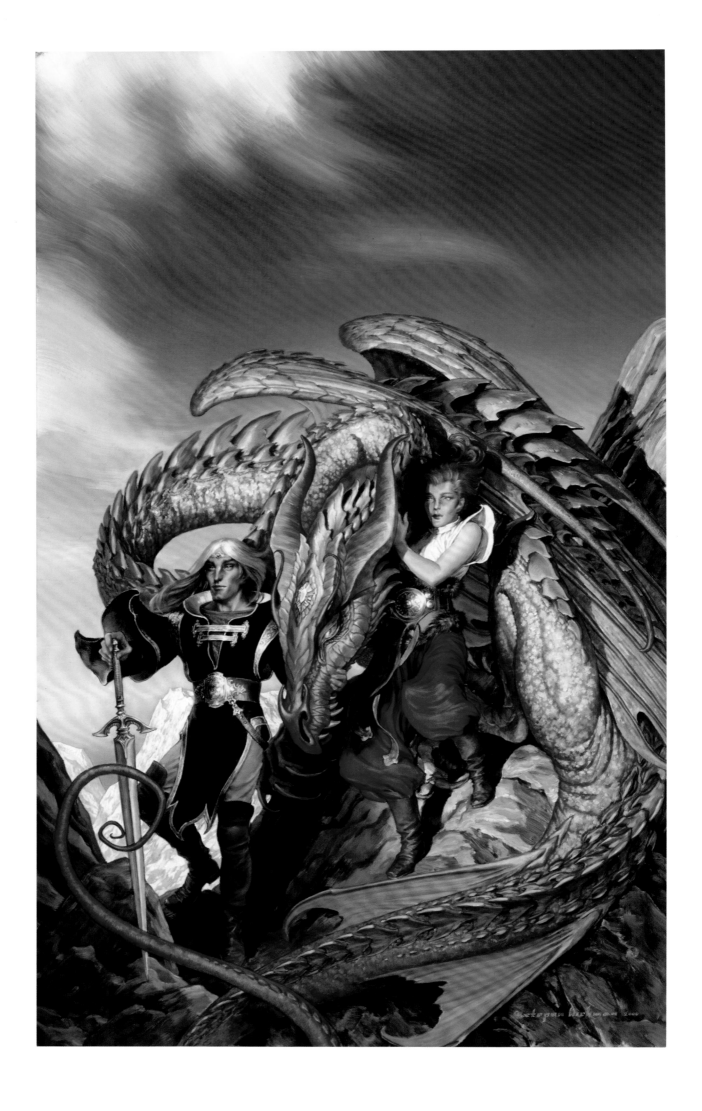

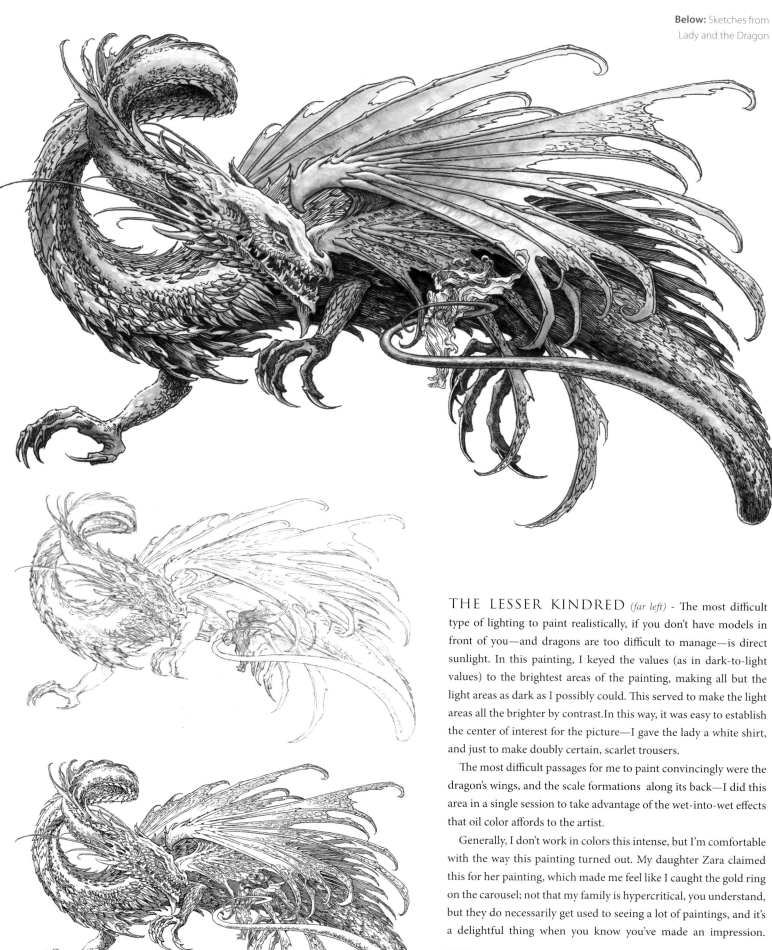

THE LESSER KINDRED *(far left)* - The most difficult type of lighting to paint realistically, if you don't have models in front of you—and dragons are too difficult to manage—is direct sunlight. In this painting, I keyed the values (as in dark-to-light values) to the brightest areas of the painting, making all but the light areas as dark as I possibly could. This served to make the light areas all the brighter by contrast.In this way, it was easy to establish the center of interest for the picture—I gave the lady a white shirt, and just to make doubly certain, scarlet trousers.

The most difficult passages for me to paint convincingly were the dragon's wings, and the scale formations along its back—I did this area in a single session to take advantage of the wet-into-wet effects that oil color affords to the artist.

Generally, I don't work in colors this intense, but I'm comfortable with the way this painting turned out. My daughter Zara claimed this for her painting, which made me feel like I caught the gold ring on the carousel; not that my family is hypercritical, you understand, but they do necessarily get used to seeing a lot of paintings, and it's a delightful thing when you know you've made an impression.

Technical notes: This is an oil painting, done over a gesso panel. I blocked in the color directly over the white gesso ground using my rough color sketch as a guide. I used the Venice turpentine medium for this picture.

Dragon

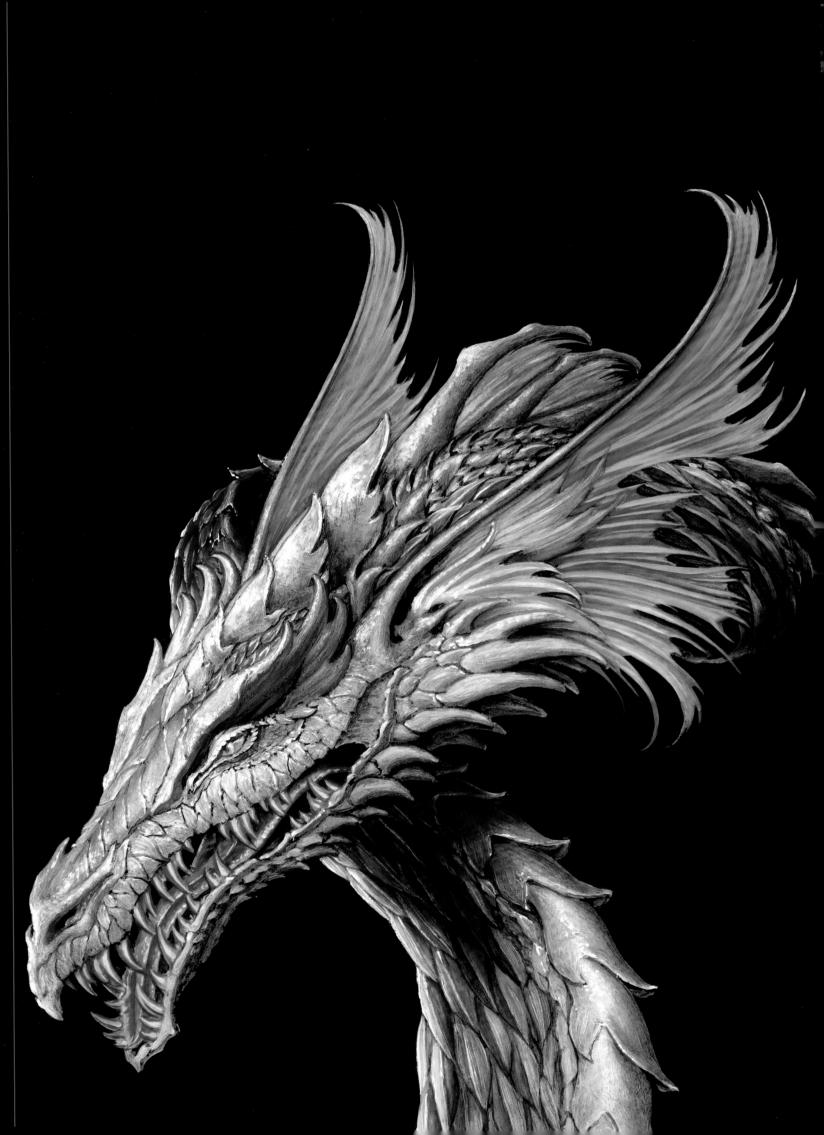

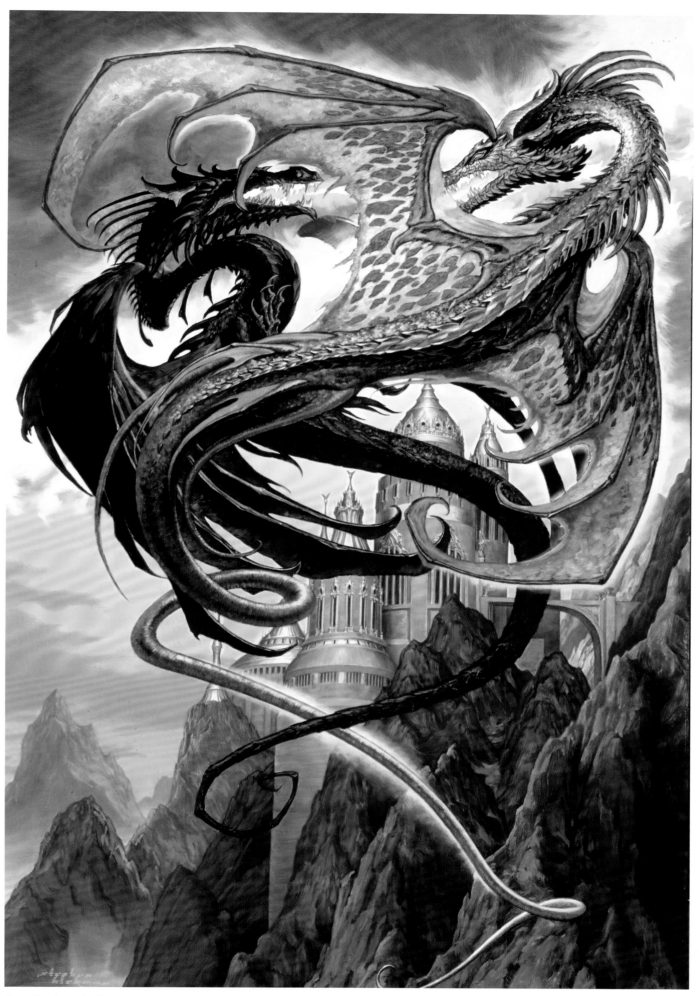

Opposite: Jhegaala **Above:** Redeeming the Lost

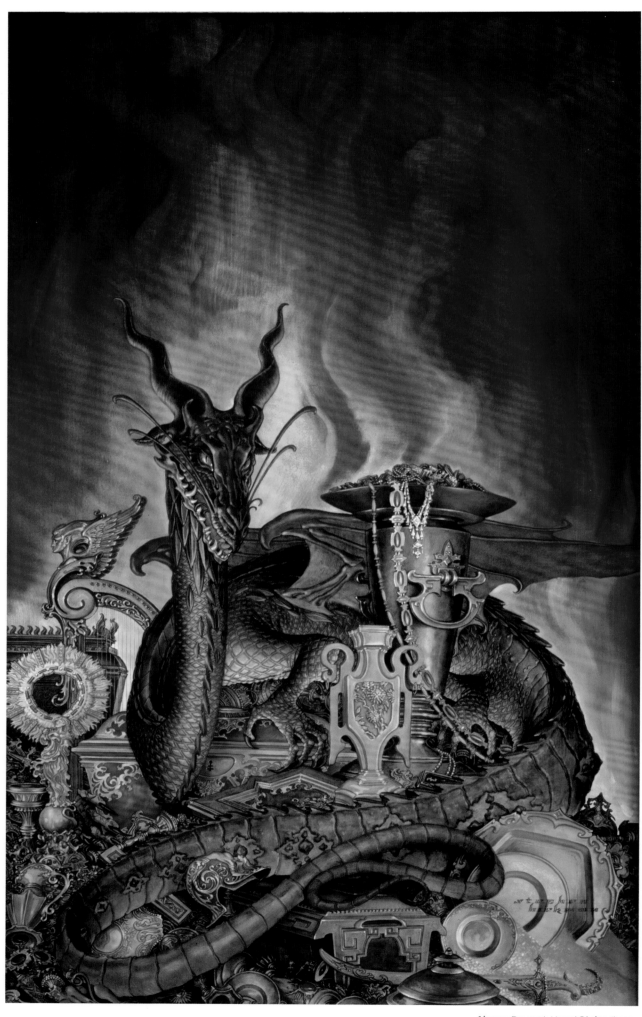

Above: Dragon's Hoard **Right:** Jhereg

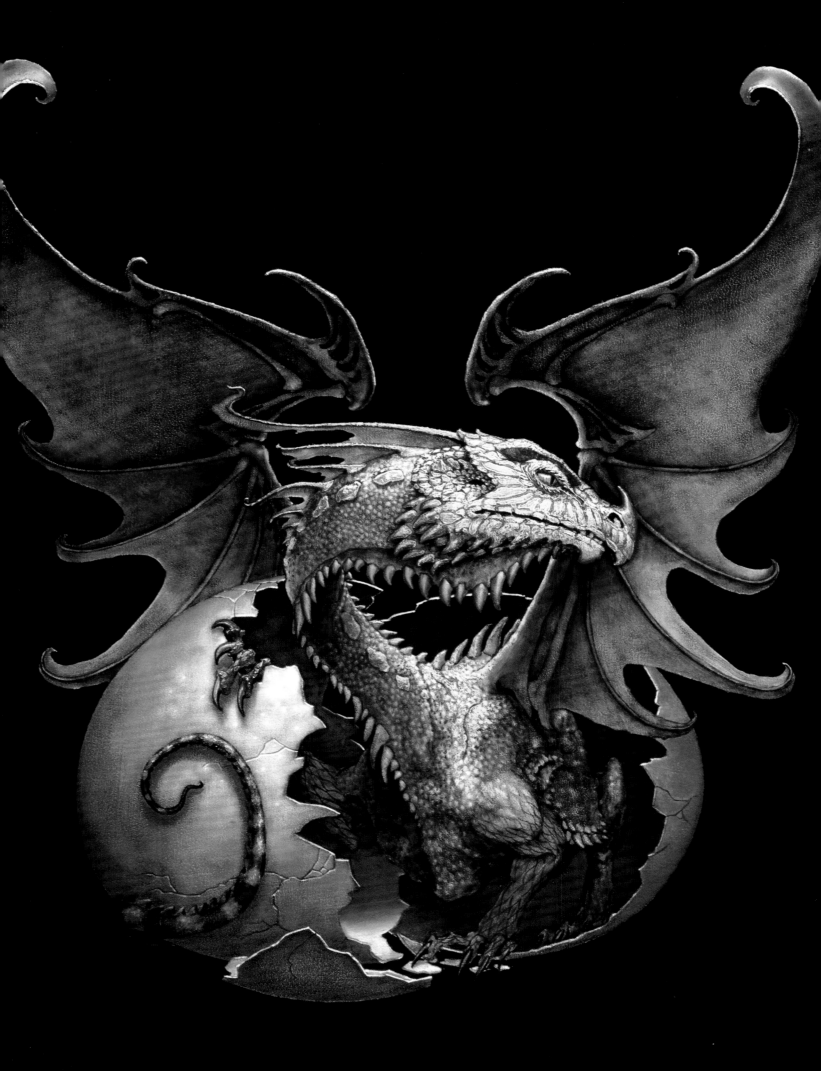

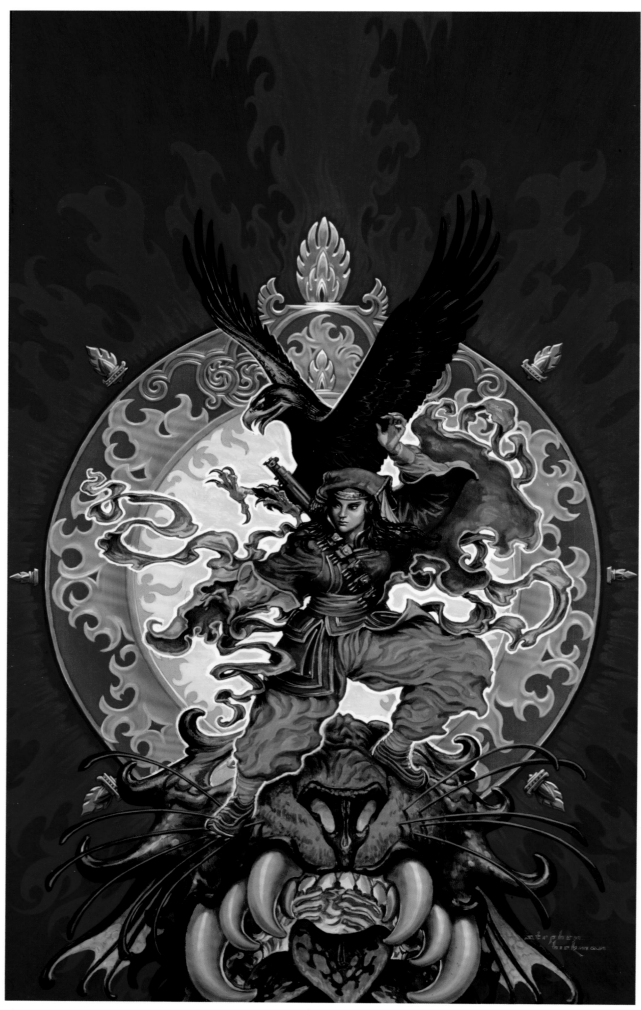

Above: Flameweaver

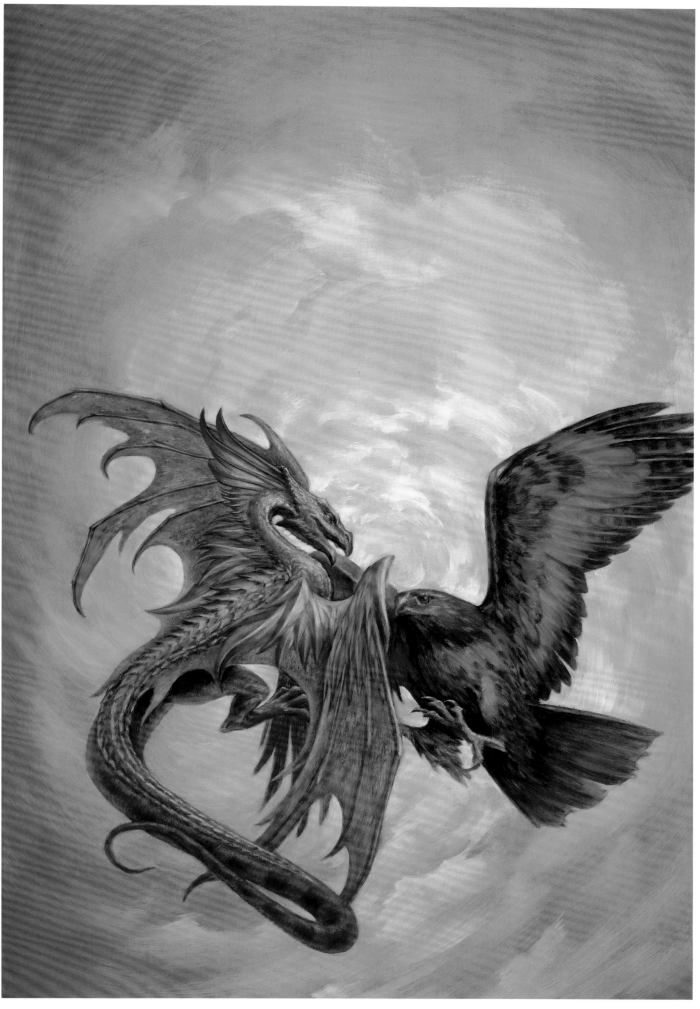

Above: Hawk

31

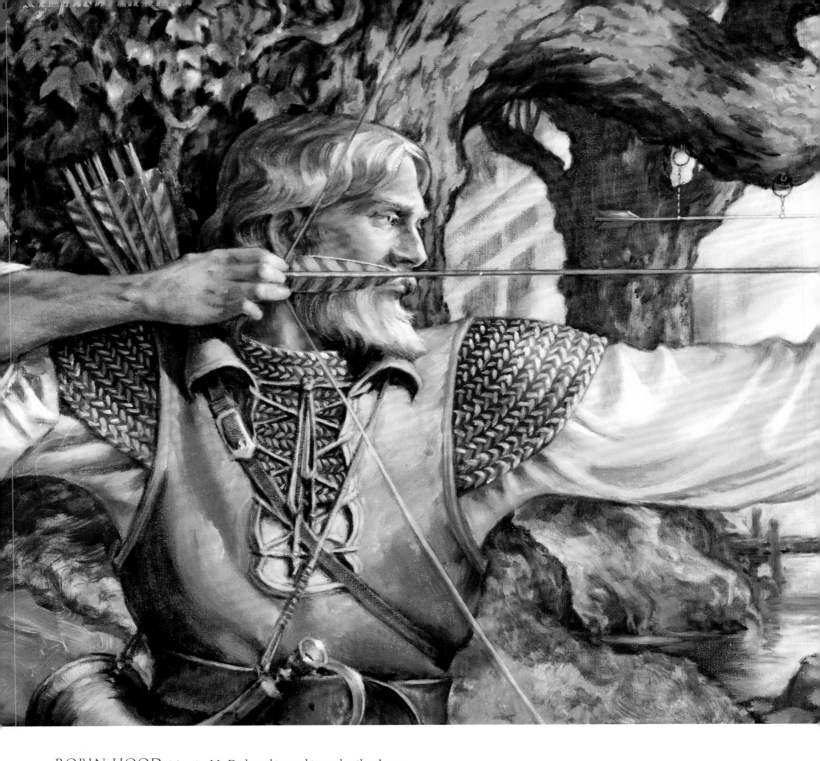

ROBIN HOOD (*above*) - My Dad used to read to my brother Lance and me, and one of our favorites was always *The Merry Adventures of Robin Hood*, by Howard Pyle. I remember it was one he read to us while on a voyage to Manila on board the *President Cleveland*, just to add that extra touch of the exotic to the romance. This story by the great illustrator, author, and teacher is far and away the best version of the Robin Hood tale—it evokes images and a mystic poignancy of romance with an almost supernatural ease.

I've always wanted to see what I could do with a scene from this story, and I did a charcoal study first as a sort of proof-of-concept drawing. This painting is actually a color study for a much larger painting which, at the time of this writing, is still floating somewhere over my head in that brighter realm from which all paintings come.

Technical notes: Oil on canvas, the smallest in this book at 12 x 12 inches. I used a raw umber underpainting, and probably oil-modified Liquin as the medium.

Above: Dirge for Sabis

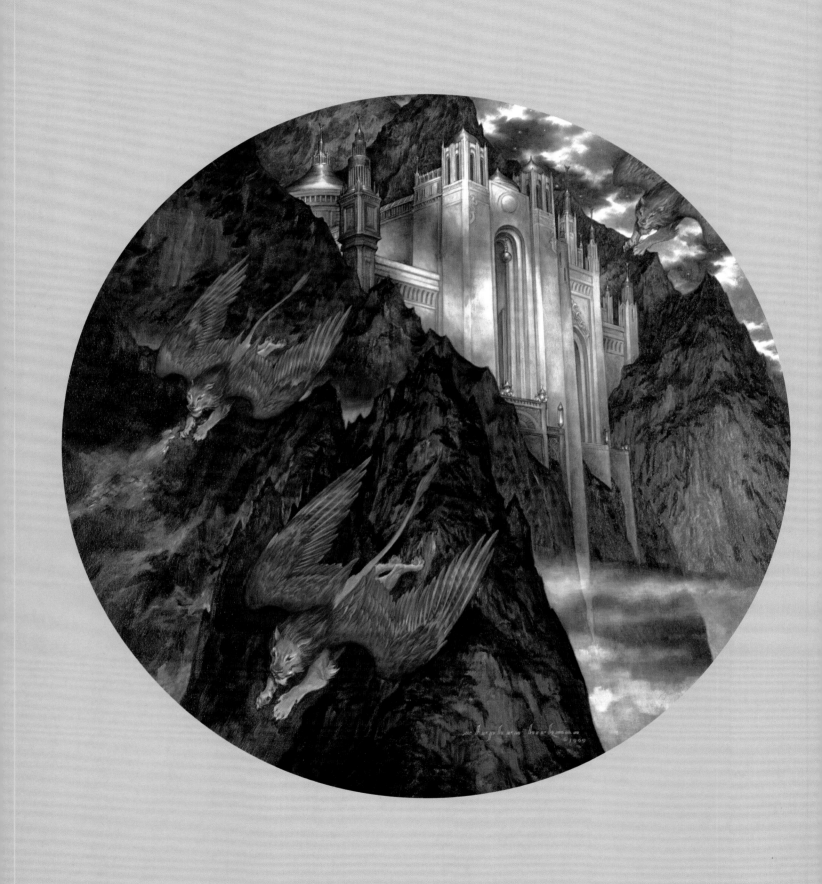

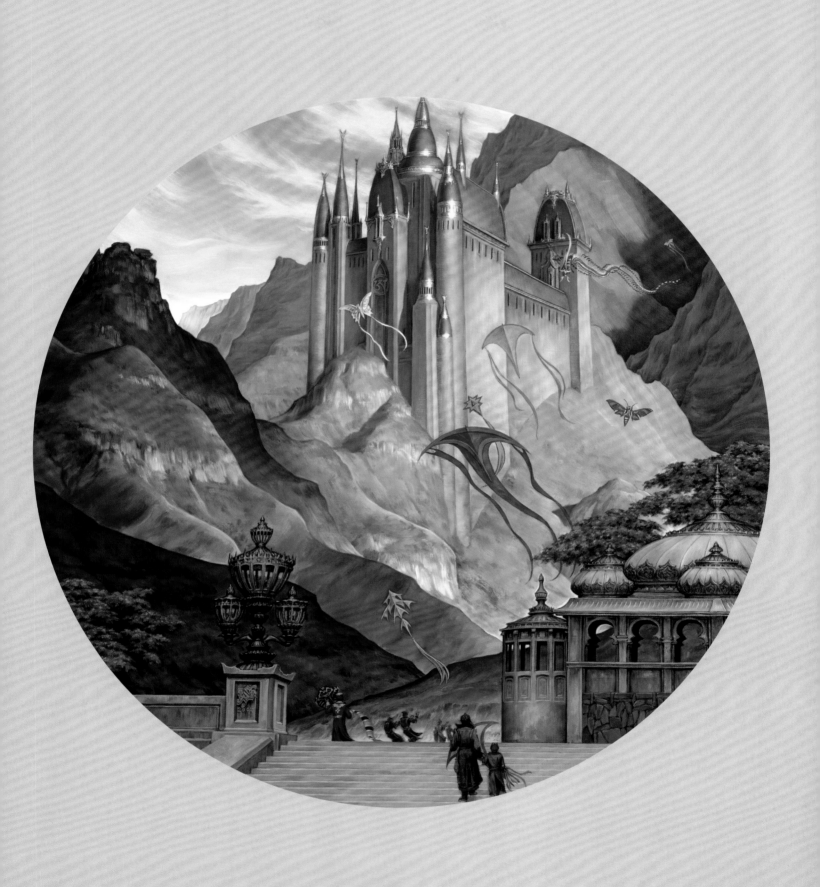

MOON SHADOWS *(Previous spread left)* - I love painting round pictures. Did I mention that? Round pictures make people feel good—they make me feel good.

I got this idea of winged lions when I saw a picture of Ezra Tucker's, and was reminded how cool winged lions were. I had already done a design for a business card with a winged lion on it, but I didn't want people to think I was a docent at St. Marks, so I didn't use it.

Anyway, when a dear friend of mine said she loved lions, I painted this for her as a commission. One of these days I want to write a story around this painting.

Composing a picture in a circle requires a different kind of intuition than for a rectangle or square. That's the fun of it: thinking differently is great.

Wings are a kind of obsession with me—they've got to be just right, the right size, with the feathers the right shape and in the right place. And lions are always a challenge to make convincing, never mind flying lions.

This turned out sweetly, to my way of thinking—the only references I used were some vacation photos taken in the Drakensburg Mountains in South Africa.

Technical notes: Oil on a circular stretched canvas, with a Damar varnish medium.

THE KITE FESTIVAL *(Previous spread right)* - This painting started out as a color sketch of an idea that came out of nowhere—these generally occur right in the middle of some heavy work load when it is the most awkward possible time to stop and sketch it out: which you must do, or it will fade out on you. The original notion may have come from seeing some vacation photos of the Drakenburg Mountains in South Africa. Cloud shadows over mountains have always fascinated me.

This was the first of my circular paintings where I decided to make a round cradle with which to clamp the painting onto my easel: it is really annoying to have to level the painting by eye if it should happen to shift in the painting process.

I was able to work on this picture in two different sessions about a year apart. The greatest luxury for an artist is to have time to sit back and look at a painting long enough to know what needs to be done to get it right— at that stage, it is a simple matter to sit down and do the work with no wasted effort.

Technical notes: This is an oil painting on a standard size (as in, you can find a frame for it) 24-inch round canvas stretcher. I used raw umber for the monochrome painting, over a gray-toned

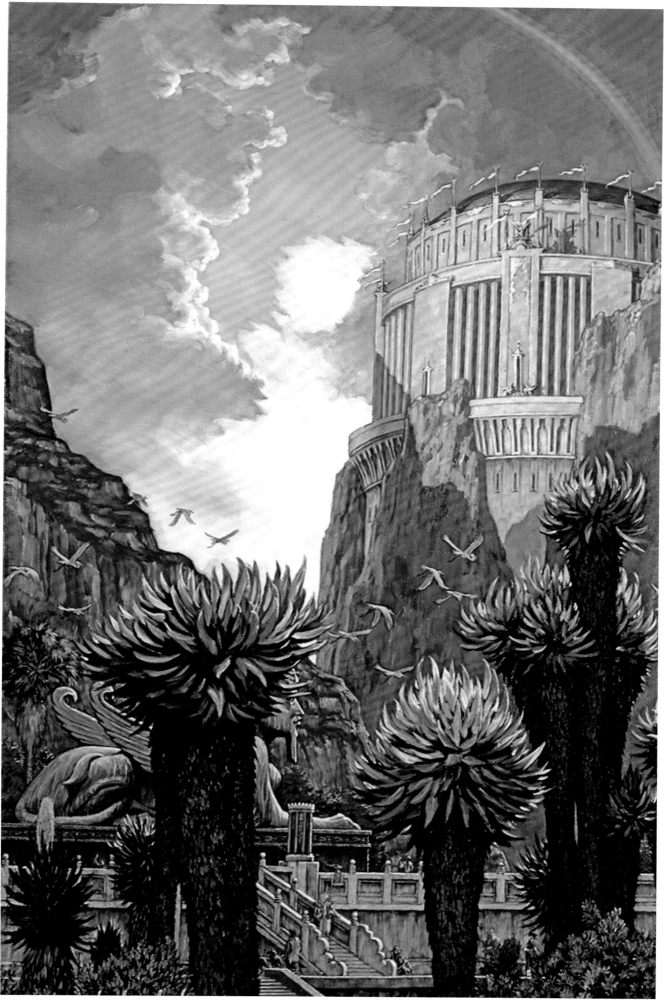

Above: After the Rains

THE ARCHERS *(right)* - The successor painting to the *Lion Pavilion* picture, I deliberately chose to use a contrasting mood of controlled energy and motion, and late afternoon lighting. The choice of the vertical format canvas and more intense use of color as a logical approach to this choice.

I placed two large figures prominently in the foreground, with the gulls and blowing garments suggesting the energy of the wind. Even the juniper at the bottom of the painting contributes to the impression of activity.

I've always been interested in archery, probably from the description of the great match in Finsbury Fields from Howard Pyle's Robin Hood book. So I made the focal point of the painting the two figures practicing archery, selecting as the moment of focused tension of the instant before release.

Technical notes: Oil color on canvas, over a mars violet monochrome. I used a heavy double weave Belgian linen as the ground to provide a solid surface to paint on, and mars violet because of the intensity of the emotional tone as an underlying emphasis.

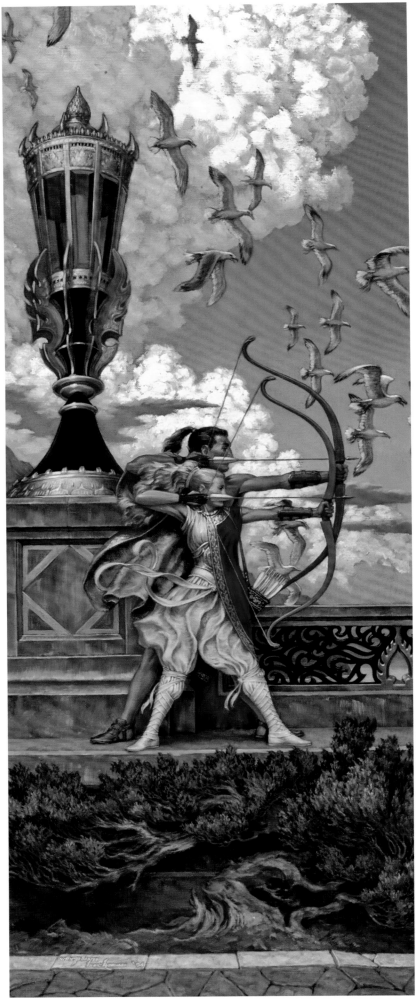

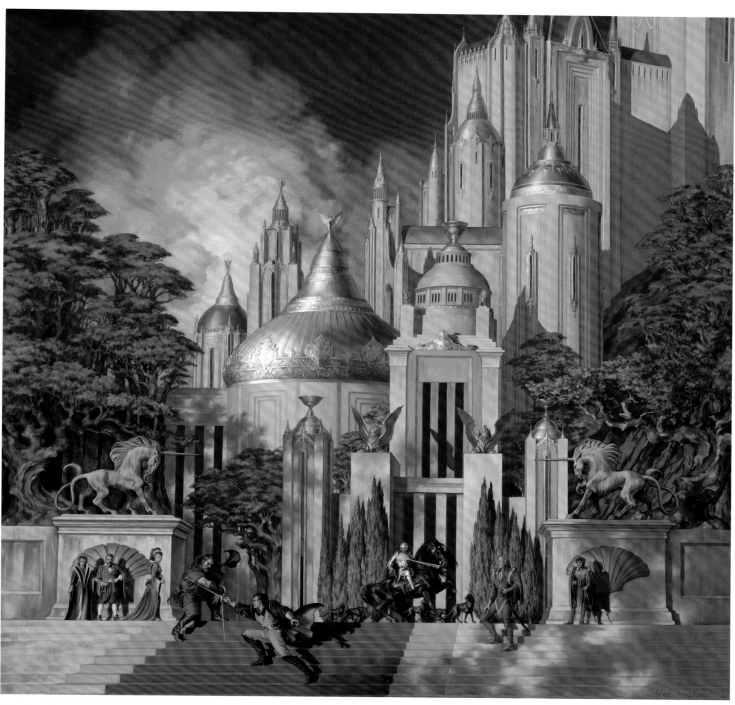

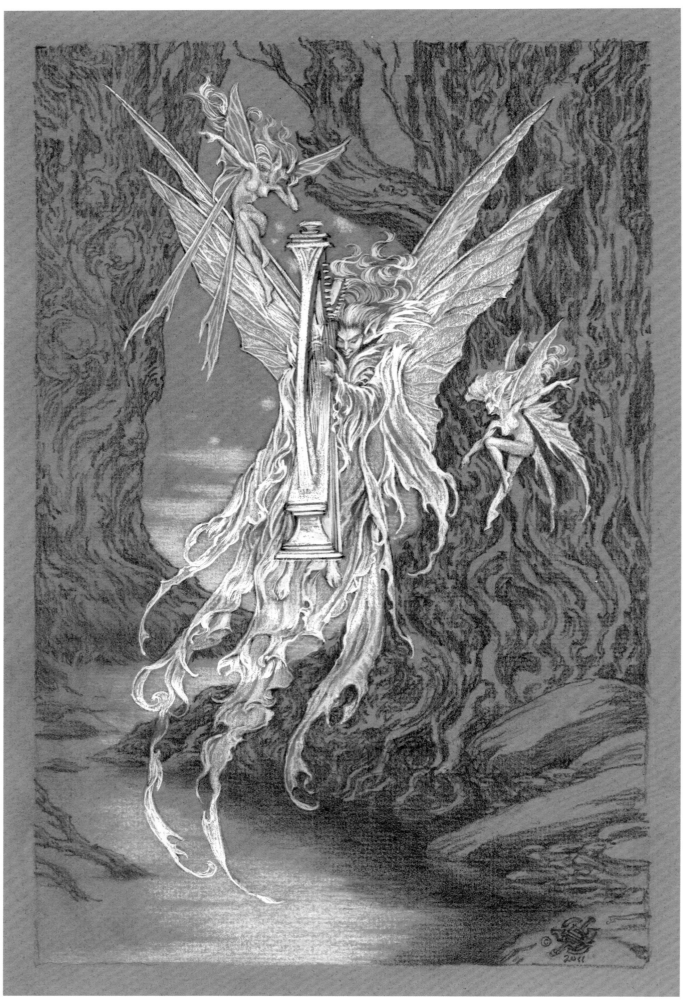

Above: Dark Music **Right:** Nightmare Academy

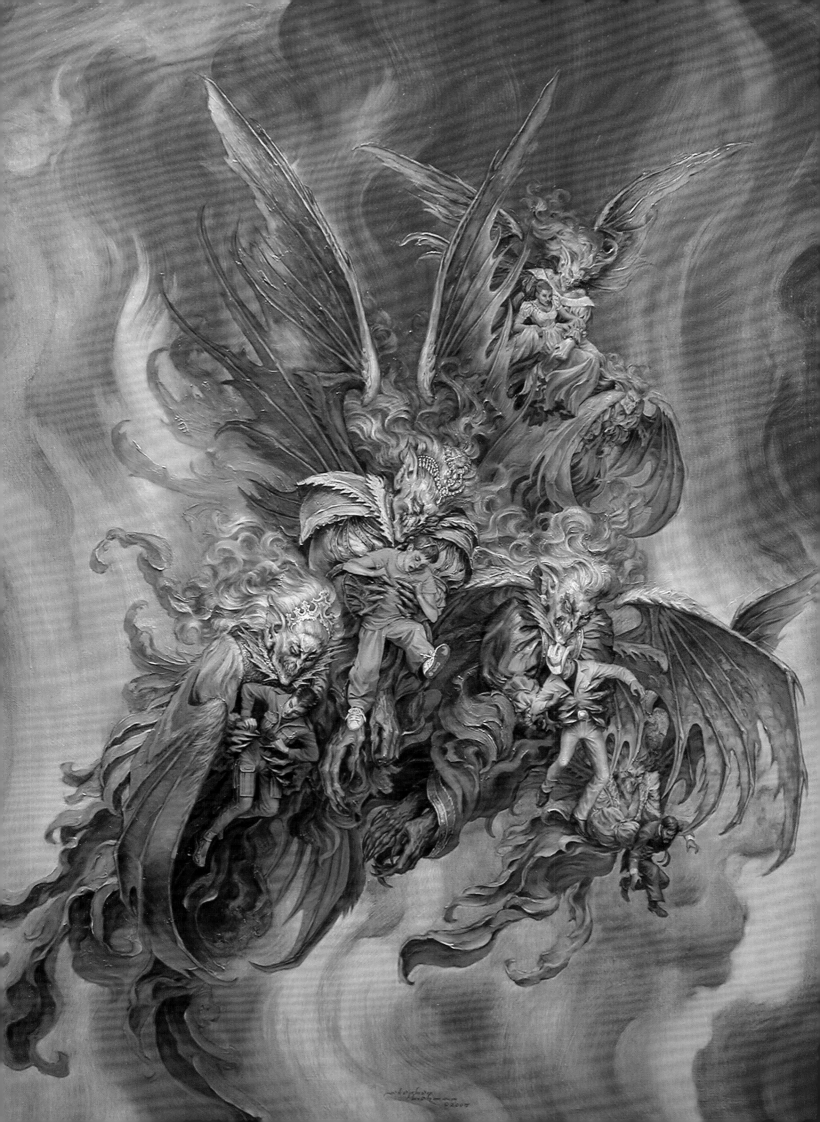

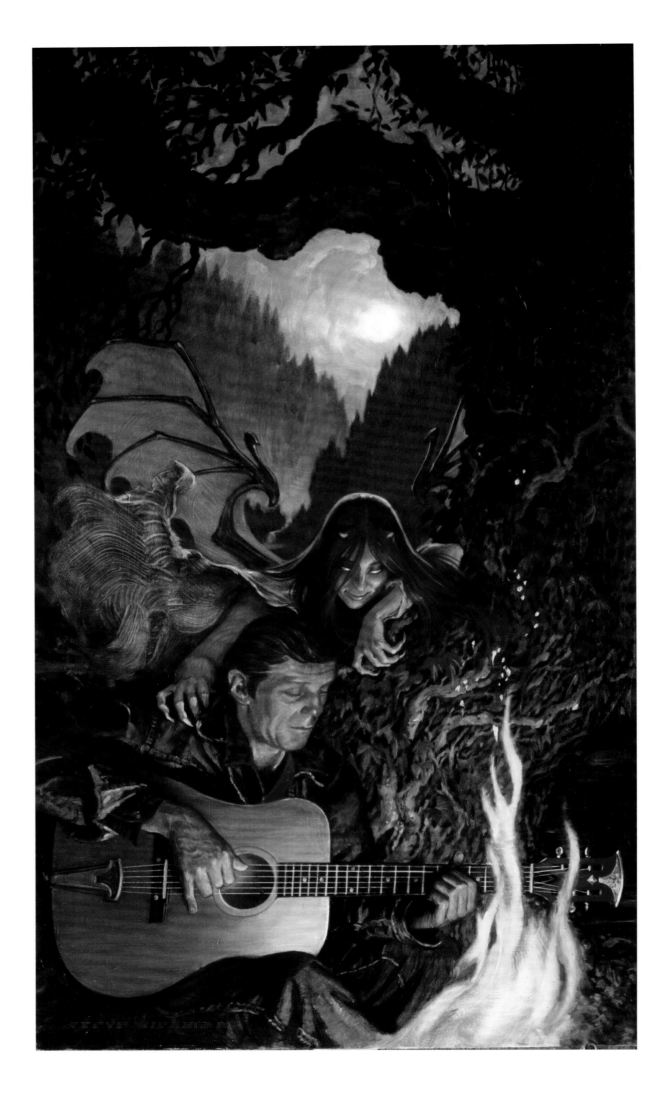

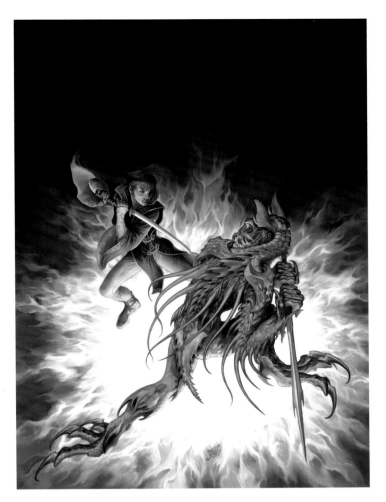

Above right: Death Angel
Above left: Princess of Wands

JOHN THE BALLADEER *(left)* - In the wee small hours of the night, some twenty-five years ago, I said aloud to myself, "I wish someone would give me a book I'd really love to do a cover for, like *Who Fears the Devil!'*

When I awoke at the crack of noon the same day, there was a message on my answering machine from Betsy Mitchell at Baen Books, "We're not sure it's your kind of material, but we'd like you to do a cover for a collection of short stories by Manly Wade Wellman called *John the Balladeer…*" (originally titled *Who Fears the Devil*).

Well, as Huck Finn would have put it, it fairly gave me the fantods!

Theological implications aside, John the Balladeer (the hero of the complete collection of stories from which *Who Fears the Devil* was taken) has always been an important character to me—in fact the start of a life-long obsession with acoustic guitar playing. So I particularly wanted this painting to turn out right.

I was fortunate to know just the right model, my friend Darryl Sims, whose looks and background experience matched the character of John perfectly; so I had a start. My schedule allowed just barely enough time to get the painting done, so I resorted to what I might call the Bushido approach and jumped directly into the painting stage without a finished drawing. I had done this before, when I occasionally could not face the tedium of the usual procedure, and knew from experience that this is a distinctly risky business. It's generally either a triumph or a mess, with no in-between. But it turned out one of the most satisfyingly "right" paintings I've done for a cover.

Technical Notes: I pre-textured the surface of my panel by slathering thick gesso on it with a vague idea of what my finished picture would look like, trying to get the movements and brush-marks to flow in the right places.

When the gesso had dried, I covered the textured panel with a thin wash of mars violet imprimatura to bring out the brush marks. I then projected my rough sketch onto the panel, and blocked it in using the same color. In the sketch, the background had all sorts of weird figures which somehow didn't look all that good, so I wiped them out one by one until only the female spirit-figure was left. The brush marks for something else perfectly suggested her wings and the garment blowing off her shoulder, as if on a sinister breeze.

When the underpainting looked like I had something solid, I finished off the painting using a Damar gum/stand oil medium, which lends itself to a "painterly" quality to the brushwork. Incidentally, the brushy effect is much more difficult to achieve than blending everything smoothly together—it looks effortless when it's done right, no matter how many times you've had to re-paint a passage until it looks fluent. And the finished result is much more fascinating than the tedious photographic effect.

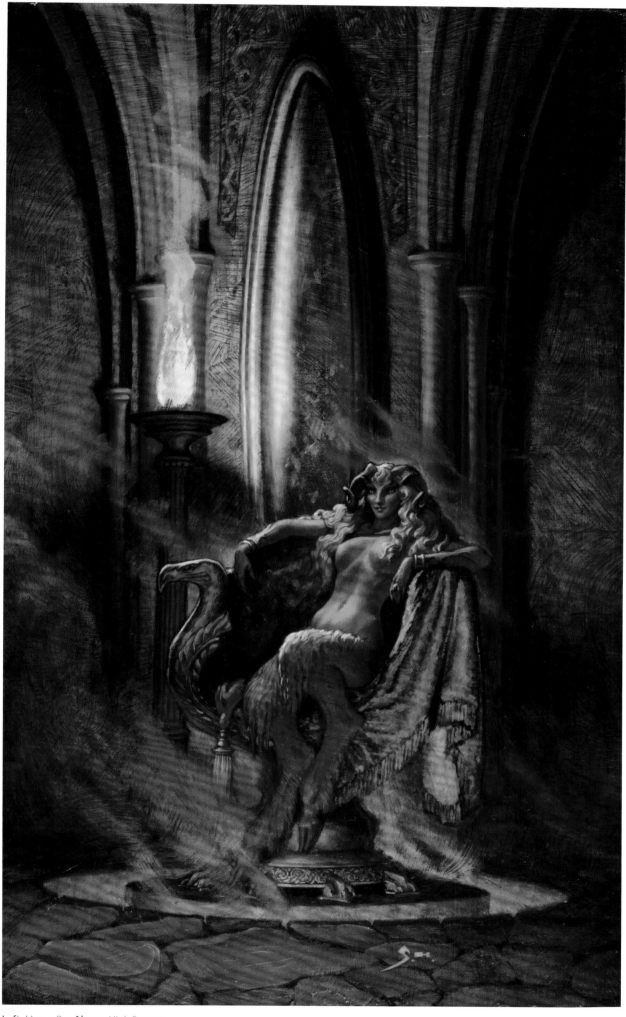

Left: Magus Rex **Above:** High Sorcery

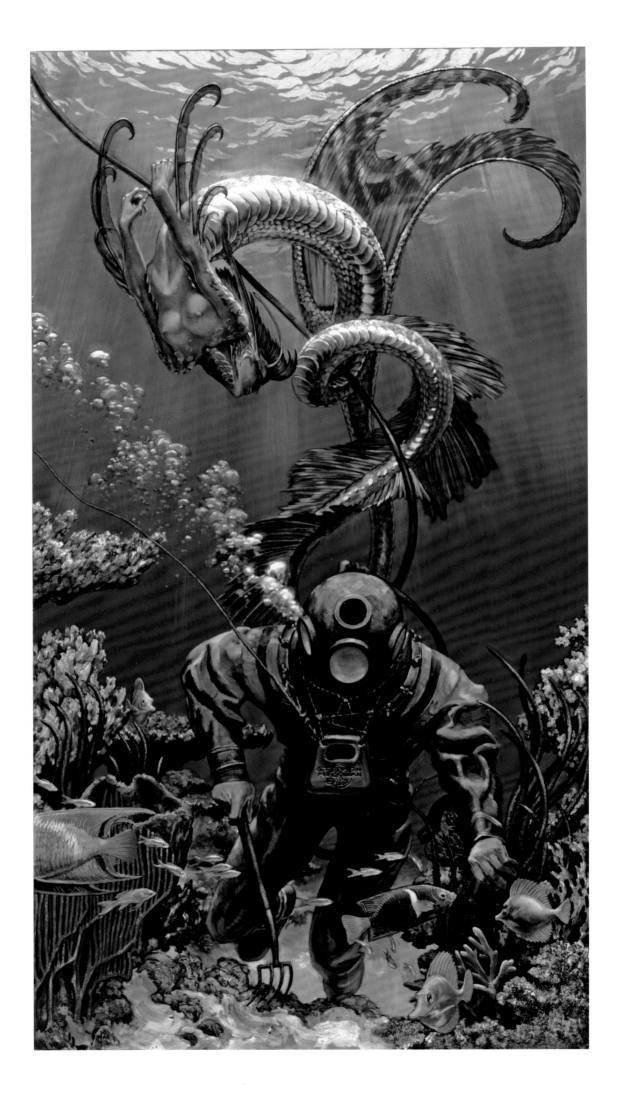

DIVER AND MERMAID - I've always been fascinated by divers and undersea subjects, ever since my mom took my brother and me to see *Twenty Thousand Leagues Under the Sea*. I was about five years old then, and the incredible submarine, Nautilus, and the wonderful diving suits designed by Harper Goff made such an impression on me that I read everything I could get my hands on about diving; from the article in our copy of the *Encyclopaedia Britannica,* to a book on the salvage of the submarine S-23, through the latest articles in National Geographic.

This obsession was also indelibly underlined when my dad took me on a snorkeling expedition around some reefs off the coast of Luzon when we were stationed in Manila. I was petrified (I couldn't swim yet), but the unearthly beauty of the incredibly intense color and light of the reef is beyond my power to describe.

I did this picture as a private commission, and ended up buying it back from my client when he ran low on funds several years later. A year later, I got a call from Harlan Ellison asking if I had any unpublished paintings he could take a look at. I sent him transparencies of several, including this one and *The Temple* painting, and Harlan chose this one to write a story around. Naturally, the picture served merely as a starting point for his ideas, but in due course of time *Midnight In the Sunken Cathedral* (one of the world's

great titles) appeared in Harlan Ellison's *Dream Corridor Number Zero,* with this painting on the cover.

Some years later my friend Peter Andrews gave me a collection of audio recordings of Harlan reading a number of his stories, *Voice From the Edge.* I listen to recorded books while I'm working, and in a preoccupied mood put the disc in my CD player and I'm painting along thinking to myself "My, that certainly is a vivid mental image I'm getting here!" That's right, major *déjà vu* time.

The painting now holds a place of honor in Harlan's living room.

Technical Notes: This is an oil painting on an oil-primed stretched canvas—meaning that the canvas was oil-primed before it was stretched; not only is this type of canvas expensive, it is also an incredible pain in the posterior to stretch properly. In addition, I found out the hard way that you can't fix a charcoal layout on this type of canvas with acrylic matte medium…

What I did was project the sketch (again) onto the canvas, and line it in using mars violet oil color thinned out with turpentine, and underpainted the foreground and figure using underpainting white and mars violet. This painting probably has the best brushwork of anything I've done so far.

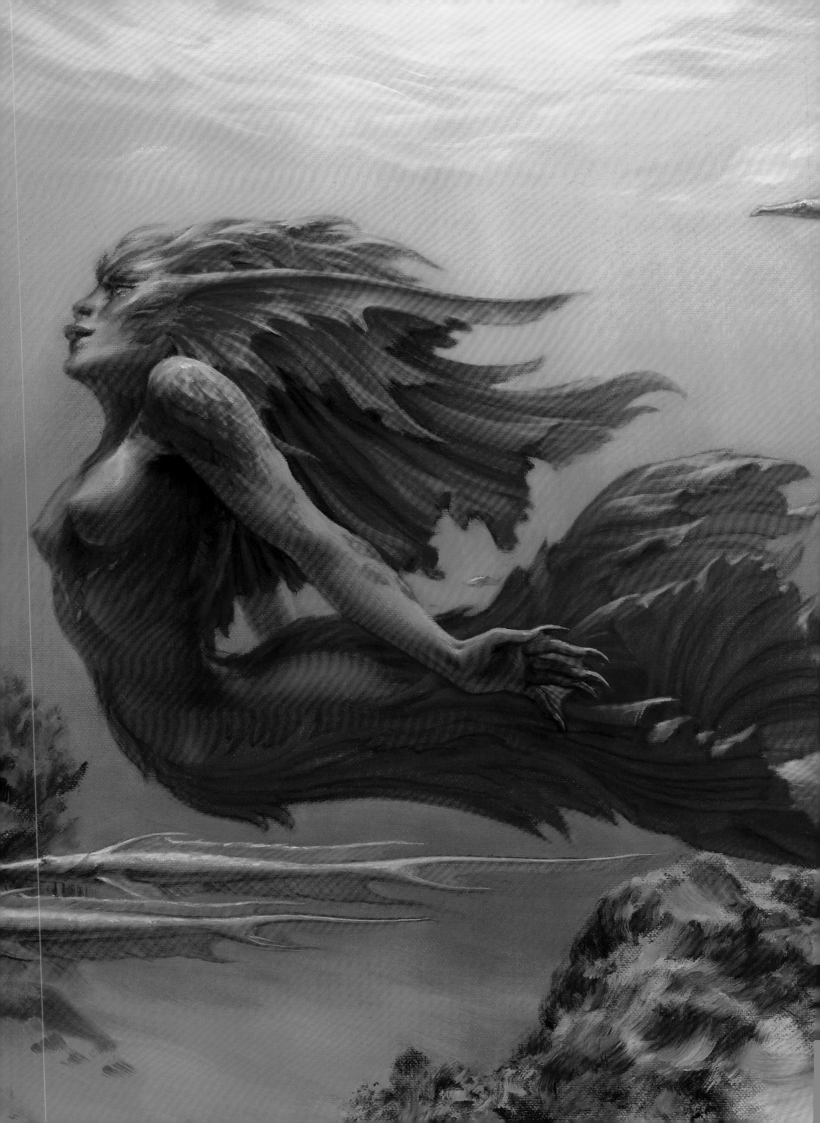

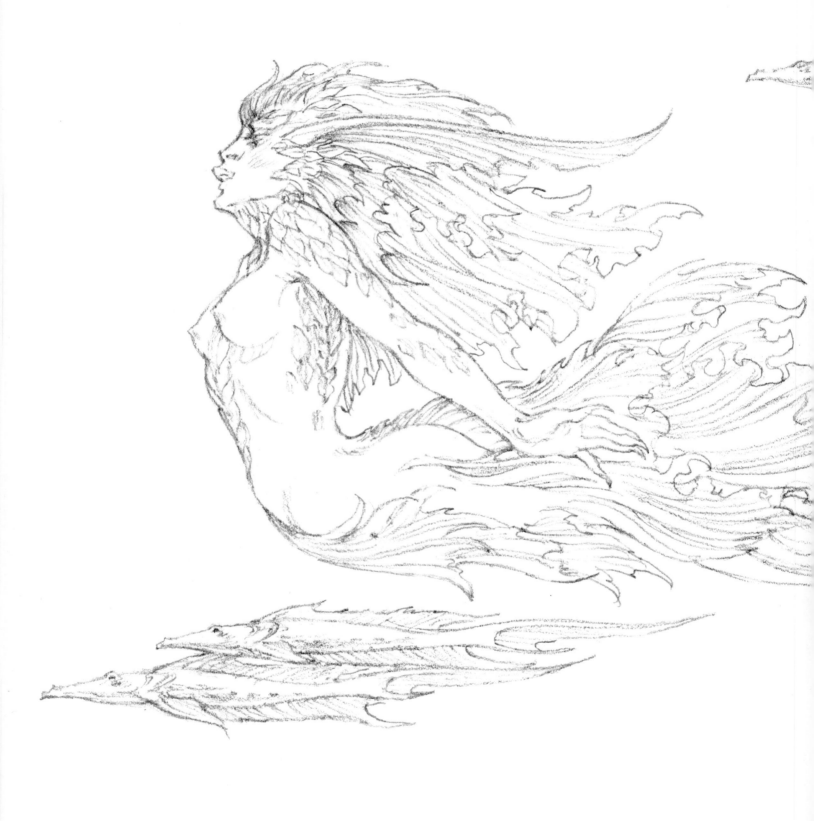

Above: Red Mermaid, sketch **Previous spread:** Red Mermaid

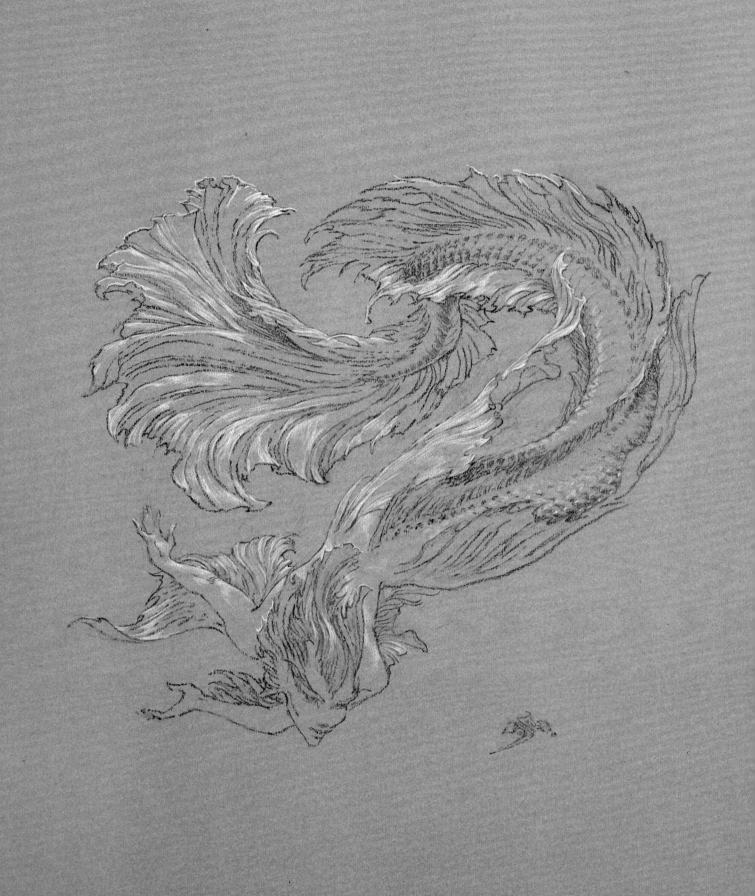

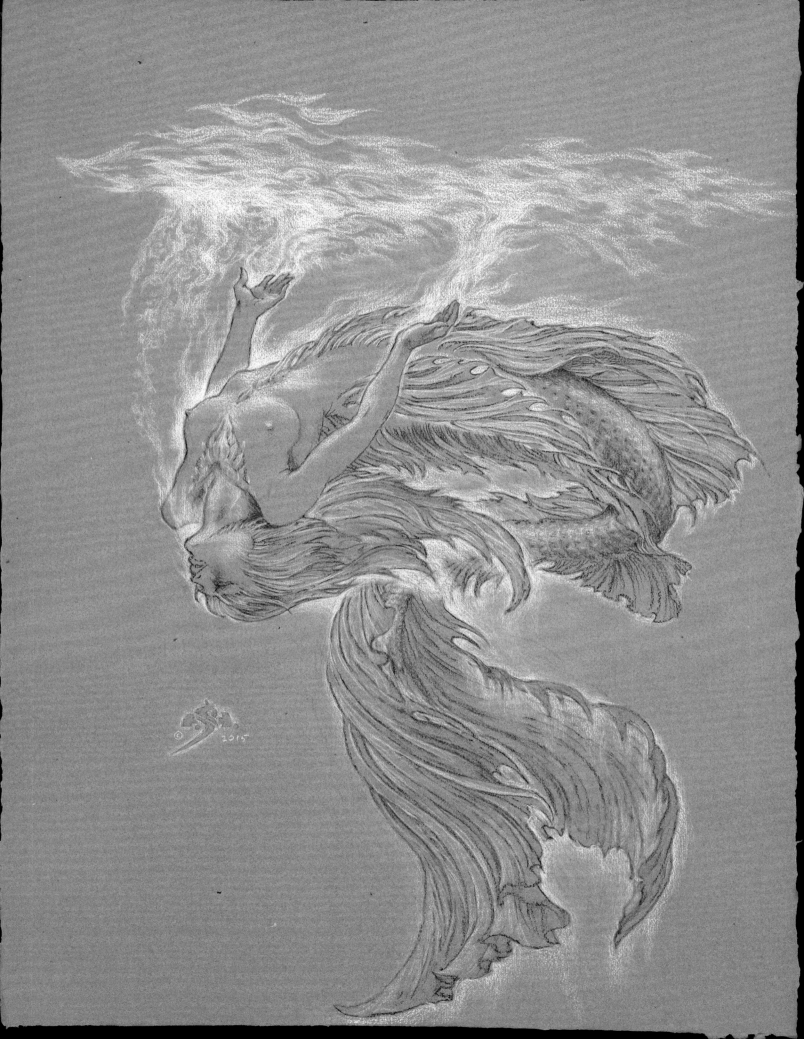

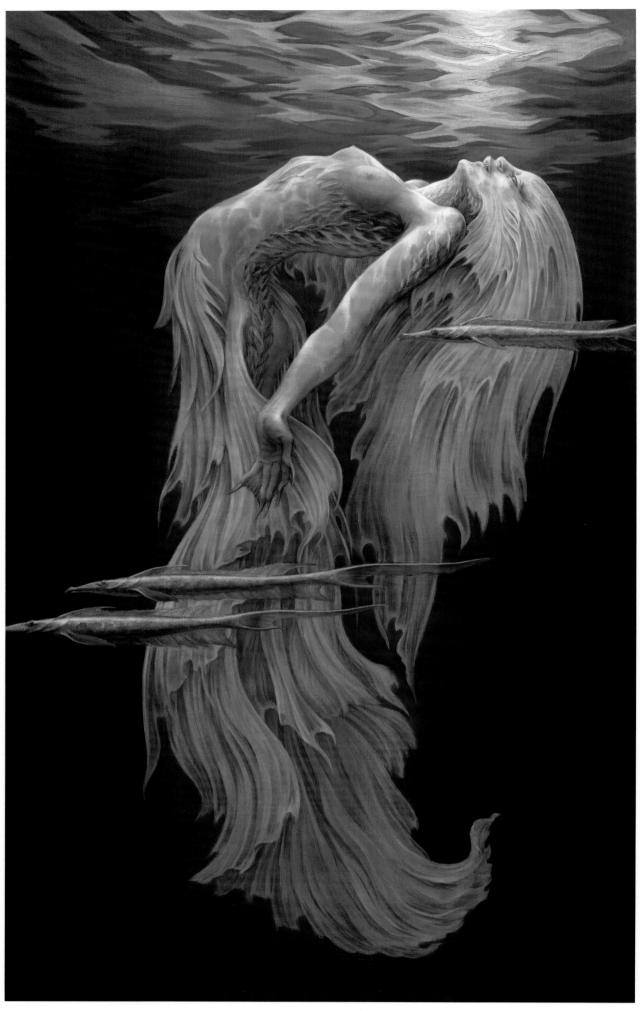

Above: Moon Gazing

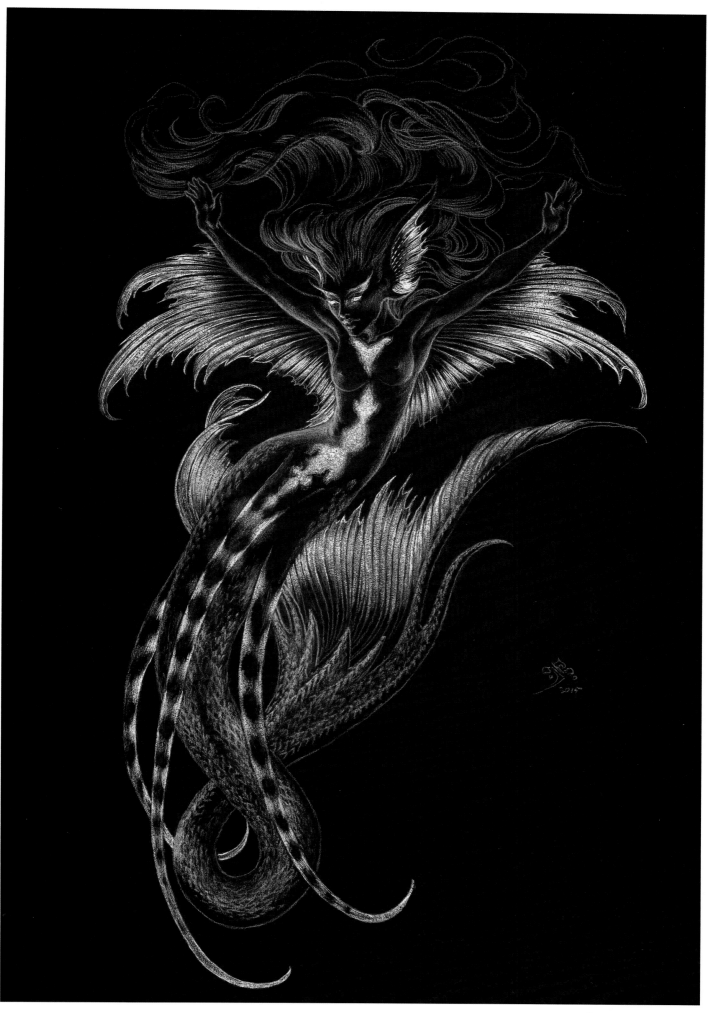

Above: Luminous Mermaid

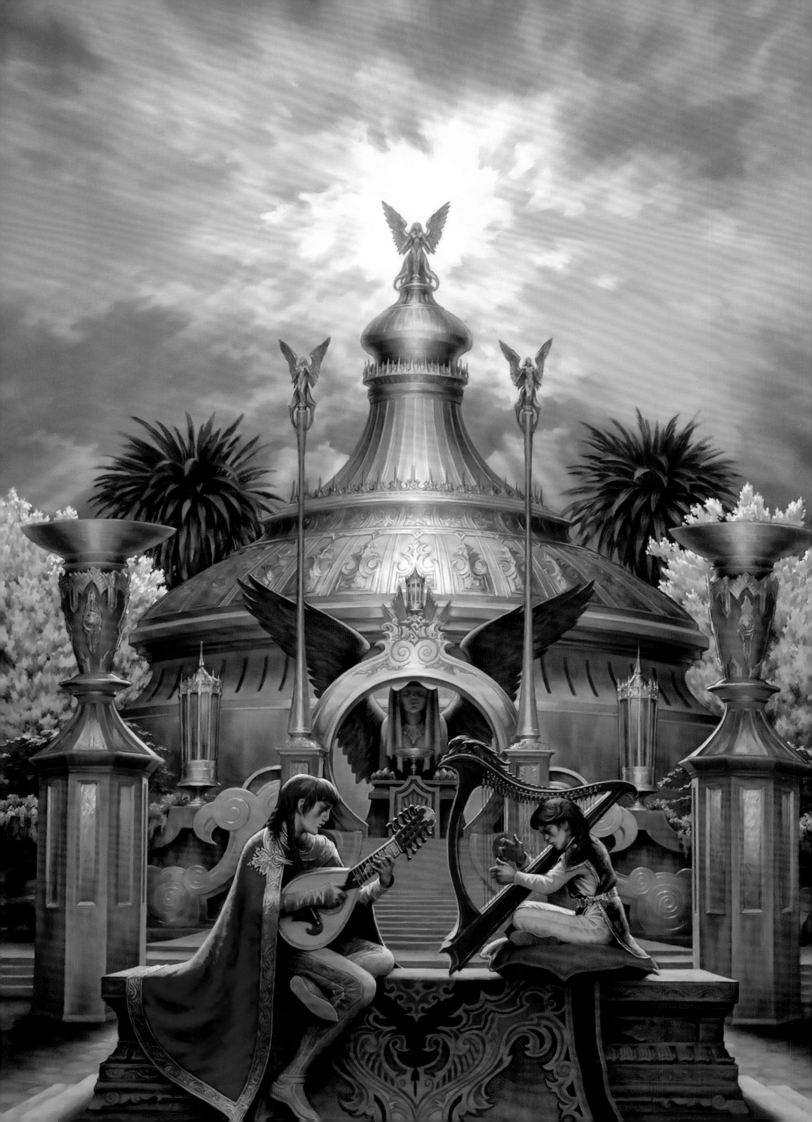

PHARAZAR

"The view of that world is a vision of blessed beholders." - *Plato*

Based on the series of images I developed for a proposed line of prints, entitled *Dream Gardens*, the scenes were inspired by a fantasy novel I wrote called *The Lemurian Stone* (Ace Books, 1989, Fontana [UK] 1989). I wrote the following in a promotional piece to accompany my proposal -

"The Golden Realm, Pharazar—dreaming in the twilight, when the notes of lute and harp replace the whirr of noon dragonflies. Beloved of musicians and poets, it is said that when the purest of music fades to the ear, yet it reverberates silently in the dreams of the Golden Realm."

What I did with these paintings was to make a list of all the things I thought were enchanting, wrote a book about them, and painted pictures of what I'd imagined when I wrote it.

DREAM MUSIC *(previous page left)* - "All objects in nature are made visible to the sight by the light of the sun shining upon them"— Howard Pyle (known as the Father of American Illustration).

Sounds obvious, doesn't it? Yet I've known artists who have literally spent entire careers learning this.

There is something very dream-like about certain types of lighting conditions—everyone's favorite class, when I was going to art school at RPI in Richmond VA, was Mr. Carlyn's Introduction to the Arts, though they were at 8:00 AM, and a very dream-like hour for art majors it was, too. He said something one time that has stayed with me: Mr. Carlyn believed that every great work of art has in it at least a trace of the surreal .

Light is the poetry of painting, and dreaming is the essence of life, in a very real way (paradoxically enough) for artists of Imaginative Realism.

I've thought about that ever since, both when looking at works of art, and looking at real life. Naturally, I have made up my mind about a few things of my own in that time, but I have grown in my appreciation of the dream-quality that you can see in certain types of lighting conditions.

One lighting mood I've always been fascinated by is where you as the viewer are facing the light source, and the object you are looking at is in shadow but outlined by the light behind it. It's tricky to do convincingly, but it is the mood I wanted for this scene.

The center of mass is an ornate golden dome, and the centers of interest are the two musician figures in the foreground. The images in this painting represent a sort of distillation of visual significances for me, in a manner of speaking, with the lighting as the emotional carrier wave, or maybe silent theme music...

Technical notes: This is an oil painting on archival paper mounted on birch plywood, using yellow ochre as my color choice for the monochrome underpainting. I used the Venice turpentine medium for the color work.

LEMURIAN STONE *(right)* - Ideas for paintings arrive in various forms: some with the first rough sketch, some after 25 sketches and a lot of blue language, and some after several finished versions. The flying city with winged horse motif holds the record, with (at least) five finished versions, the latest of which is *On Empyrean Wings*.

Between the first version, produced by Portal Publications as a poster in the late '70s, through this cover for my book *The Lemurian Stone*, to *Empyrean Wings*, the main element to evolve was the flying city. The woman on the flying horse, remains the focal point in all the paintings; though in the last two, in the interests of comfort, I have given them warm leather flying suits.

Especially in the realm of Fantasy, I believe in making things as real as I possibly can, as a convincing springboard for the imaginative elements: the horse's wings look large and powerful enough to actually support them, while the extra-long tails would plausibly provide directional stability. The painting for the original Portal poster was bought by Mr. William Lawerence, a retired airline captain, who was impressed with the clouds, and the fact that the winged horses were the first he'd seen in paintings that actually looked like they could fly.

Technical notes: This cover was done in oil color, using W&N Liquin as a paint medium, on a stretched canvas, over a monochrome underpainting of mars violet..

Following Spread: Ymirschemeh

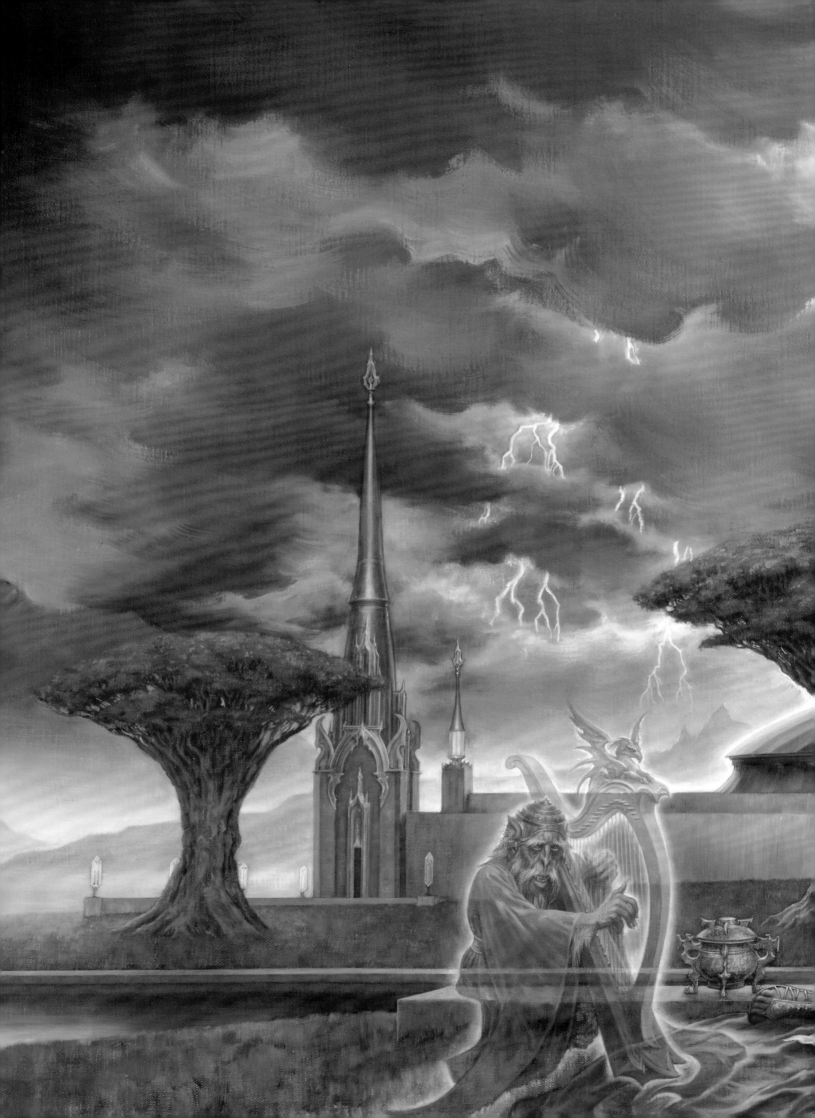

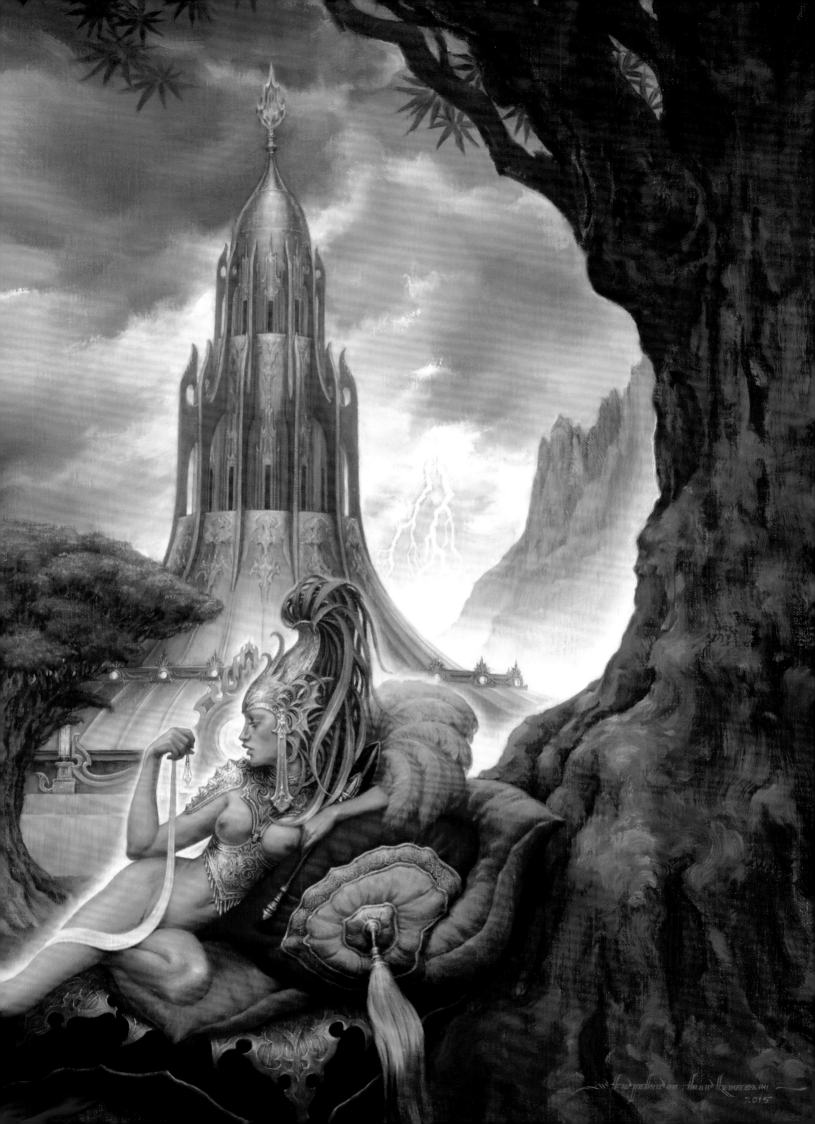

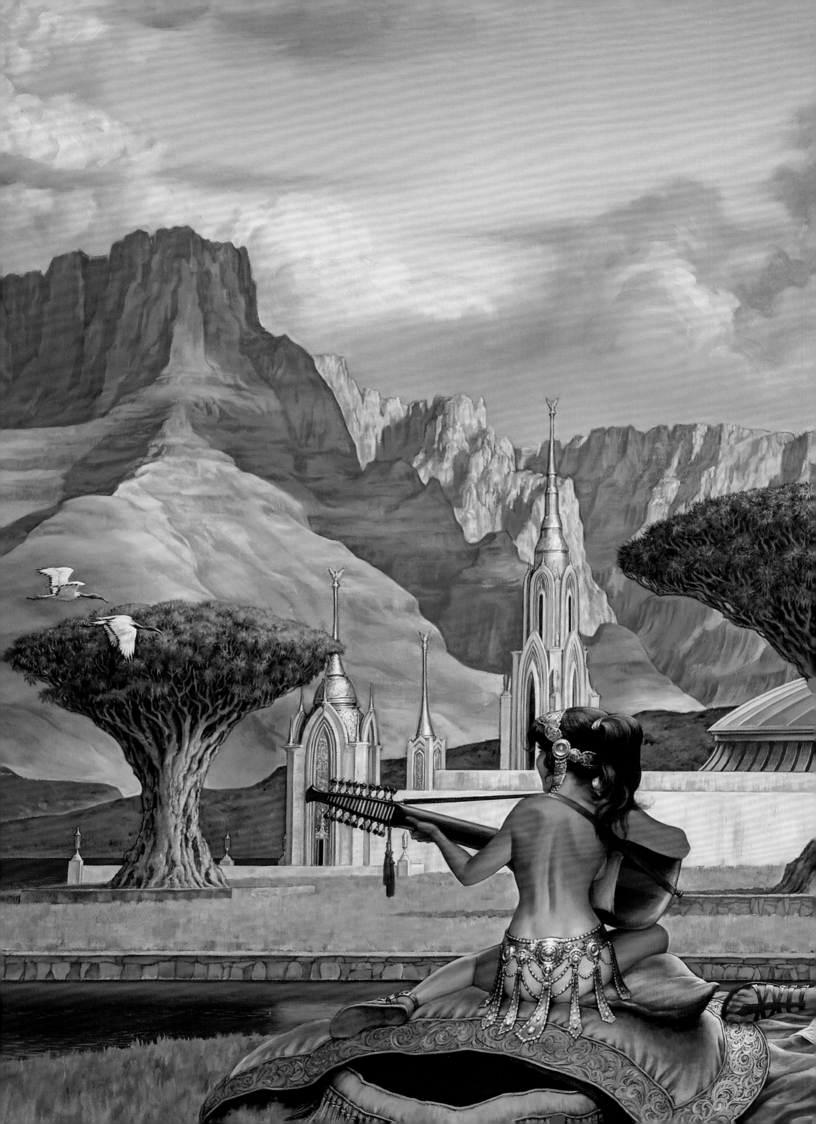

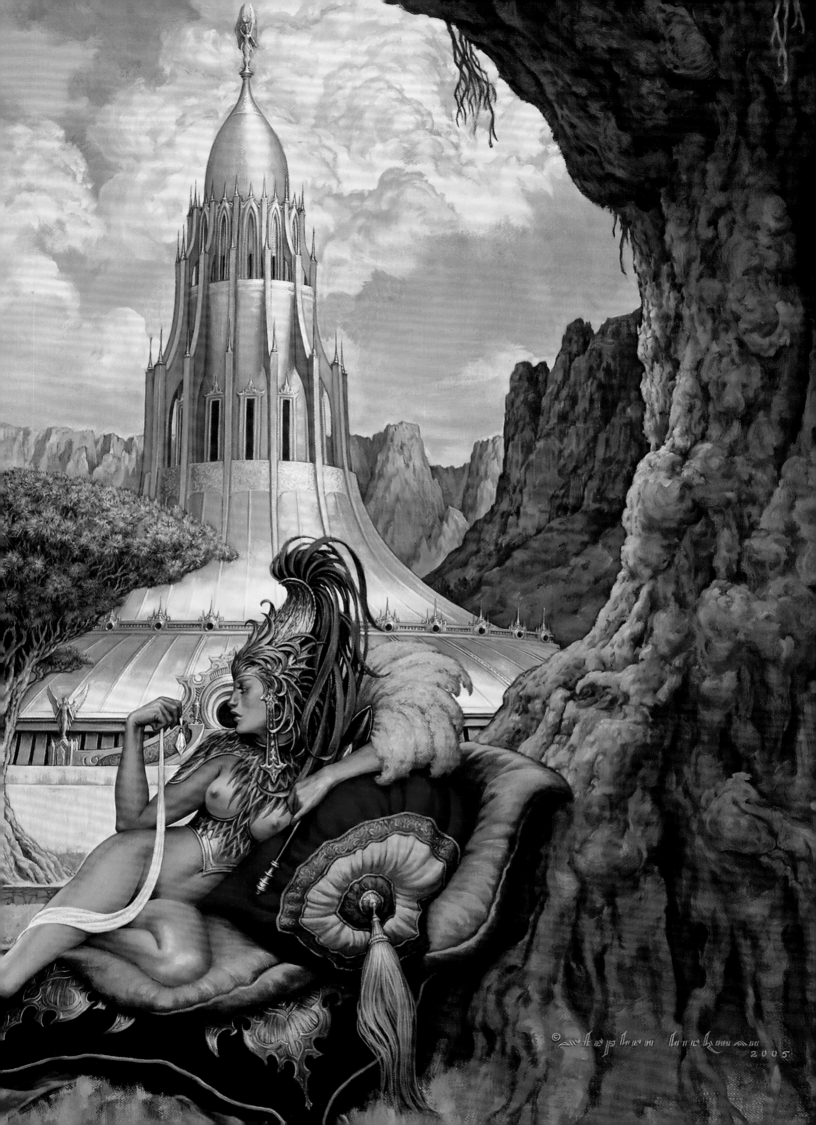

THE SEA OF VAYNU *(previous spread)* - I did the first small painted version of this fifteen years ago. I love these dragon trees, which nowadays live to be thousands of years old. In the past, kings cut them down for the supposed longevity-giving properties of the sap and wood.

Painting a very detailed color sketch or small painting saves quite a lot of time in executing a large picture. All the basic problems are solved by the time one starts, which allows the artist to concentrate on the brushwork and to take the painting to its next stage.

I seem to have a genius for making up simple poses that turn out to be torturous or impossible for a human being to paint. To my surprise the pose of the main figure in this picture turned out to be one of these.

The picture was projected up from a detailed sketch onto the canvas and refined in charcoal—take a look at the gold dome and imagine drawing the outlines for that accurately with willow charcoal sharpened on a sandpaper block. Keep in mind that it has to be the same on both sides. This phase took at least a week to finish.

Hardest of all turned out to be the mountains in the background. I wanted to give the impression of distance, and yet keep the amount of detail that a person with at least ordinary eyesight would see.

My favorite part of this painting is the coloring on the cushions and silks in the foreground.

Technical notes: Oil color on canvas, over a raw umber under painting, using a Venice turpentine varnish medium.

EMPYREAN WINGS *(right)* - Every once in a while, I paint a picture and almost get it right, but sometimes I hit on a theme that is somehow significant to me and worth doing again, to try and come closer to capturing my original inspiration.

This time there were four previous versions of this painting to get to the version you are seeing here. There are a number of paintings in this book that are re-worked themes, but fortunately this is the only painting I have had to do five times to be happy with. In all fairness, two of them were private commissions, but still.

When I paint a picture for myself, I rarely have a story in mind that I'm trying to tell, unless I have taken it deliberately from a story or myth I am fascinated with. Generally I paint from a mental list of things that I happen to like looking at—in this case, clouds (especially moonlit clouds), mysterious cities, creatures with wings, adventurous ladies with magic swords—yet the juxtaposition of images in this painting does seem to suggest a story beyond what the list of romantic images might seem to suggest: the beacons are lit, in an otherwise lightless city...

Technical notes: After I did a basic tonal study in charcoal on toned paper, I found a canvas of the right size that I had prepared with the right gray-toned gesso ground—I projected by drawing onto that, lining it in with charcoal, and then laid in the color with an unusual (for me) 'duotone' approach, using a grayed blue-green, with a complementary dark red-violet for the darkest shadows. From there, the color block-in went according to my usual procedure, using oil-modified Liquin as my medium.

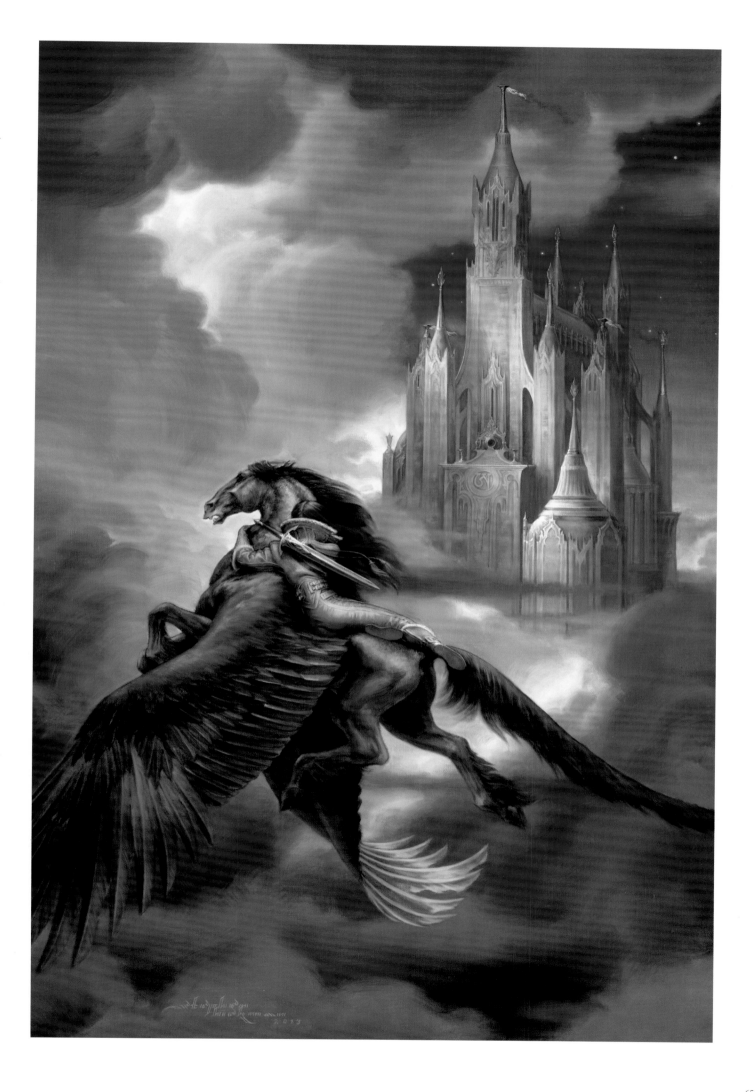

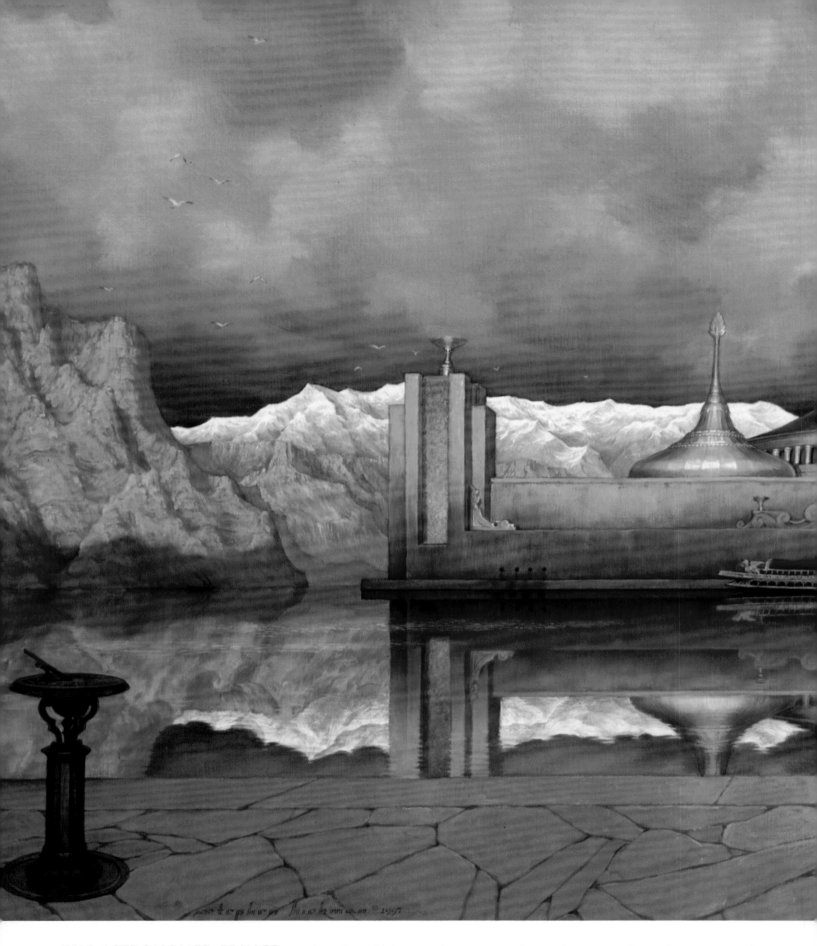

THE ASTRONOMER PRINCE - Here's another gold-dome extravaganza. The thing I like most about this one is that there is an immediate feeling of space and depth to the painting, despite the fact that I did not use atmospheric perspective—that is, the fading out and blurring of color intensity and hue to give the impression of distance to areas of a painting that the artist wants to recede. I wanted to have a feeling of space in the painting, and an early morning clarity of space, apparently. I say apparently because I don't recall any conscious decision to try and do this without the usual solutions. I noticed this when I looked at the file of this piece to try and figure out what to write about, and was struck by how clear everything looks—notice the barge moored at the palace, and the craft in the distance to the left. I think the delicacy of the detail is what does the trick.

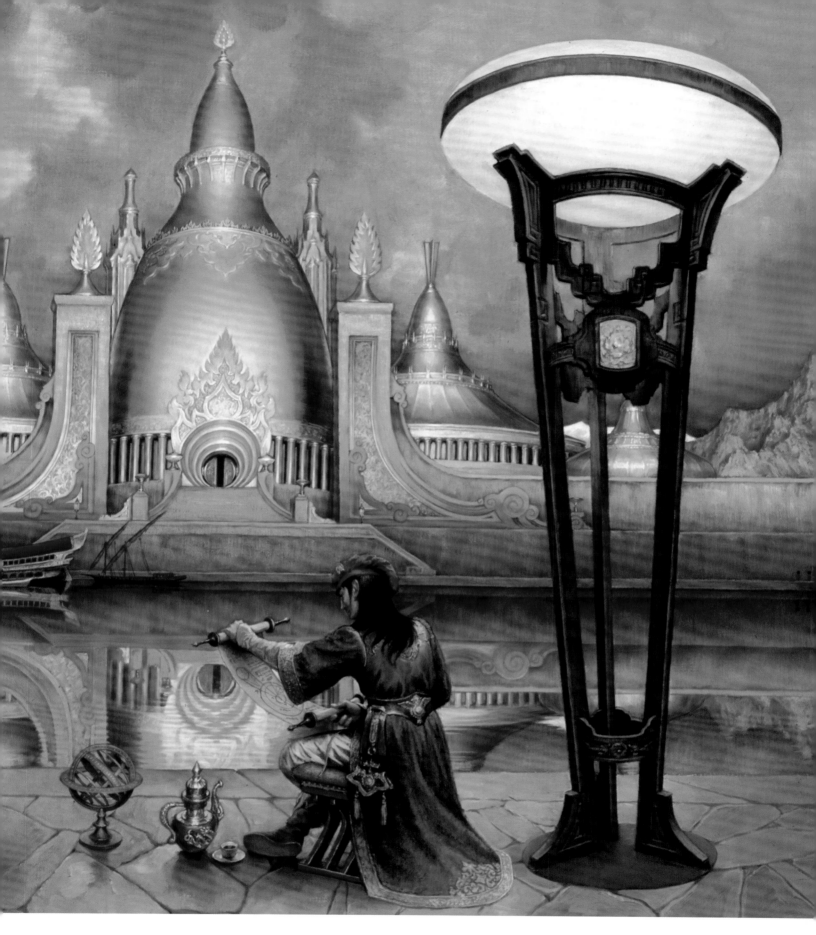

Actually, the most difficult thing to create was the reflected image (at a different eye level), and then painting the rippled surface on top of that.

Technical notes: This would be one of the paintings I would have used a varnish medium on. I was using a damar varnish mixture then. I make my own damar gum solution, which is a bit thicker than many of the store-bought brands.

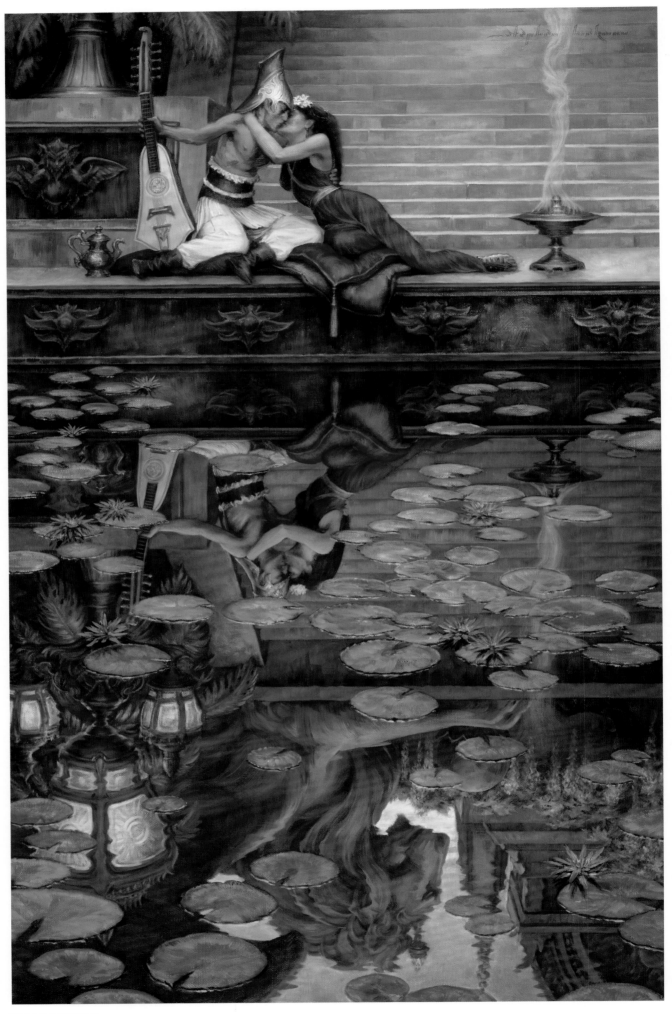

Above: Love's Mirror

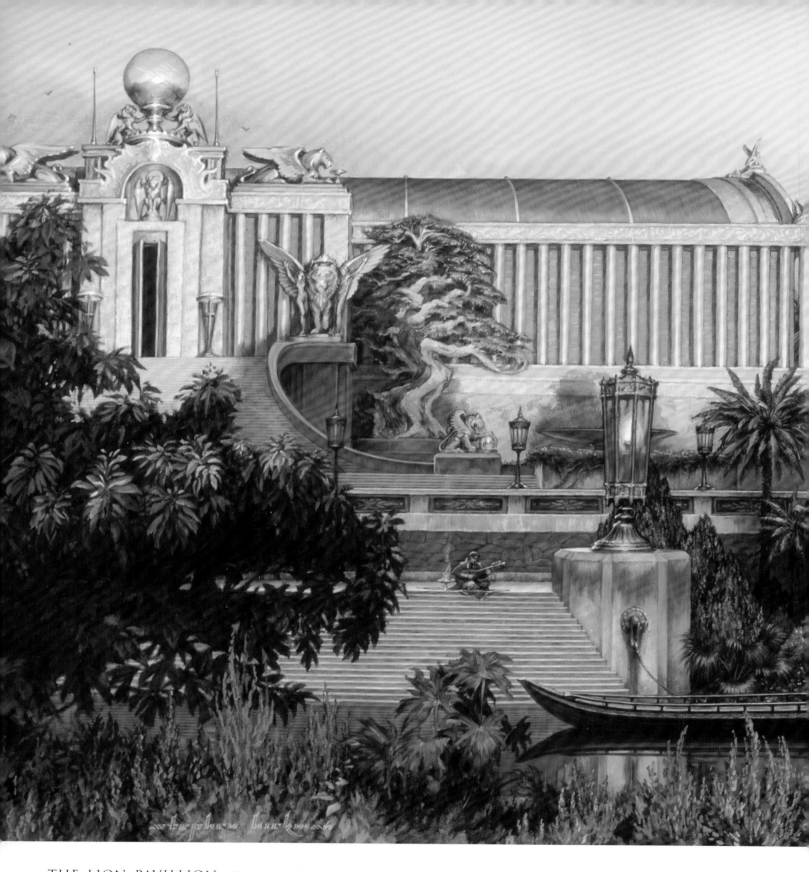

THE LION PAVILLION

THE LION PAVILLION - This is one of my signature pieces, which is good considering it took two months to complete, working every day. It is the development of a color sketch I had done five years previously.

I wanted to try and capture the mystical moment of early morning stillness. At the same time I deliberately decided to use a beautiful visual vocabulary as a sort of reinforcing visual therapy. Using a transcendental beauty as a subject matter was originally just a challenge, being by far the most difficult image to create effectively, not to mention being an exotic contrast to the hectic intensity of most modern work. Standing out is always supremely desirable. Beyond that, I wanted to

reinforce the psyche of my fellow mortals, which is also a good thing.

Use of color, emphasis on the serene horizontal line (which influenced the choice of a horizontal, rectangular format to begin with), and choice of imagery including the golden dome and orb (suggested by the antipodean imagery in Aldous Huxley's *Heaven and Hell*), all contributed to a sense of well-being I experience when viewing the painting.

Technical notes: Oil on canvas over a refined charcoal outline, and one of my rare paintings using yellow ochre as the monochrome color. I used a Damar varnish medium on this.

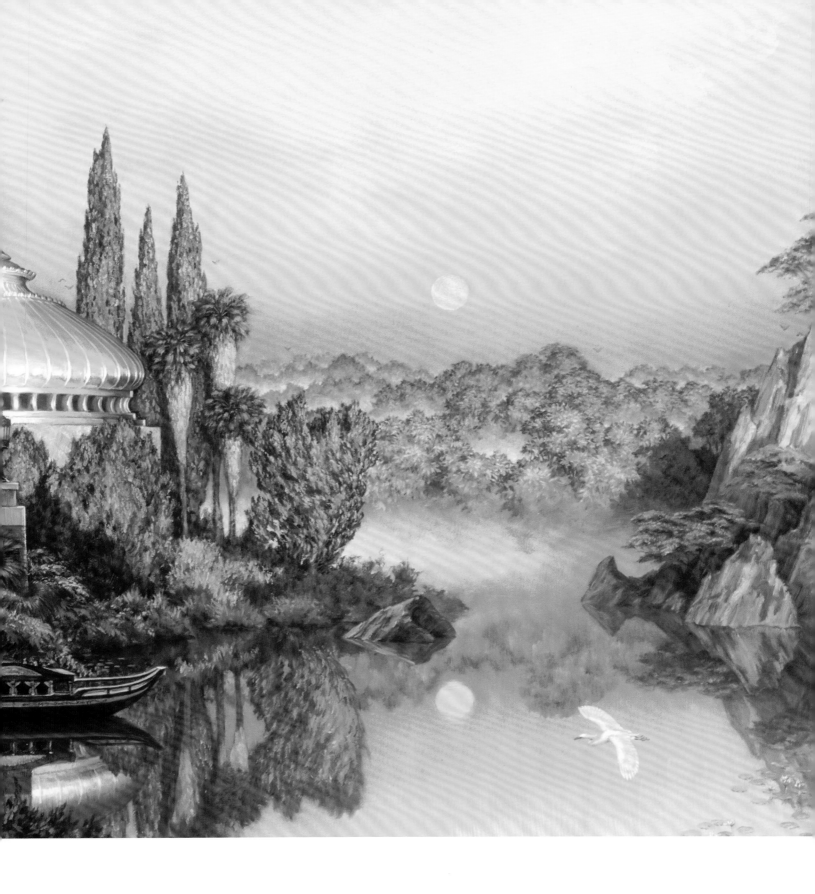

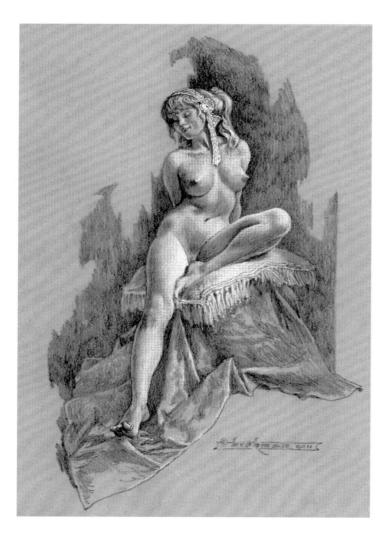

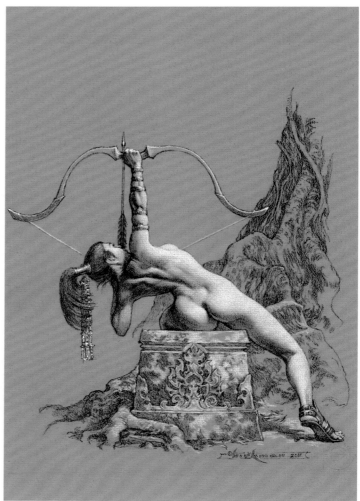

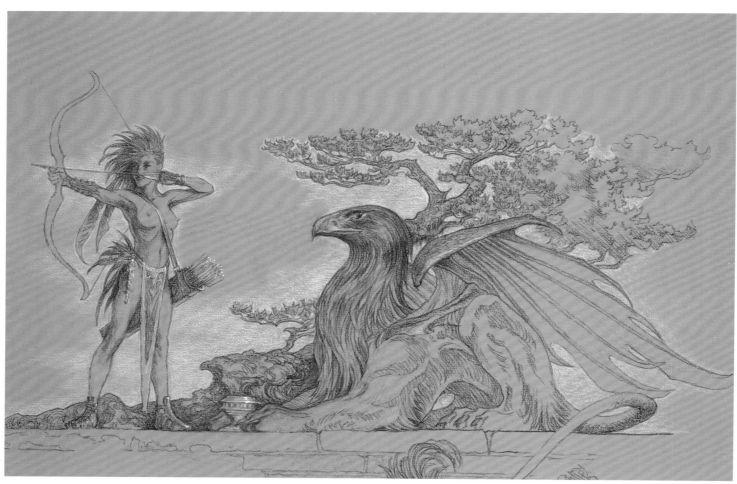

Top left: The Toe Ring, **Top right:** The Challenge, **Above:** Gryphon Archer

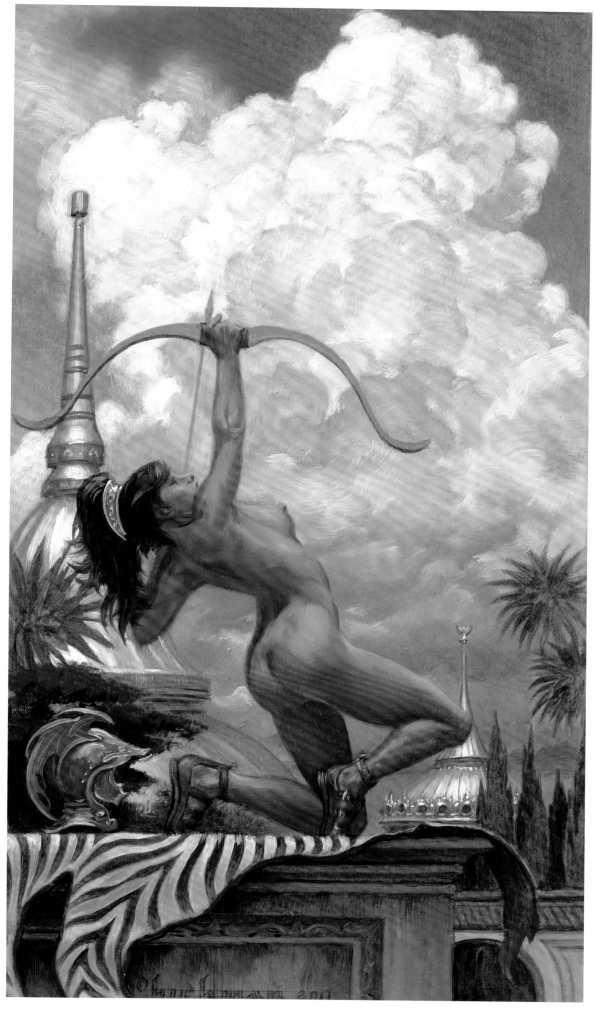

Above: The Arrow

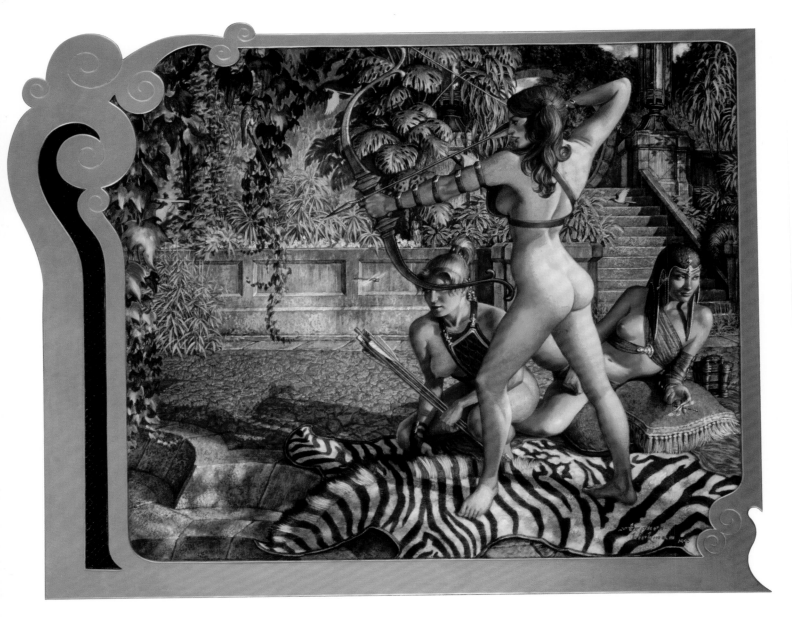

THE ARCHERS OF LHUNE (*above*) - These young persons are
characters in a fantasy novel I wrote, *The Lemurian Stone*. They are
Sharmane (standing), Minko (lounging), and Yvonne (paying attention).

The setting is a sub-tropical monsoon-weathered garden, so the key note
here is character. This I decided to suggest right from the beginning by pre-
texturing the canvas. A stylized wave motif in the raised border extends the
stylistic influences of the setting.

This is one of those paintings where the mood was strongly influenced
by my childhood impressions of Manila (as whole parts of the novel were
also). The effect is deeply satisfying to me, as I managed to catch a glimmer
of the magic I felt at that time—Manila was a wonderful city in the mid
1950s. The first time I actually saw an artist mixing paint using
complementary colors was a friend of my parents, Bessie Casteneda.

Make a list some time of all the things you think are cool or beautiful or
fascinating, and make that what you paint—I think it is a grave mistake to
try and figure out what people want to see, because folks almost always
sense the lack of complete sincerity.

Technical notes: Oil on pre-textured canvas, with the addition of a raised border
epoxied to the canvas surface. The medium I used was a Damar gum solution/
stand oil formula.

THE LEMURIAN PRINCESS (*right*) - This is what I might
call a pivotal image for me. Done originally to be printed up as posters, it
was the first in the Pharazar series, and inspired *The Lemurian Stone*, my
fantasy novel published by Ace Books around 1988.

It was also a first for several other reasons as well: it was my first painting
using the raised border treatment, an idea I got from seeing an exhibit of
Maxfield Parrish at the Brandywine Museum. It was also the first extensive
use I made of pre-texturing, using the old formula Sani-Flat (see technical
notes below). It was the first time I ever made a serious effort to capture a
likeness as closely as I could.

The exotic features of my model, Valerie Kidwell, were perfect for the
character of Tara Wing-Tzu in my book as well. It stayed in the monochrome
underpainting phase so long that everyone got used to it, and when they
found I was going to put in the color they were sure I'd ruin it—of course
this was all very encouraging, but after all, the painting had not gotten as
far as it did by accident.

The color work proceeded on and off for twenty years, the final work
being done about the turn of the century.

Technical notes: The canvas was first pre-textured using Sani-Flat applied with a
paint roller. The raised border was cut out as a single piece from a sheet of rag
museum-grade matt board, and the edges carefully rounded with sand paper. The
border was glued onto the canvas surface, and several coats of sanding sealer.

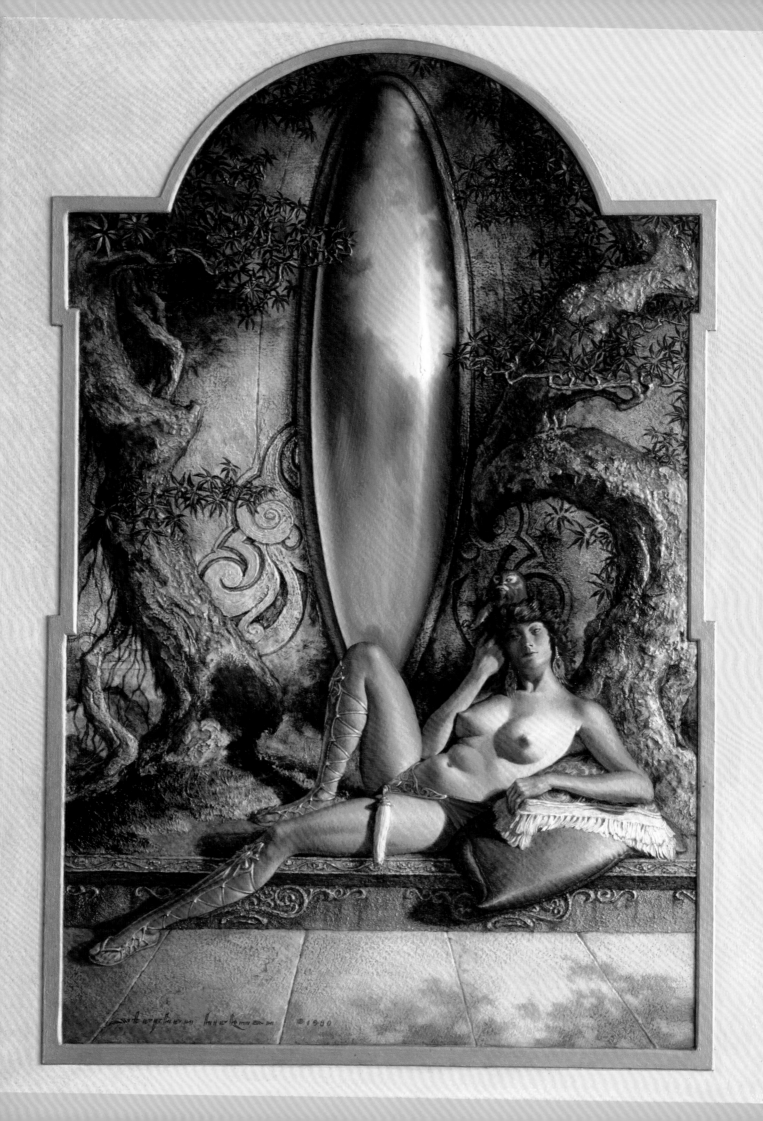

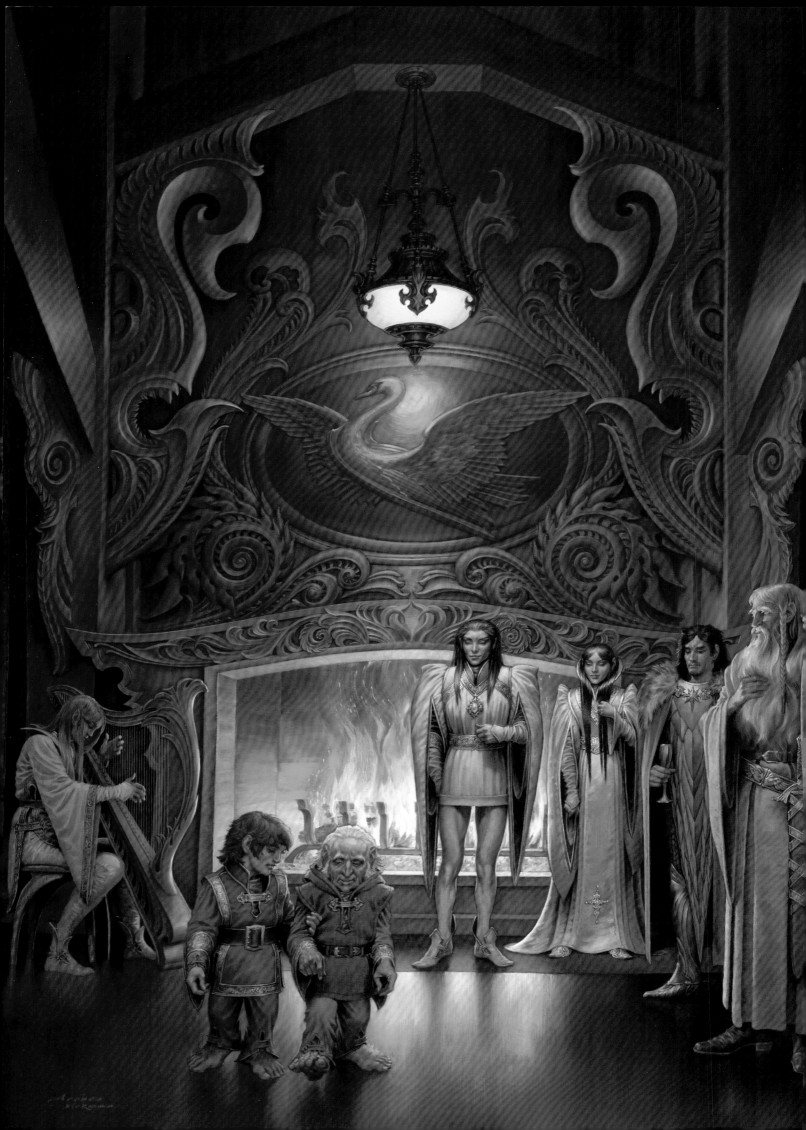

TOLKIEN

I've always considered the writing of J.R.R. Tolkien as the perfect subject for the ultimate doctoral thesis of illustration—using, as he did, traditional and familiar character types for his stories (heroes, elves, dwarves, goblins), Tolkien was nevertheless able to imbue these somewhat shopworn stock types with a deeply poetic and wondrous sense of character, and back-histories of epic elegance; his elven peoples, for instance, are among the most magical in all of fantasy literature.

The difficulty in illustrating Tolkien, then, is to bring the poetic magic of his writing into paintings without falling back on the stereotypical imagery that popular culture has presented to us all our lives. Professor Tolkien is unique in his ability among writers of modern fantasy in his ability to evoke the magic of names and language. To create a reality beyond the mere outlines of story, epic though it undoubtedly is, and which seems to grow richer with every reading. What I aimed to do in my illustrations from *The Lord of the Rings*, and *The Silmarillion*, is to paint pictures with the strength to resonate with that richness.

Left: The Hall of Fire

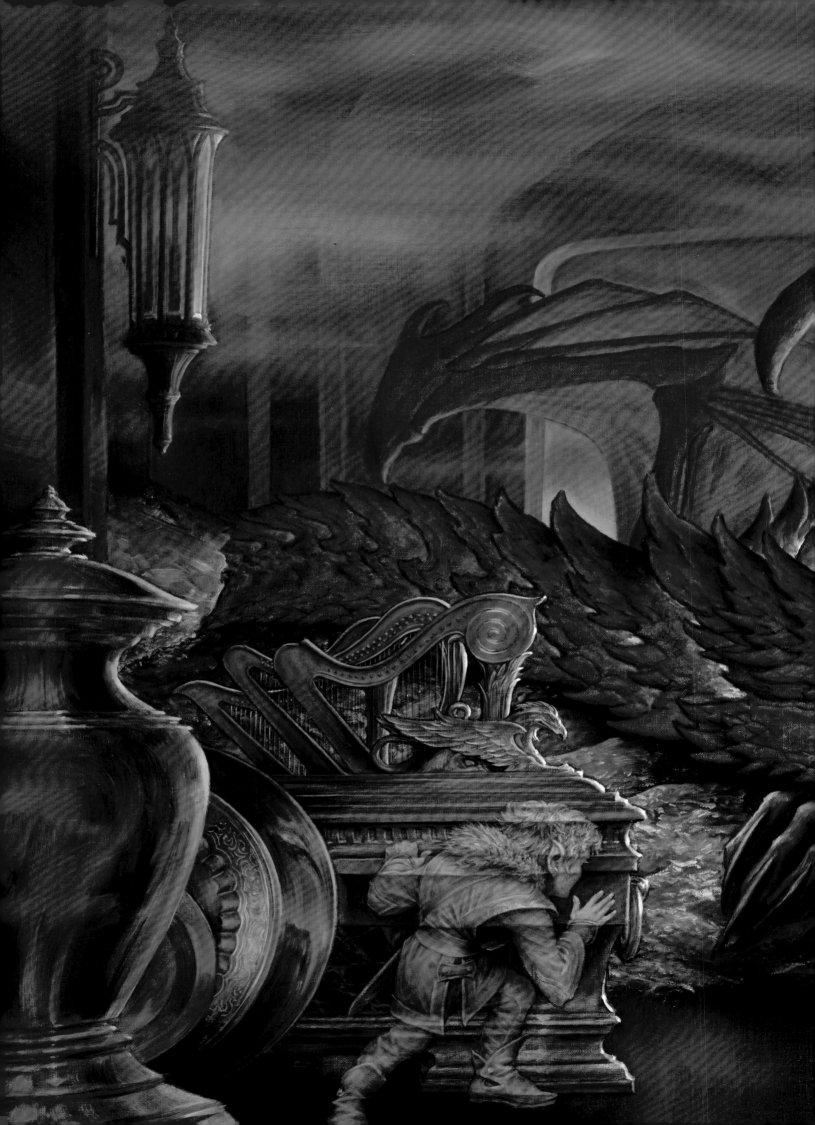

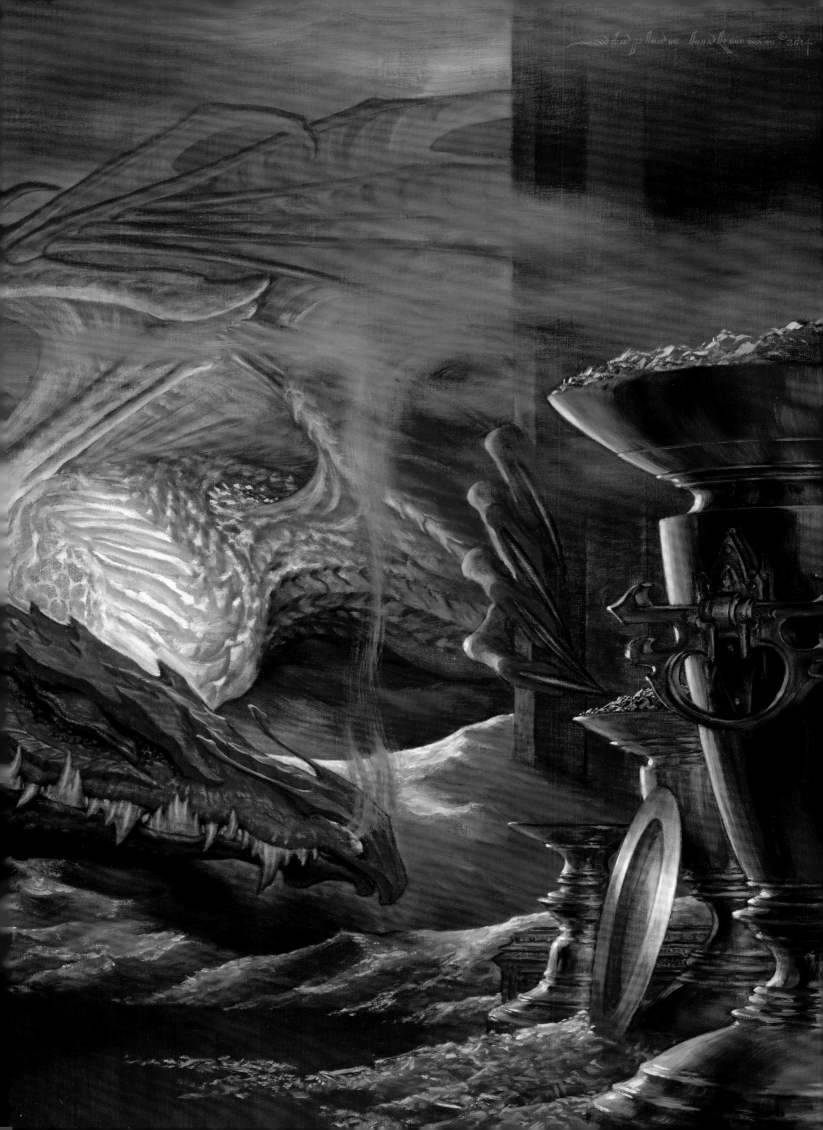

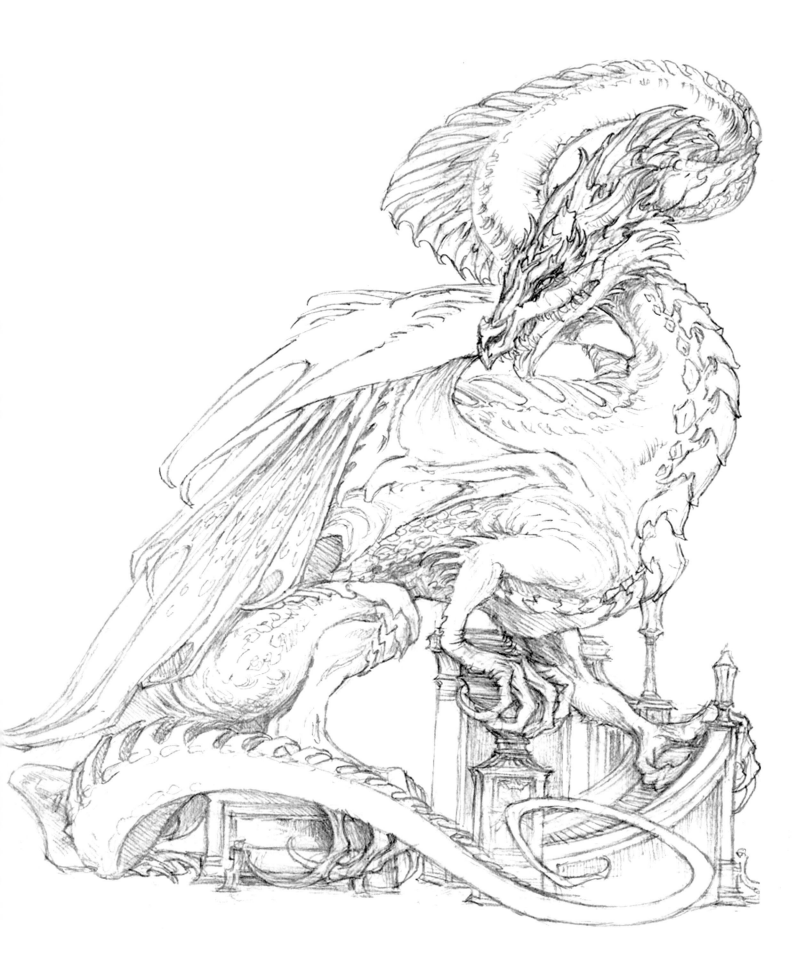

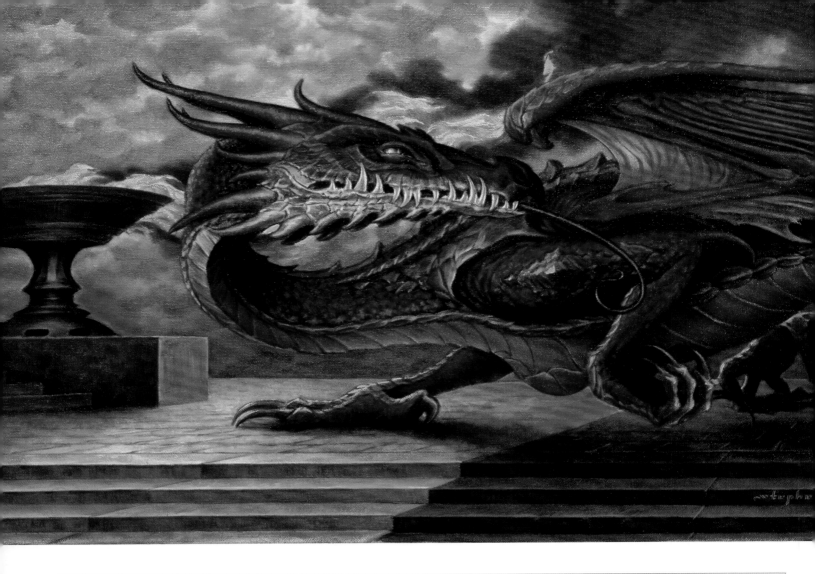

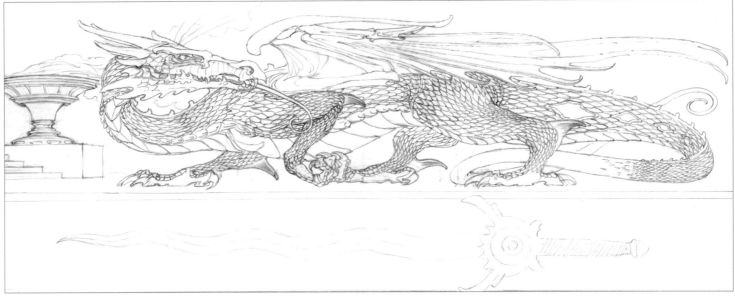

SMAUG AT ANGBAND - Of all my dragon paintings, this one might just be my favorite (so far, that is)—I like the concept, the mood, the drawing of the wings, the color, all of that stuff. The real trick with a dragon picture is to suggest the character of the creature; after all, dragons can get away with a lot of attitude. And Tolkien was the master of the dragon-spell, as readers of *The Silmarillion* can attest.

As with the Black Rider painting, this is a peripheral sort of scene, implied by the text rather than directly described. Here, Smaug is still a young dragon, prowling restlessly on the parapets of Angband, the fortress of Morgoth, the Great Enemy.

I do love working on a shape which does not involve leaving the top half of a vertical rectangle open for type, as is customary for book cover work. The design possibilities of a private commission like this is are such a pleasure.

Technical notes: This is an oil painting, done of pre-sized fine-grain cotton canvas, over (if I remember rightly) a raw umber underpainting.

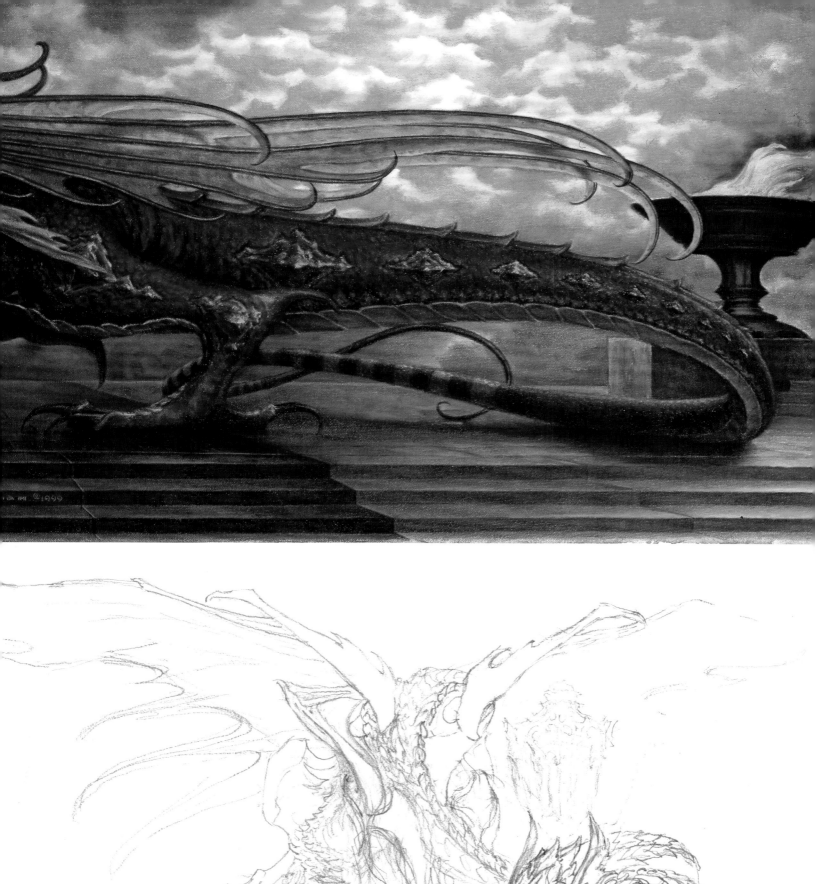

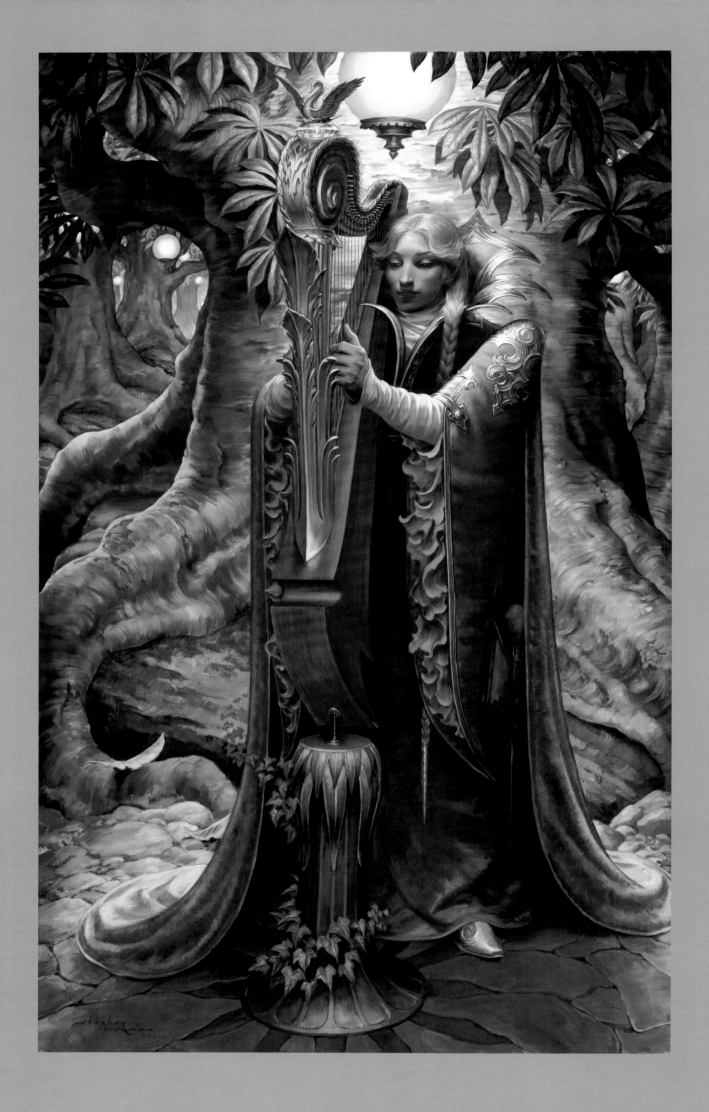

THE HARP OF GALADRIEL - This scene started out as the tonal sketch you see here, and continued to intrigue me every time I looked at it. Eventually I was tired of wondering what it would look like, and decided to paint it.

I had a canvas prepared, and unwisely decided to try out an oil priming I had been saving, which, according to best authorities, is the proper way to paint. What the proper authorities fail to mention is that a traditional turpentine-thinned monochrome underpainting will turn into an appalling, smeary mess. So I had to paint an opaque monochrome underpainting, more in the mode of Solomon J. Solomon.

While I was dealing with the technical 'details' (the painting took about eight months), I happened to discover the chapter on Galadriel in

Unfinished Tales, and was completely captivated. The single most fascinating and powerful character in the *Rings* trilogy, Galadriel became much more of a living presence to me, and became a real challenge to properly characterize. I ended up by painting the face over and over, mostly dealing with subtle nuances of eyes and hair that seemed to change everything about the character. Unbelievably frustrating, but I found a look that was right for me, finally.

Technical notes: This is an oil painting on canvas, executed over a smeary opaque monochrome underpainting, for which an oil primer was responsible—I highly recommend this for those who like a challenge. The painting medium I used was the Venice turpentine/sun-thickened linseed oil/turpentine one.

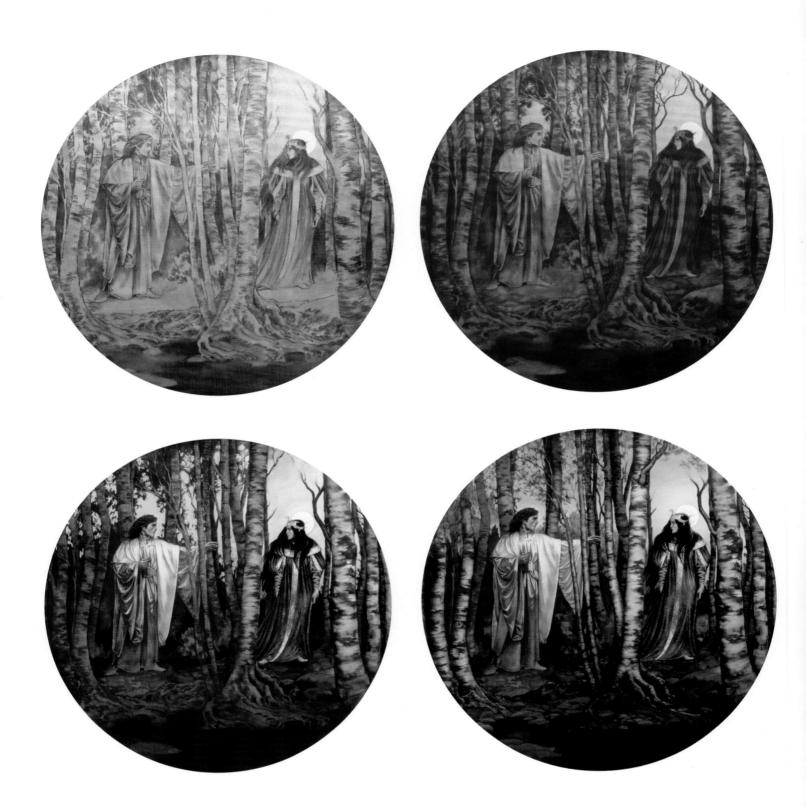

THE MEETING OF ARAGORN AND ARWEN - *The Lord of the Rings* is a book particularly rich in intriguing peripheral scenes; that is, though not directly described, they are suggested by dialog or narrative. In this case, the scene is described directly, though not in the main body of the story: you can find HERE FOLLOWS A PART OF THE TALE OF ARAGORN AND ARWEN in Appendix A, at the end of the third volume, *The Return of the King*.

Following this entry as closely as I could, I drew a scene that shows the moment Aragorn sees Arwen for the first time in the birch forests above Rivendell. Here, Aragorn is twenty years old, and has just been told of his kingly birthright, and clad in elven white. The deep poignancy of the meeting lies in the fact that, though young for one of Elven kind, she is of immortal race: Arwen is already thousands of years old.

The great challenge for this painting was the faces of the two characters—I knew that if I could only make the faces convincing, the entire painting would work. Aragorn had to look young but of a kingly nobility, and Arwen had to have a presence beyond that of human race.

My favorite touches were suggested by my client, Ms. Jacqueline LeFrak; the bit of color in the background, the flowers and mushrooms.

Technical notes: Oil color over a Gray-tinted gesso, the outline refined in charcoal, and a mars violet underpainting. I painted this using the Venice Turpentine medium.

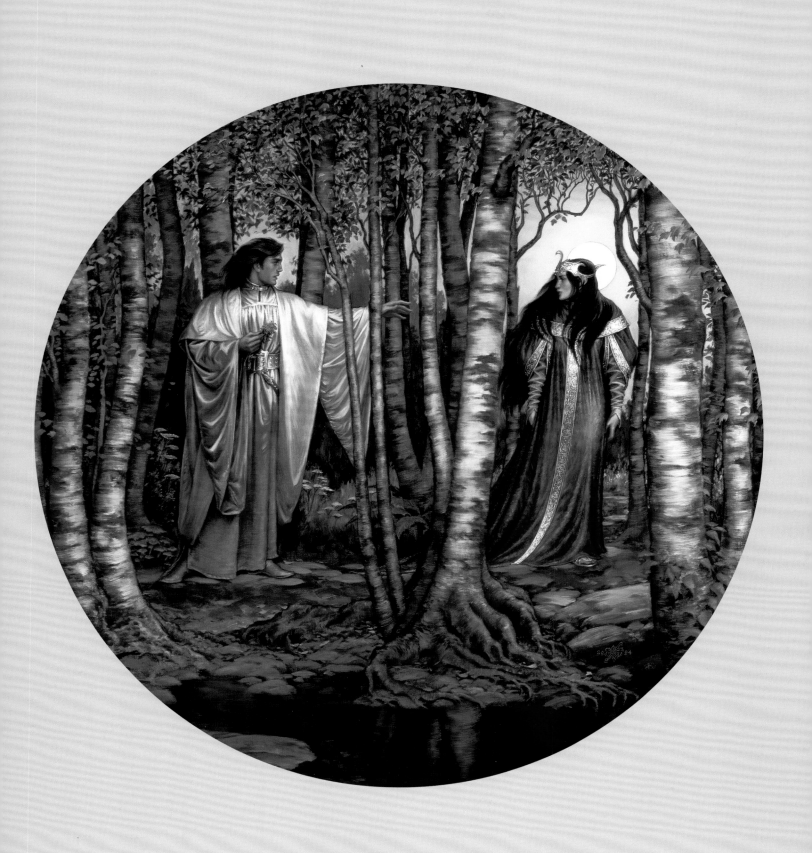

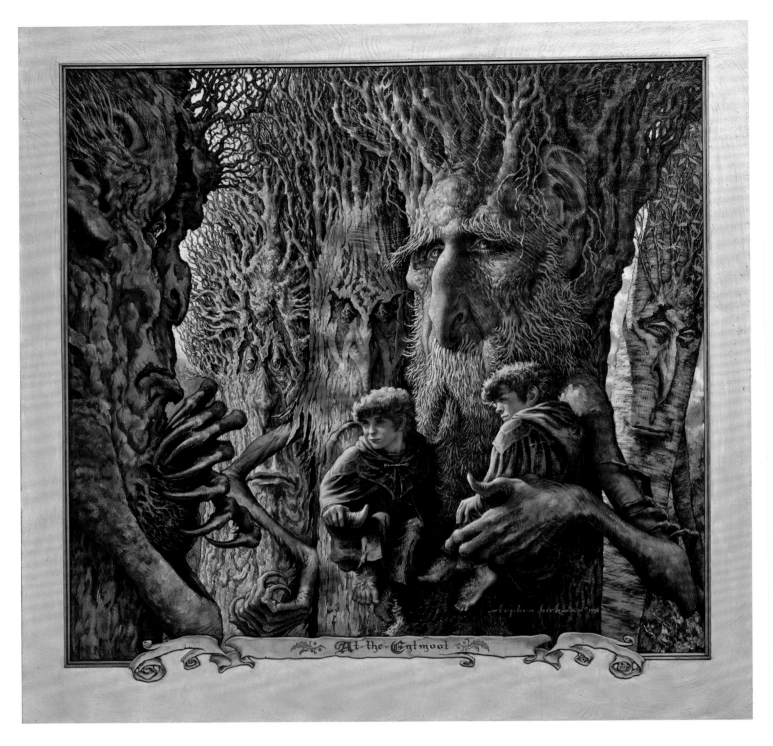

AT THE ENTMOOT *(above)* - This is one of my favorite Tolkien paintings for several reasons, not least in that it is a scene that has been done previously by any number of brilliant artists, and so it was a real temptation to try my hand at it. I'm glad I did, because it won Best in Show when I first showed it at the 25th World Fantasy Convention in Providence.

For whatever reason, the Entmoot wasn't a scene I had previously considered for a painting. When I was contacted by Mr. Alfred Roberts for a commission, though, this was the scene that he wanted to see, so I decided to try my hand at it.

The first step was to read the scene again carefully, to pick up anything I may have missed on the countless previous readings. Naturally, when you read a description of an Ent, you feel you know instinctively what they look like, but to take a pencil and start drawing...

The next thing to do was to work out the characterizations of the various Ents, who resemble certain types of trees. While I was doing this, I had my friend Susan Andrews working on the hobbit cloak, working

from a design that I had found in my Tolkien portfolio.

When I had done some Ents that I thought looked interesting, I put everything together and shuffled a bit. When things fell into place, I had our neighbors' two sons, Shawn and Casey (since grown considerably larger), take turns posing in the hobbit cloak for the figures.

When this preparation work was all squared away, I was ready to start painting twigs.

Technical notes: After stretching and sizing the canvas, I projected my drawing onto the surface. Then, using a heavy gesso, I pre-textured the canvas according to my projected drawing—I kept the brush strokes fairly restrained, as I intended to have the raised border and scroll to glue down on the canvas next. If you look at Treebeard in the finished painting, you can see how I let the vagaries of the brushwork determine the final form of his face. I let a lot of the raw umber underpainting show through the subsequent color for just this purpose. I used the Damar varnish medium for this picture.

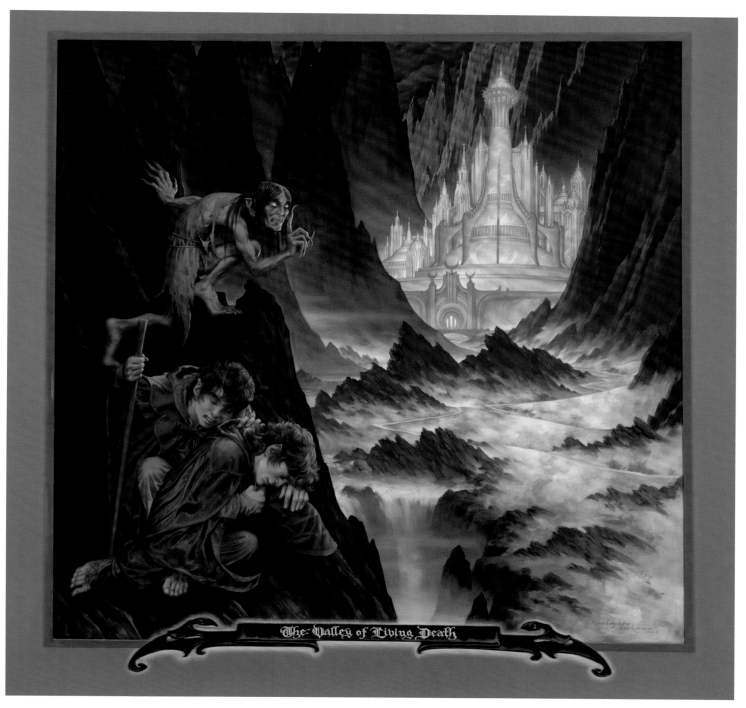

The Valley of Living Death

At the Entmoot

THE VALLEY OF LIVING DEATH (above) - In this life it is not often granted to us mortals to undo a regrettable mistake—in the words of the immortal Omar Khayyam (peace be unto his soul), "The moving finger writes, and having writ moves on..." But with this commission, I had a chance to have another try at a scene I had made a dog's breakfast of back when I did a series of paintings for Christopher Enterprises in the late 70s.

I used basically the exact same composition, but the rest of the painting is a dramatic example of how a lot of hard-won experience and reading the *Rings* Trilogy fifty times can mature an artistic vision of a scene.

After seeing the Peter Jackson film, I think the Academy missed a golden opportunity to create a new category for the Oscars: Best Virtual Character in a Feature Film, and to award it to Smeagol.

Technical notes: You can see my signature raised-border-and-scroll treatment in this painting. I used charcoal to refine the drawing on the canvas, then painted a monochrome in mars violet. The painting was finished with the Venice turpentine medium.

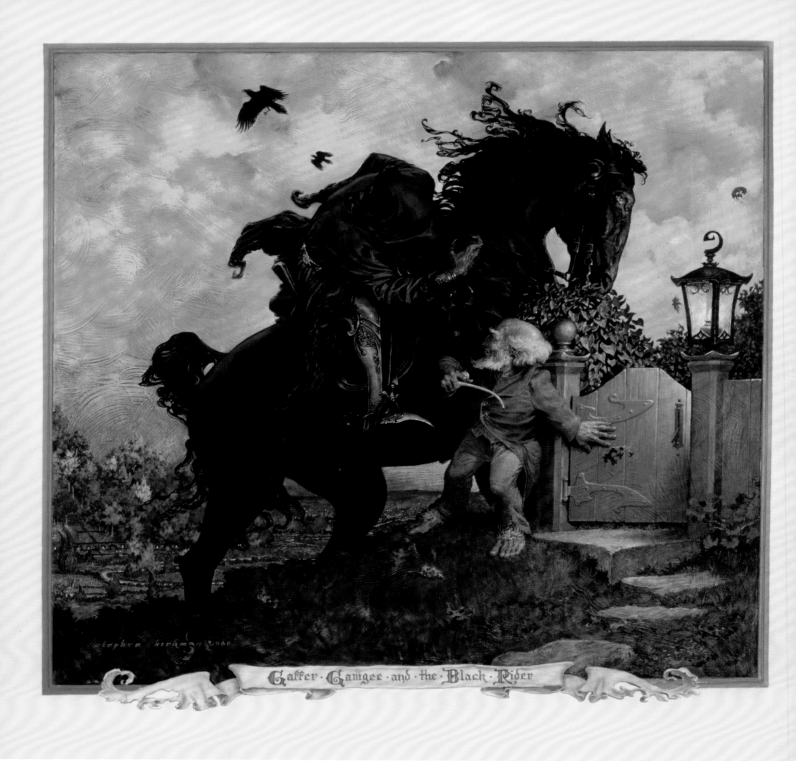

Gaffer Gamgee and the Black Rider

GAFFER GANGEE AND THE BLACK RIDER *(above)*

- An artist friend once remarked that I talk about my paintings as if they were done by someone else. This is true: for me, a painting has either missed the bus (a large majority), or is one of the happy few that are right there with their tickets at the right time. I've seen this painting since I sold it and it impressed me a lot more than I remembered. This *never* happens.

Furthermore, it was one of those paintings that just seemed to do itself, without any particular effort. I can count on the fingers of one hand how many times this has happened. Not that an artist is always the best judge of their own work, mind you. But you have to have your standards. And it is reassuring to feel that you are doing something right for a change. At one point I was down to a single 4 x 5 transparency of the painting, one which had a lot of glare on the pre-textured surface of the canvas. So I was

compelled to go into Photoshop and carefully 'paint' out all the unwanted highlights. This was the first time I ever used Photoshop to any extent, and while I was at it, I finished up the horse's face, and added some other touches as well. So this represents a version of *The Black Rider* that has not been generally seen before.

The fall of 1980 when I painted this was the most beautiful I'd ever seen in Virginia, and I worked hard to try and capture some of the magic of the color in the trees in the background.

Technical notes: This is an oil painting on an ivory-tinted pre-textured canvas. Because of the huge black horse, I decided to do a pen-and-ink drawing over the transferred outline, blocking in the solid black with waterproof ink. A monochrome underpainting was done in raw umber oil color.

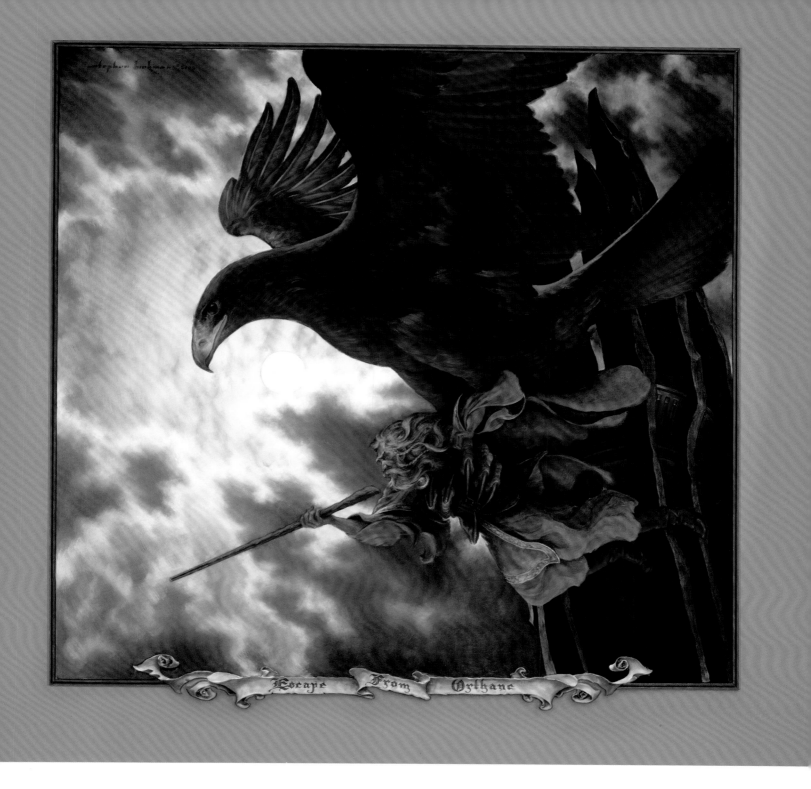

ESCAPE FROM ORTHANC *(above)* - Occasionally, on the order of about every 20 years or so, my mind will play an interesting trick on me. The story behind this painting is one of the better of these tricks, as to the way it turned out.

A friend of mine, the late Michael Scott, commissioned me to paint this scene, so I proceeded to go through my usual laborious process of sketching to work out the composition and poses of the wizard and giant eagle. This went through several arrangements of the elements, including at one point a treatment for a circular canvas.

I was happy with the finished painting. I felt it had captured a mood and the characterizations in a way that did credit to Professor Tolkien's wonderful story. Then several months later, I saw a painting by John Howe that is literally the same identical composition—it was uncanny. I messaged John about this, saying in all earnest I had not in fact copied his painting, at least not consciously. Here is John's reply: "I'd call it parallel evolution, with a tinge of convergent thrown in. Very Darwinian! How are you otherwise?"

What a gentleman. It is this kind of synergy that can make the art business a genuine pleasure.

Technical notes: This is an oil painting on stretched canvas, with a raised border and scroll cut out of basswood (very laboriously) and sanded to shape, then adhered to the canvas. I used a grey-tinted gesso ground, and blocked in the lights and darks with white and black acrylic before adding the color. I used my usual Venice turpentine medium to paint in the color.

SCIENCE FICTION

The march of technology has confounded the 'common sense' ridicule of the past 200 years in every single particular; from space ships, space suits and laser beams; from flying machines to landing on other planets. The braying yokels of yesteryear are now on the wrong side of the bars in the zoo of history. And I, for one, am proud to be on the outside, painting pictures of all the glorious dreams of Verne and Wells, literally by the light brought to me through the inventive genius of the Tesla.

Historically, the provenance of Imaginative Realism was confined for the most part to religious or mythological subjects. These scenes, inspired by a relatively modest visionary sense, could be painted from life, with human models in earthly costumes, posed on the artist's model stands in an earthly studio.

Science fiction has quickly demanded of the illustrator a much broader skill set, requiring as it does the ability to create a vast variety of machinery, costumes, air and space craft, alien creatures and landscape. Whereas before, the artist could paint from live subjects, much of the subject matter for speculative fiction was now too far away, or simply did not exist, or was too dangerous to be setting up an easel in front of.

Left: Planet Pirates

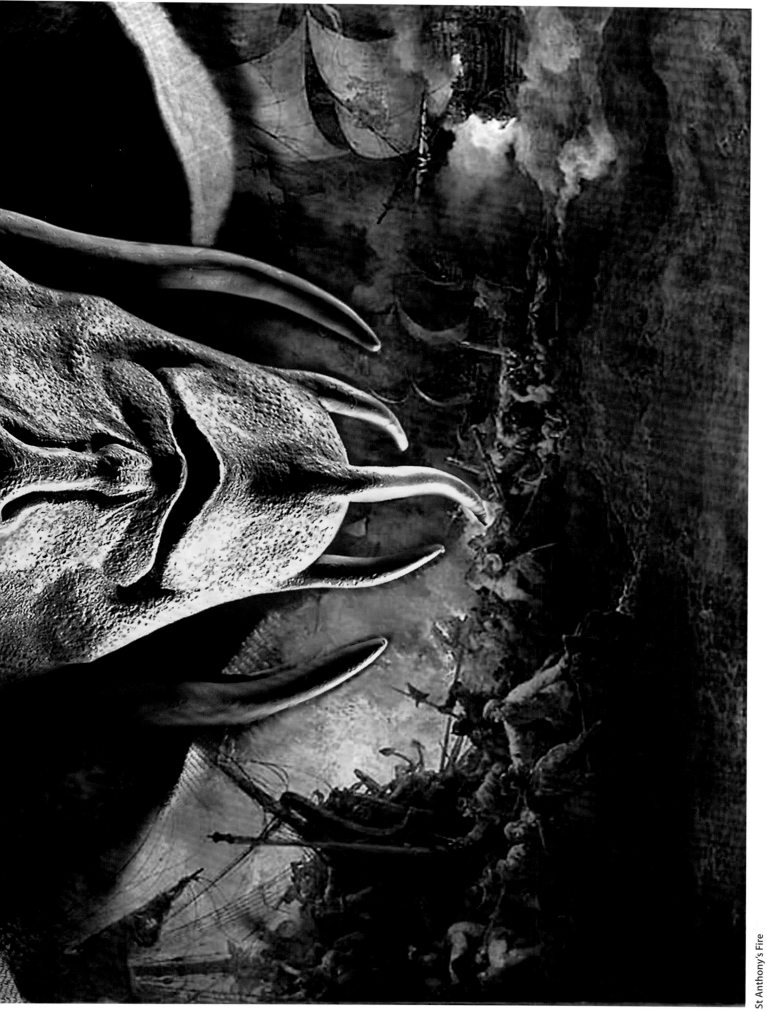

St Anthony's Fire

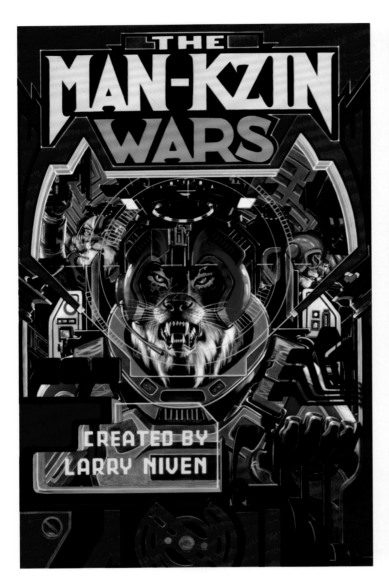

MAN-KZIN WARS VIII COVER *(far right)* Those readers who are familiar with the Larry Niven shared universe of the *Man-Kzin Wars* books know the consistent high quality of the writing in this series.

The was the first of the cover paintings I've done for the *M-K* books that I didn't paint in the title block. That entails a lot of extra work, and interferes with the re-sale value of the painting. This is also the last of the series of covers where I painted an invented scene of my own imagining rather than a scene from on the stories. It represents a Kzinti fast scout-ship pilot in a hyperspace vessel at the moment of transitioning into trans-light drive.

Technical Notes: This is an oil painting on a panel, 15 x 25 inches, done in acrylic as far as it could go, and finished in oil color, using oil-modified Liquin—the first time I had ever tried altering the quick-drying medium to extend its drying time.

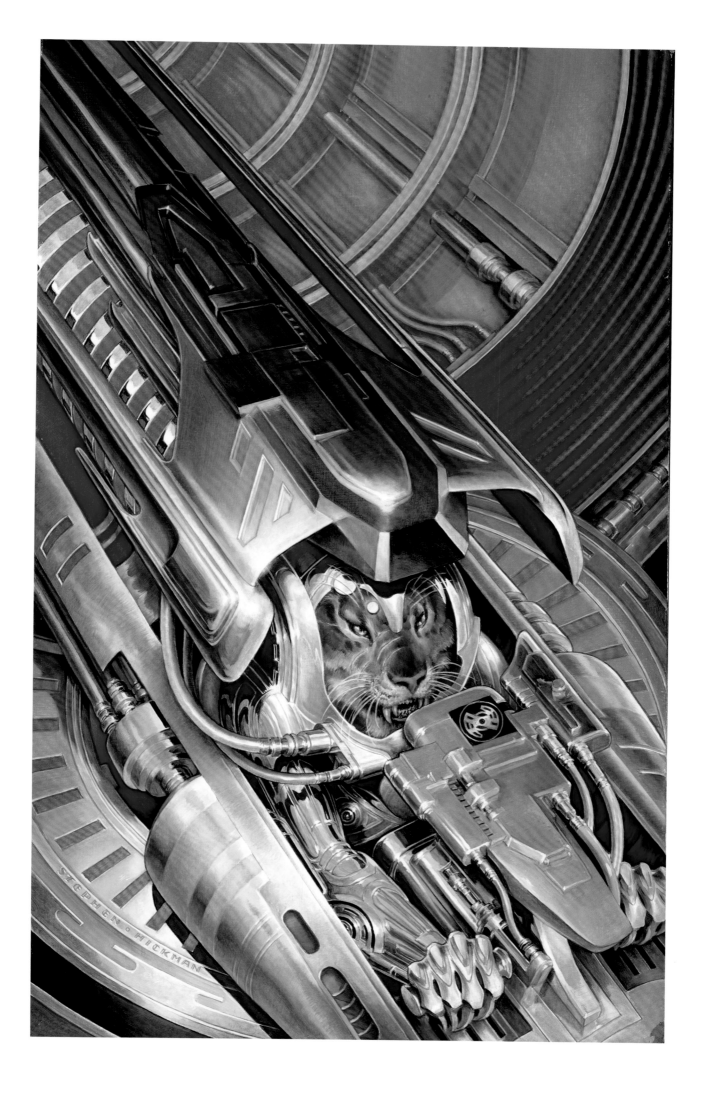

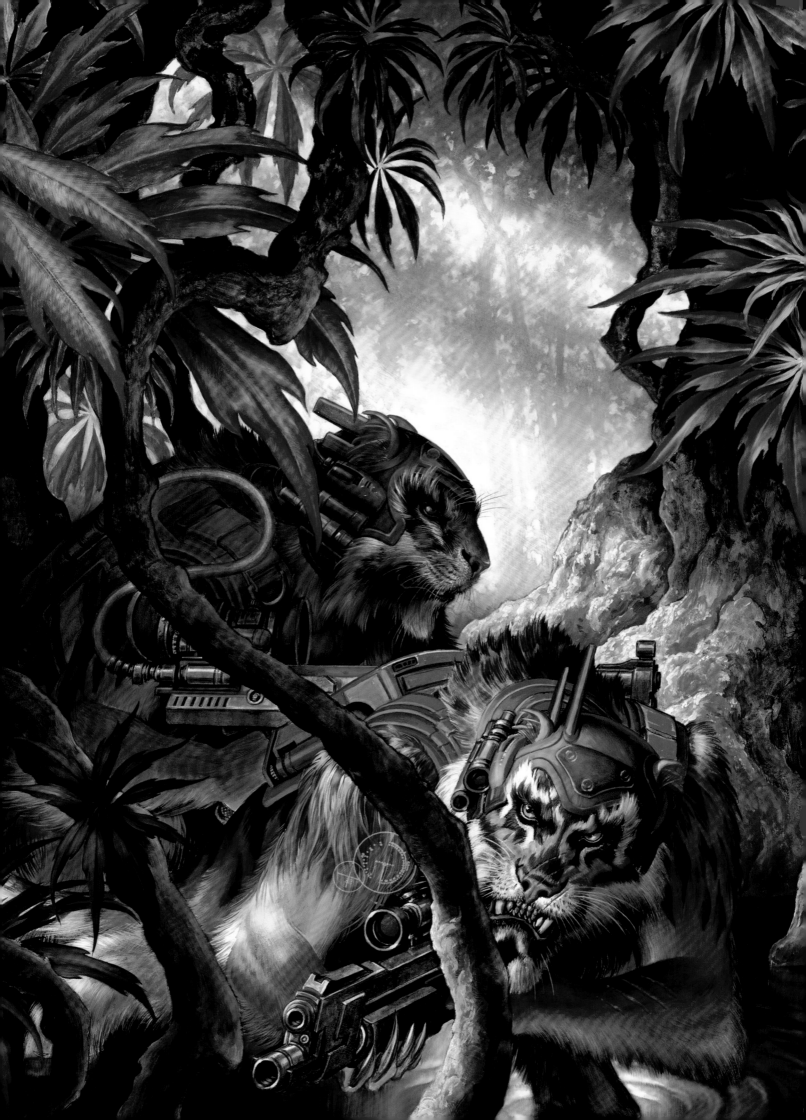

Left: Man Kzin XII **Above:** Pre-production sketches for proposed TV series

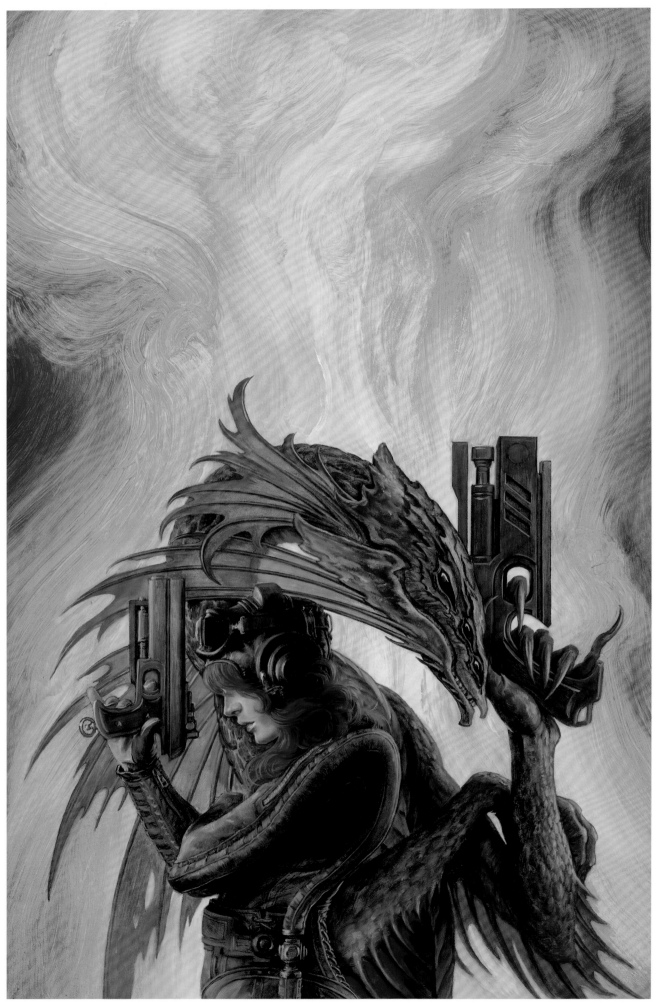

Above: Worst Contact

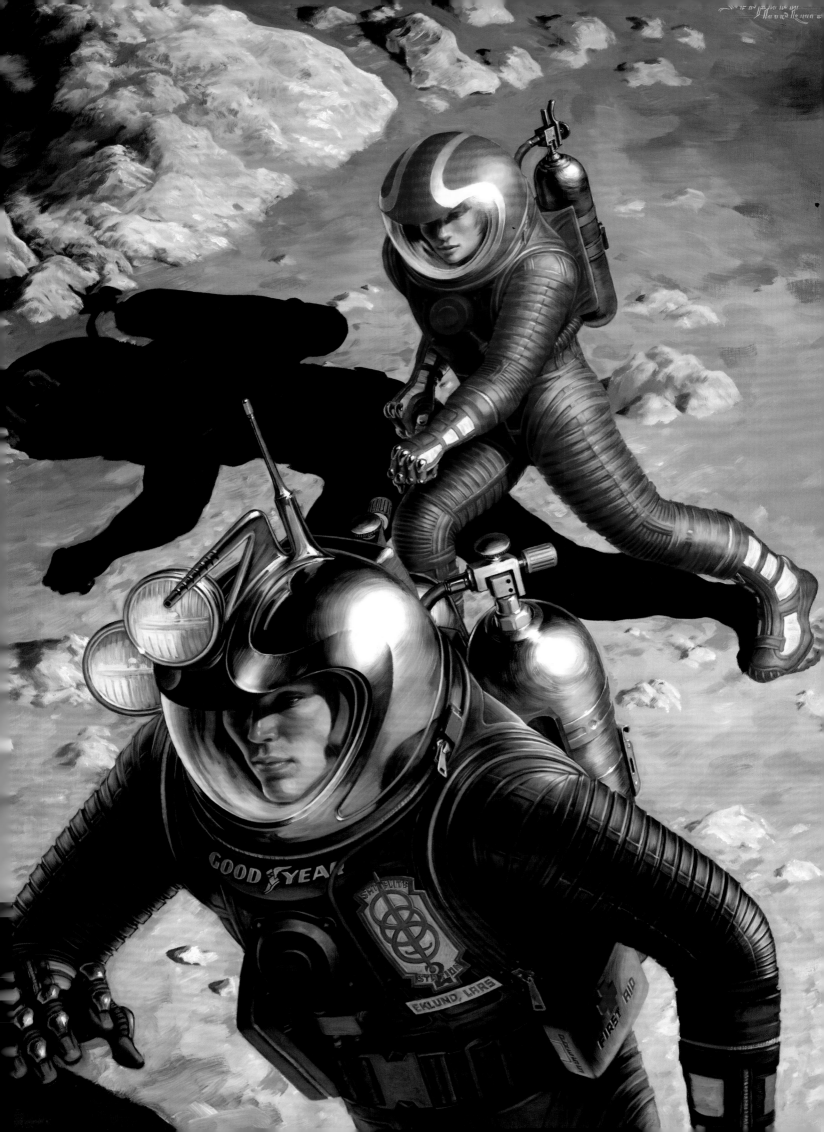

HAVE SPACE SUIT, WILL TRAVEL *(previos page - right)*
- This is the first book by Robert Heinlein I ever read, and its effect on me was tremendous. With its quirky, thoughtful, subversive, scientifically accurate and above all, intelligent characters, I can say that this was the first real book I had ever found. And by real, I mean content drawn from real-life experience and knowledge, and filtered through a brilliant mind endowed with a born gift for storytelling.

I chose a scene with the space suits to paint, appropriately enough. Heinlein was an engineer who helped in the design and development of the early pressure suits for the U. S. Navy, and he describes the problems involved in fascinating detail (to this day, terms like "semi-adiabatic expansion" will float into my mind, generally during late-night painting sessions).

With this as a starting point, I refined my drawing as far as possible, using two photos of the classic Navy pressure suit as a basis for my concept, and adding the patch emblem of his Space Resources Development Corporation as a final touch to the front of the main character's suit.

Technical notes: This is an oil painting, done on archival rag paper mounted to a birch plywood panel, over an underpainting of mars violet. I used oil-modified Liquin as my painting medium.

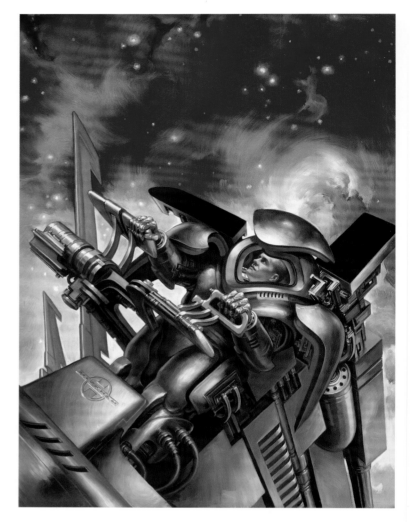

FIRST COMMAND *(far right)* - I think my fascination with space suits first came when my dad bought me two of those plastic spacemen from a dime store, the ones molded in that cool 'metallic' green and brown and purple plastic everything came in during the early '50s. My friend Ron Miller has since given me a whole set of these, and I'm tempted to paint them up like the originals.

Then came that early military-surplus partial-pressure suit from the Captain Company, and I had to have one of those. I saw the ad recently in an old copy of *Spacemen* magazine: they cost $7.50, including postage!

My favorite, though, is the one that my friend Larry Hama brought me back from Russia—this is a truly serious article, brand new, and a beautifully crafted bit of survival equipment that was standard Russian equipment until recently. I have some great friends; thank you, Larry!

This painting is one of those covers I really enjoyed as self-indulgence. It is surprising that many of my own favorites get a significantly stronger response than some of my more workman-like efforts. This cover scene was a set-up on the part of the author, Bertram Chandler: the two characters were literally wearing gold space suits, flying through space, in a scene from the book. It doesn't get much sweeter than that.

Technical notes: This is done in oil color on archival paper mounted to a birch plywood panel. I used Liquin to block in the colors directly over the white ground without the usual monochrome underpainting.

Above right: Exploring the Reaches
Right: Expanded Universe

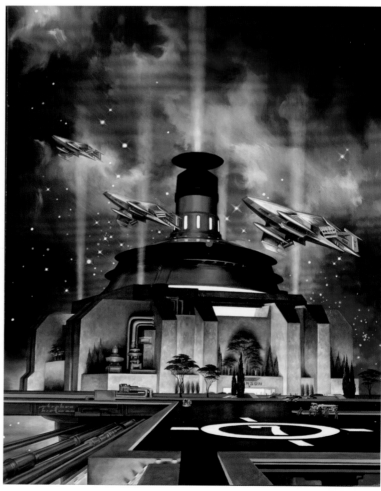

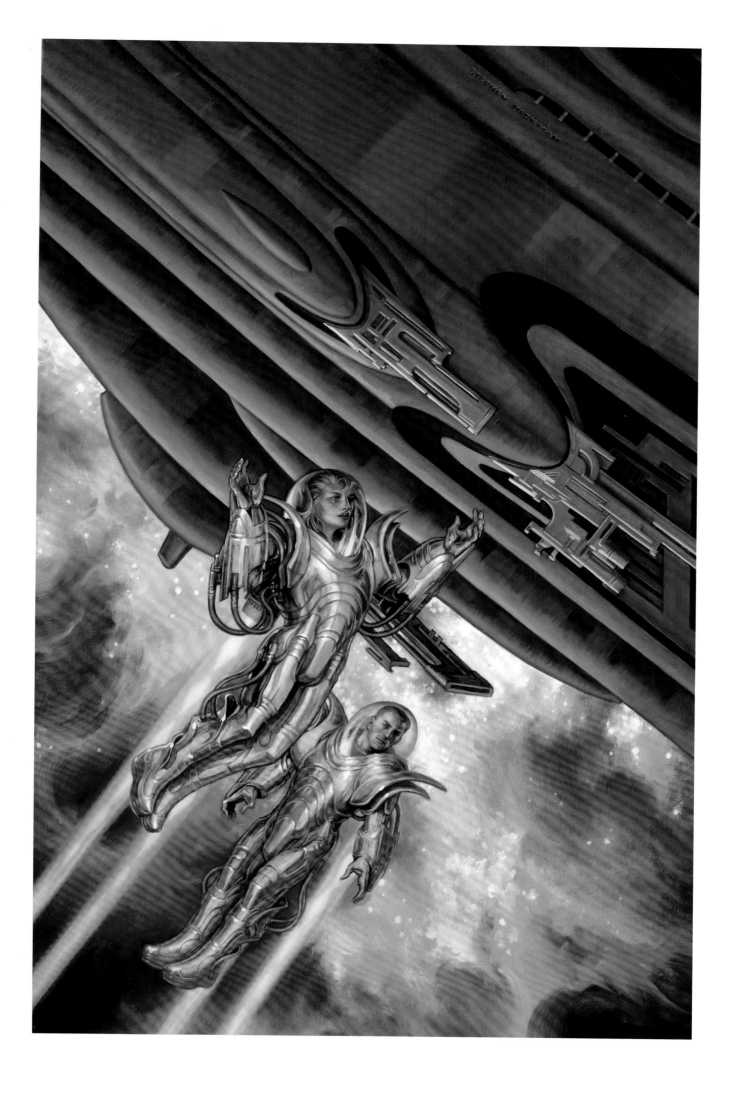

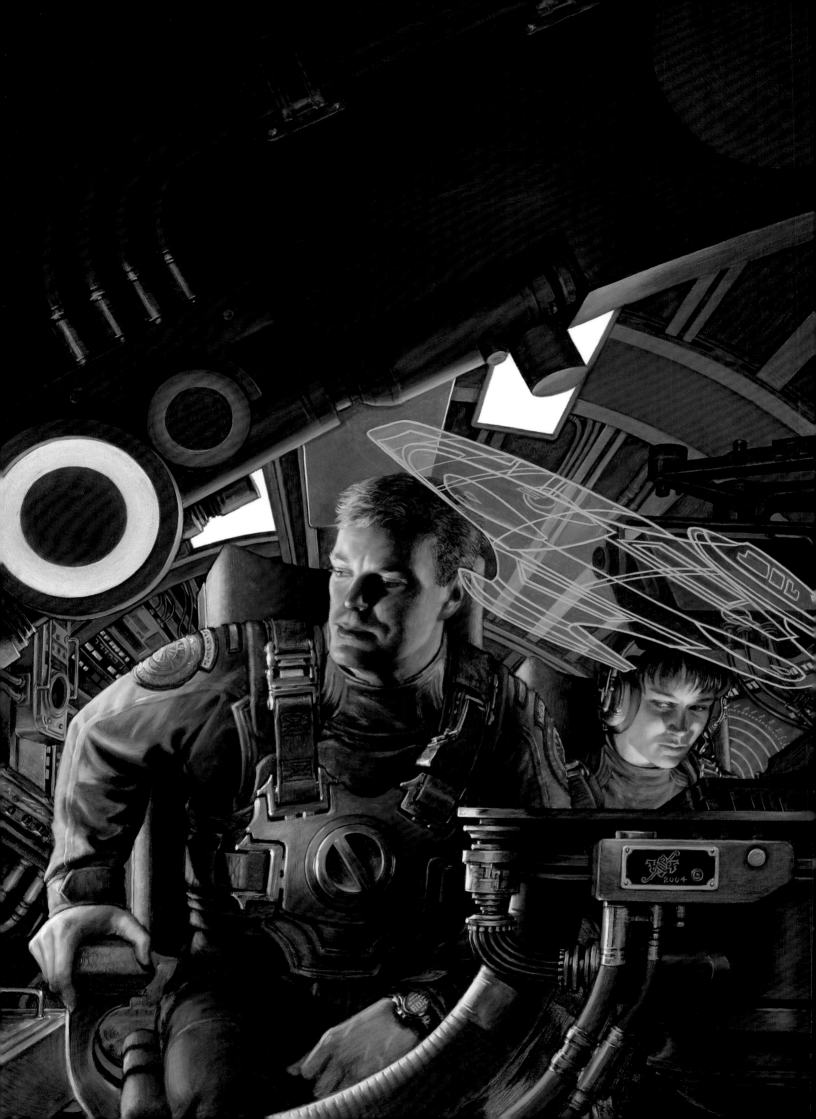

The Sea Without a Shore *Stephen Hickman*

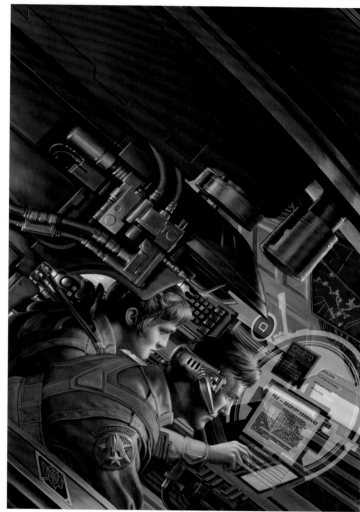

Above: As the Tide Rises

THE WAY TO GLORY *(far left)* - I think this is one of the best of the *Lieutenant Leary* covers I've done yet. It is certainly the best of the pre-Photoshop covers, where I can do things like the hologram projection more cleanly and quickly than painting them in laboriously three times to get the lines uniformly bright.

The great challenge in one of these interior settings is giving the equipment the right look and feel. I have to base it on modern naval fittings, and extrapolate the look from there, making sure to keep the overly-engineered look of shock damage-resistant equipment. And at the same time it's important to make it interesting.

I like the four-point restraint harness in this picture, too, with the stitching and the quick-release mechanism, and all the rest. And the characterizations, Leary and Adele, work for me.

Baen Books selected this painting to be a gift to David Drake, the author of this best-selling series. I consider this an honor.

Technical Notes: This is an oil painting on a panel, about 14 x 24 inches. I did a polychrome underpainting in acrylic to block in the colors, and then finished it in oil, using the oil-modified Liquin medium.

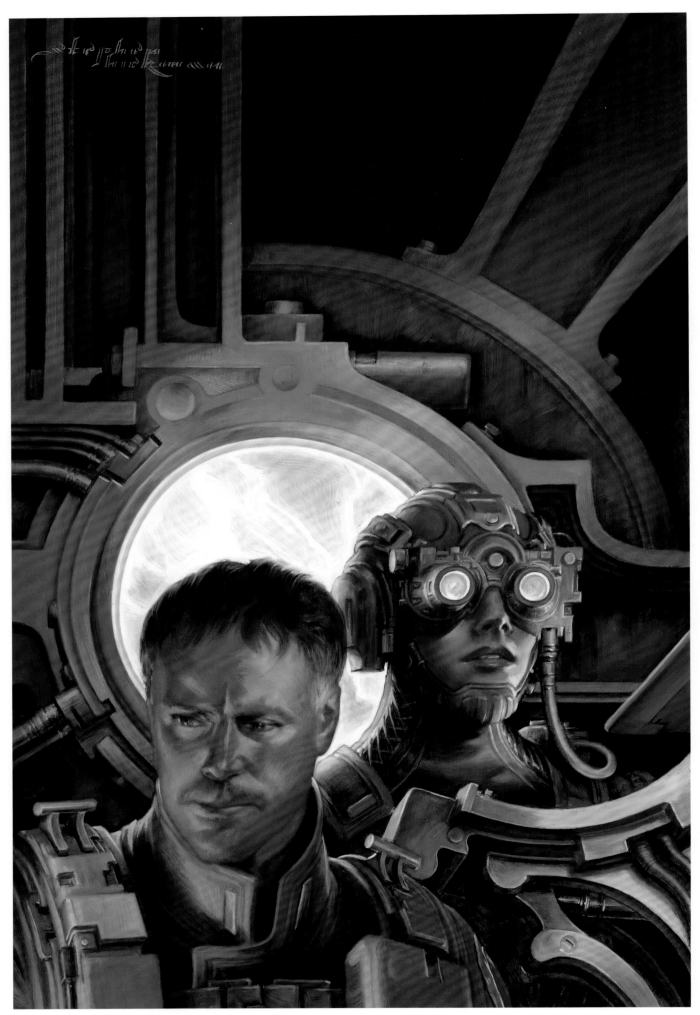

Above: Sea Without a Shore

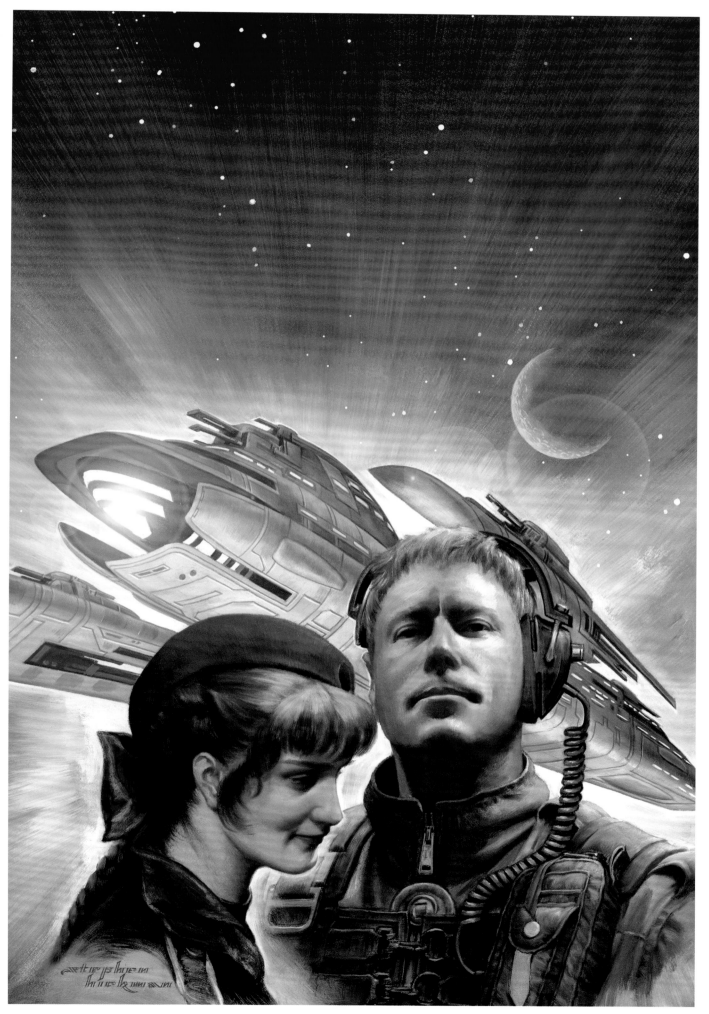

Above: Some Golden Harbor

DRAKEN *(far left)* - This is one of my favorite cover paintings. I tried several things in this picture, and they worked well for me. I got to do the painting-within-a-painting trick, which meant two distinct painting styles.

Then there is the lighting, which really makes the painting work for me: I threw a diagonal rectangle of direct sunlight across part of the painting and the figure, which meant that to do this convincingly I had to be very careful of the light levels in the rest of the picture.

Direct sunlight is so intense that I could have it reflecting from the white wall onto the polished wood floor of the gallery, a tricky effect to achieve. Then I could have the light reflecting up in an interestingly sinister fashion on the face of the Dangerous Lady, which I had purposely kept in shadow otherwise to convey the fact that she was not a very nice person—in the story, the paintings on the wall behind her came from first-hand experience of the subject matter.

That painting on the wall was another challenge: there was the part in direct sunlight, of course (my favorite part of the picture, with its suggestion of heavy impasto), and then it had to get gradually darker the farther up it was from the reflected floor light, into the pools of the comparatively dim gallery-lighting at the top.

Technical notes: This is an oil painting done over a white gesso panel, done without an underpainting. The medium was the customary Liquin/linseed oil, and the one unusual aspect was using lamp black to make sure that the dark areas of the Lady's battle suit that I wanted black were really black. I rarely use black with oil color, as it makes the colors look grimy.

This is one of those rare paintings that seemed to paint itself.

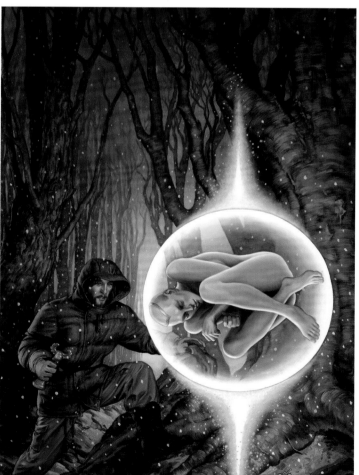

THE DEFIANT AGENTS *(following page left)* - This is for an Andre Norton book I read in high school, and again I found a scene right from the story. This always makes me happy, particularly on a job with such nostalgic significance.

The scene shows a Mongol princess climbing into a wrecked spaceship, and there are just not a lot of Mongol princesses around our little town. But I did find some references that served for the costume, and did the best I could with imagination. Close observers of the printed cover will notice that I have worked on the face since publication; the carefree and inattentive reader will not have noticed this.

There is motion in this painting: a feeling of cold wind whipping by outside, and the implied explosion in the twisted shapes of jagged metal and twisted piping.

It was a strangely satisfying thing to have these assignments for Andre Norton's books, and even more fulfilling to learn through Baen Books that the author considered these the best covers she has had on her stories.

Technical notes: Oil on panel over a polychrome acrylic underpainting, with Liquin as a medium.

Top left: Grand Central Arena,
Bottom left: Life House

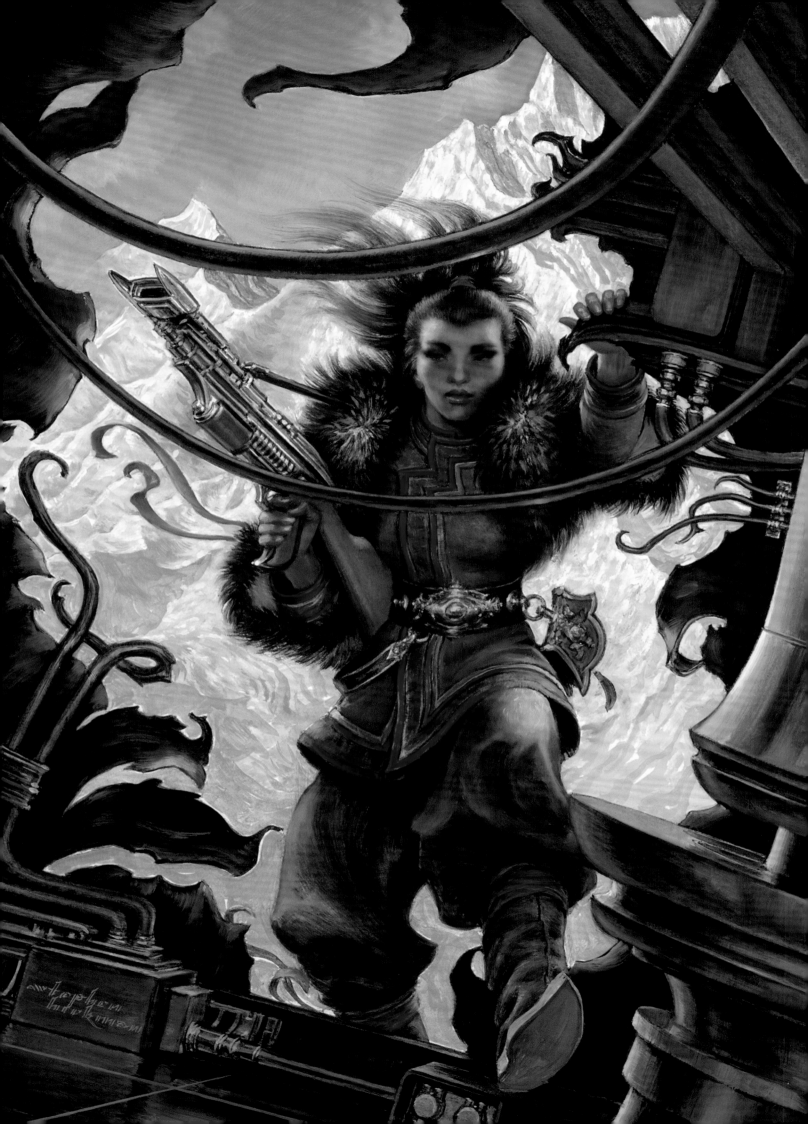

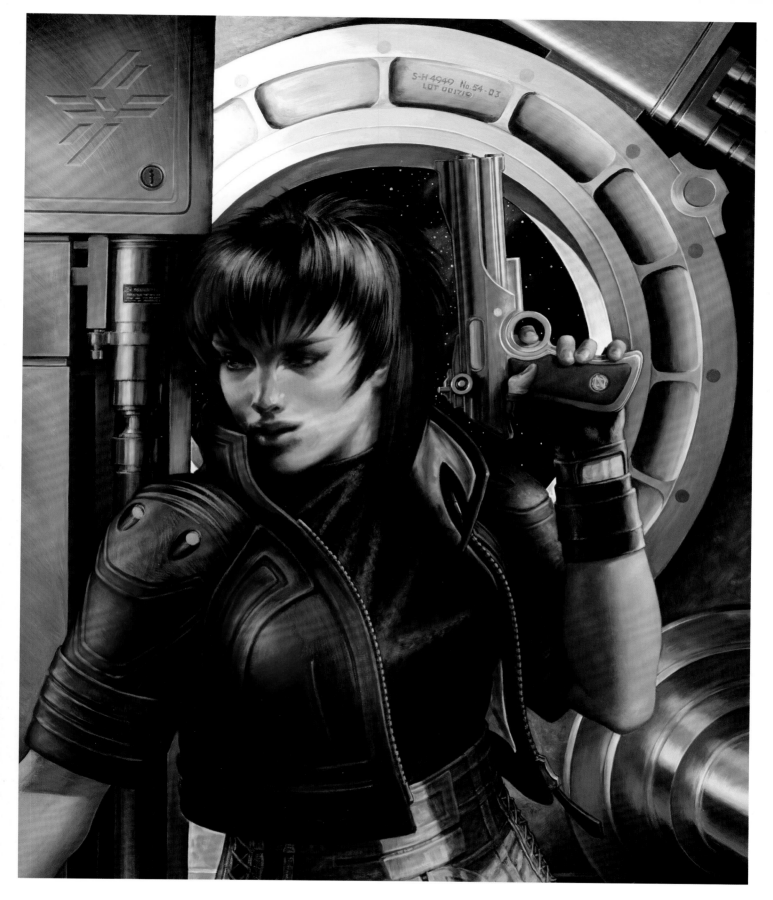

FRIDAY *(above)* - This is my favorite of Heinlein's later books. He had stopped writing for years due to blockage in his carotid arteries, until an operation to relieve this condition was developed, appropriately enough, from aerospace medicine: a direct result of experience gained in the space program, which Heinlein himself was instrumental in helping to create.

I found a scene in the first chapter to do this illustration from, a rare thing for this author, whose books for whatever reason require more ingenuity than most to find scenes to illustrate. This painting shows Friday, a cybernetically-enhanced human special agent on a mission in an Earth-orbit space station. I looked at photos from Soviet-era space hardware for my look here, as everything from that program had an appealing retro-look to it, even when it was new.

I think my favorite part of this painting is the characterization of Friday, always a tricky thing, characterization.

Technical notes: This is an oil painting, done on archival rag paper mounted to a birch plywood panel, over black-and-white acrylic tonal treatment. I used oil-modified Liquin as my painting medium.

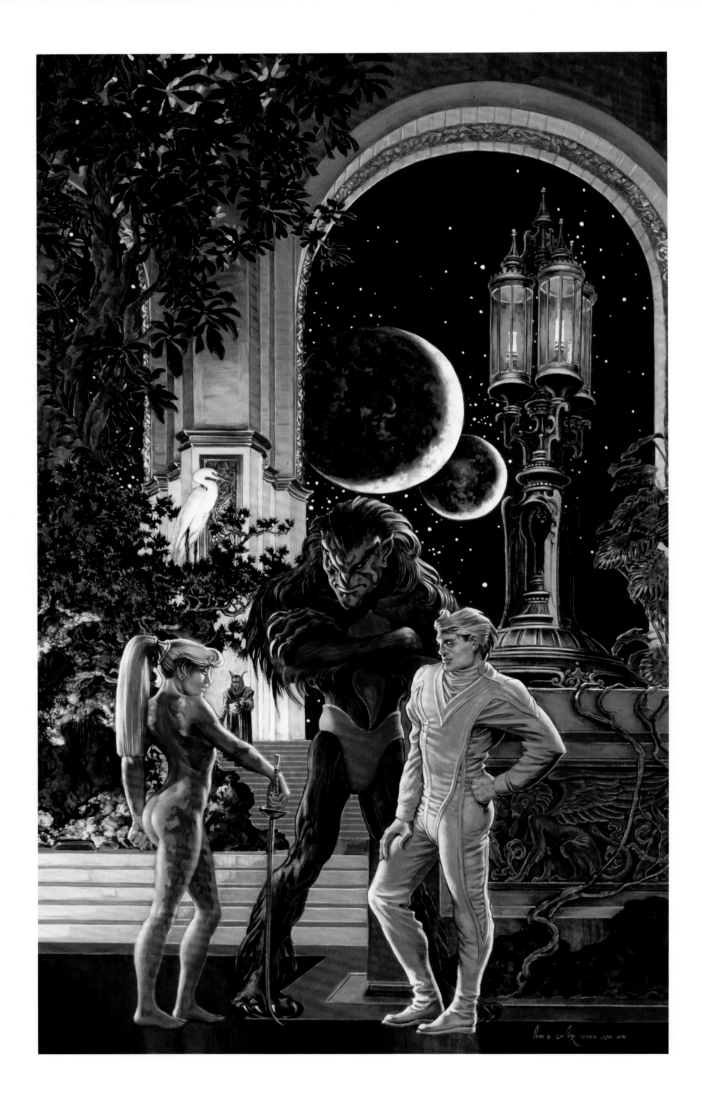

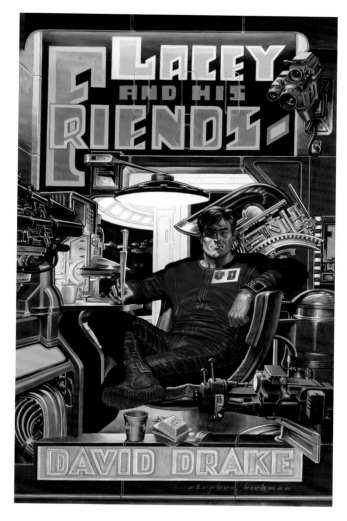

Above: Electropunk

Top left: Lacy and his Friends

Bottom left: Here Abide Monsters

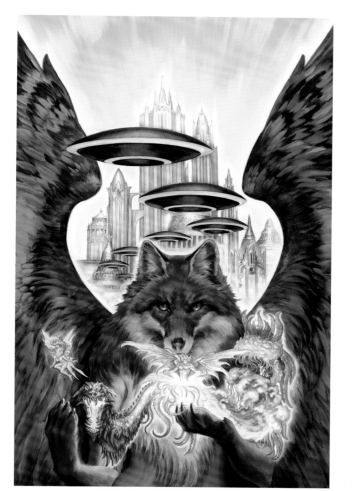

GRYPHON *(far left)* - This is one cover that surprised me. I did it in a tearing hurry, and it's still is a treat for me to look at. It's a very small picture, too and I'd like to do a larger version of this painting eventually.

It was created for a brilliant book by Crawford Killian, and the finished version was done in three days because of a deadline, which is a record for me. After a few hours sleep I caught a plane at National Airport and flew the picture to the New York publisher, it was actually cheaper than same-day delivery using airlines and couriers.

Winning a Chesley Award for best cover illustration with this painting was a genuine surprise for me, but it's still an interesting picture to look at.

Technical notes: I had never used this method before: over the layout on the panel I painted the whole picture in black-and-white acrylic, shading the tones in greys. Then I glazed the colors in using transparent oil color, and finished the picture in oil.

THE ONCE AND THE FUTURE *(following page left)* - This piece is a study in contrasts. I've always loved the Arthurian legends, so I was going to put King Arthur on at the least provocation, but this was a science fiction story, so the background was a foregone conclusion.

I've given Arthur a slightly different profile since this cover was first published by Baen Books. The title I've given it is, of course, taken from *The Once and Future King*.

Technical notes: Oil on masonite

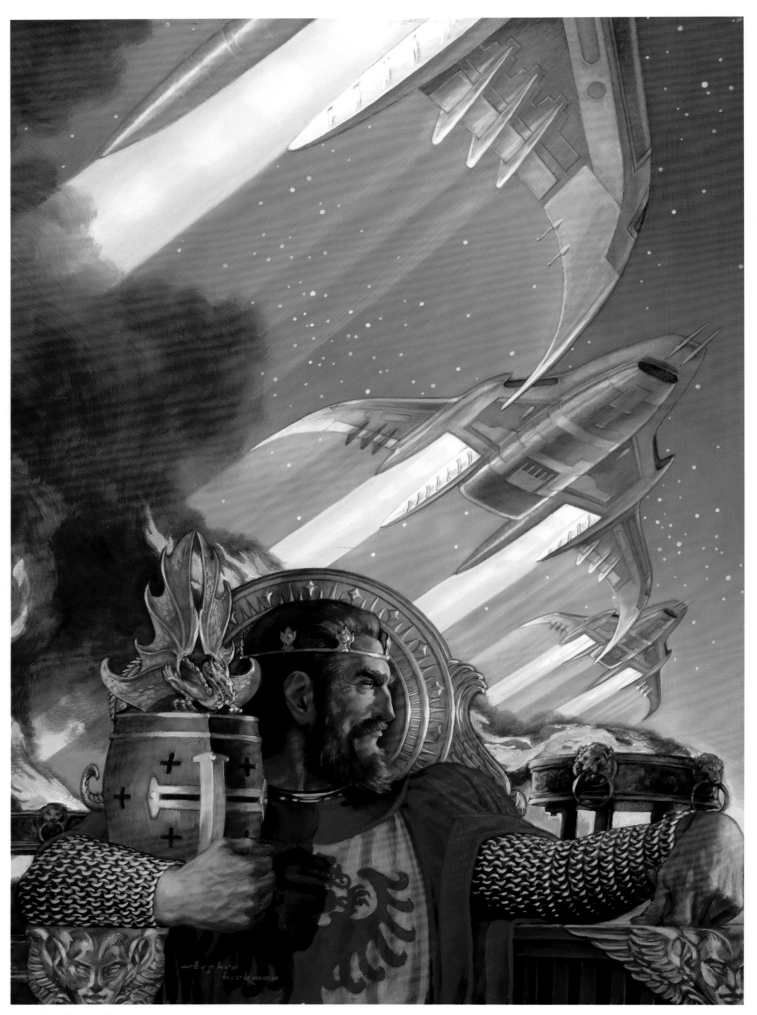

Above: The Once and Future

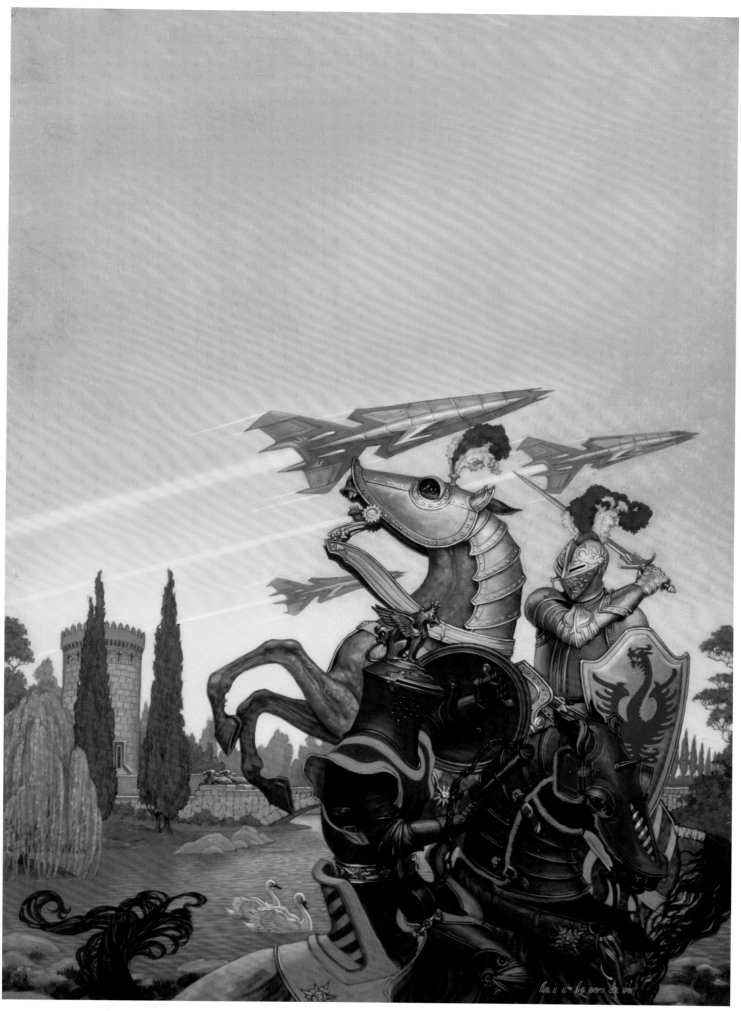

Above: Escape Velocity

STARSHIP TROOPERS - Published in 1959, this book represented a significant departure from Robert Heinlein's tremendously popular series of young adult SF books. Due to the social and moral issues the book deals with, as well as the militaristic nature of the story, Heinlein had to find a new publisher for this story.

The essence of this book is still completely relevant today. Heinlein's concept of the Mobile Infantry was based on the principles of mobility and firepower, which form the foundations of modern land warfare, as well as air combat. Studied by the most brilliant tacticians of WWII, George S. Patton and Erwin Rommel, they in turn had its principles from history's first modern army: the Golden Horde of Ghengis Khan. And if this sounds surprising, I invite any who might be skeptical to read *The Devil's Horsemen: The Mongol Invasion of Europe,* by James Chambers.

It took me some serious thought, a lot of sketches, some editorial input from Mr. Art Dula of the Robert A. Heinlein Trust Foundation, and at least two color studies to come up with this final version of the scene.

Technical notes: This is an oil painting, done on archival rag paper mounted to a birch plywood panel, over an underpainting of mars violet. I used oil-modified Liquin as my painting medium.

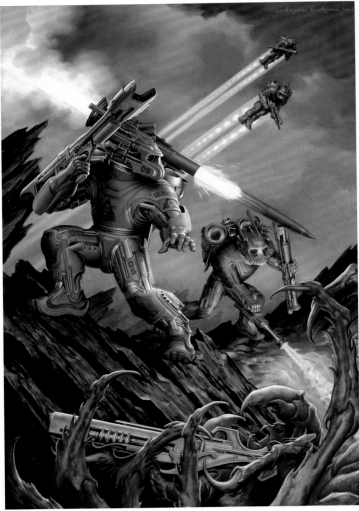

Right: Between Planets

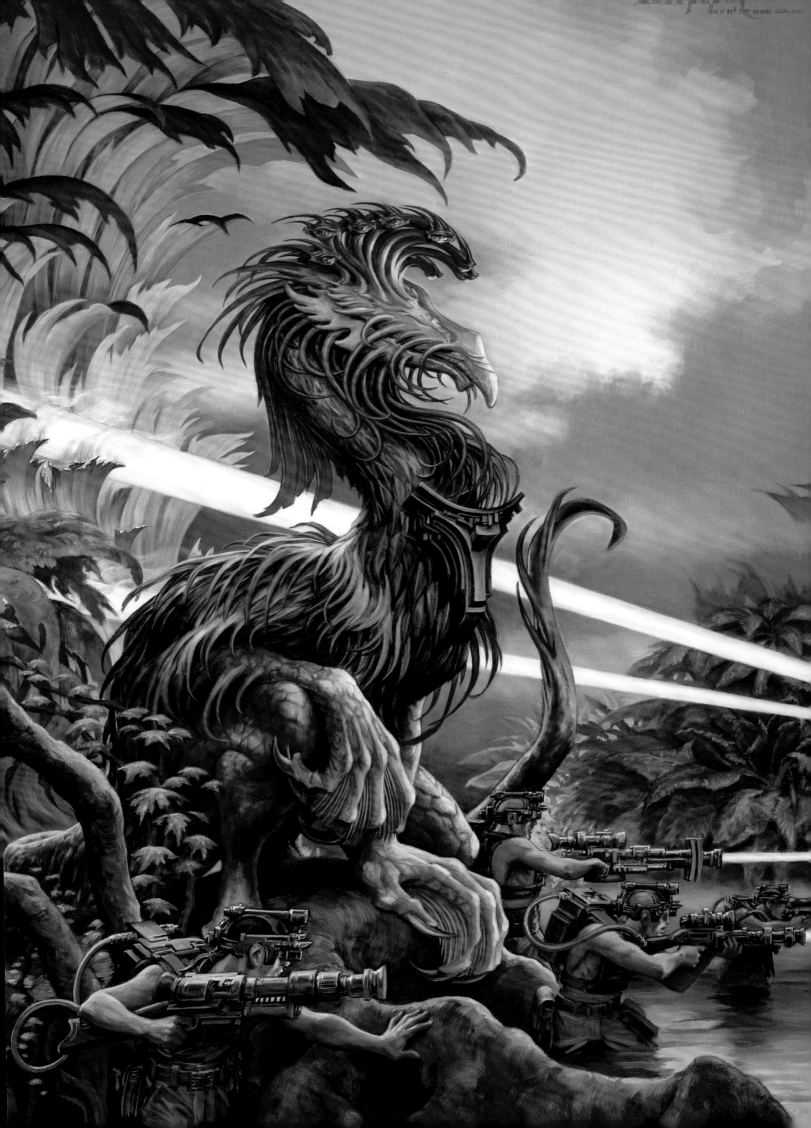

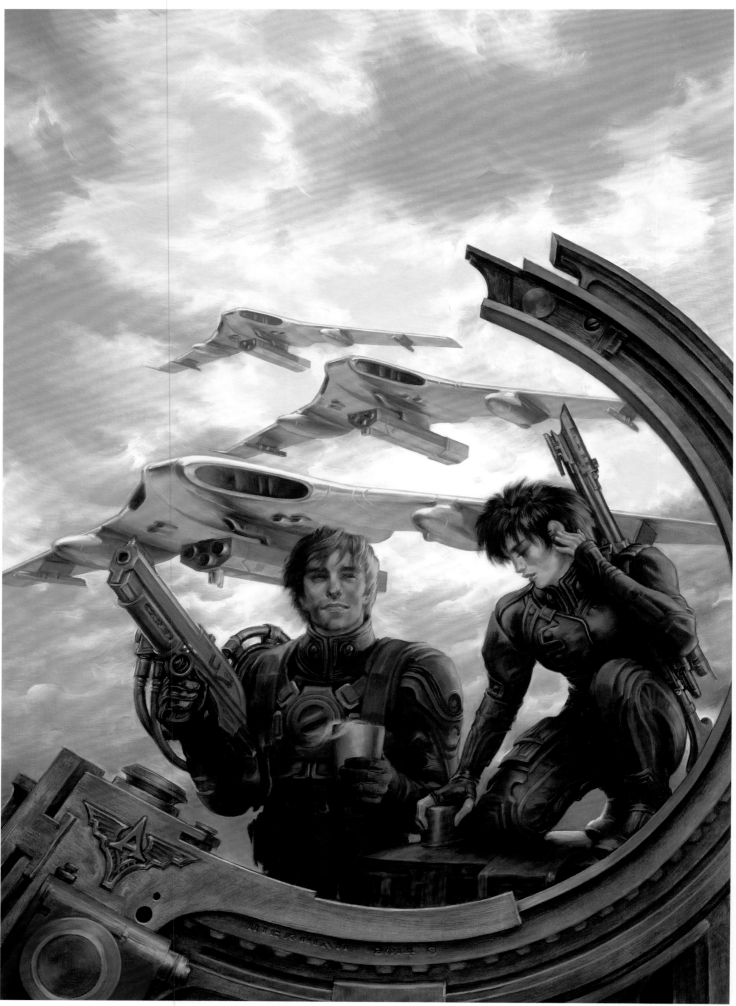

Above: Liaden Univ

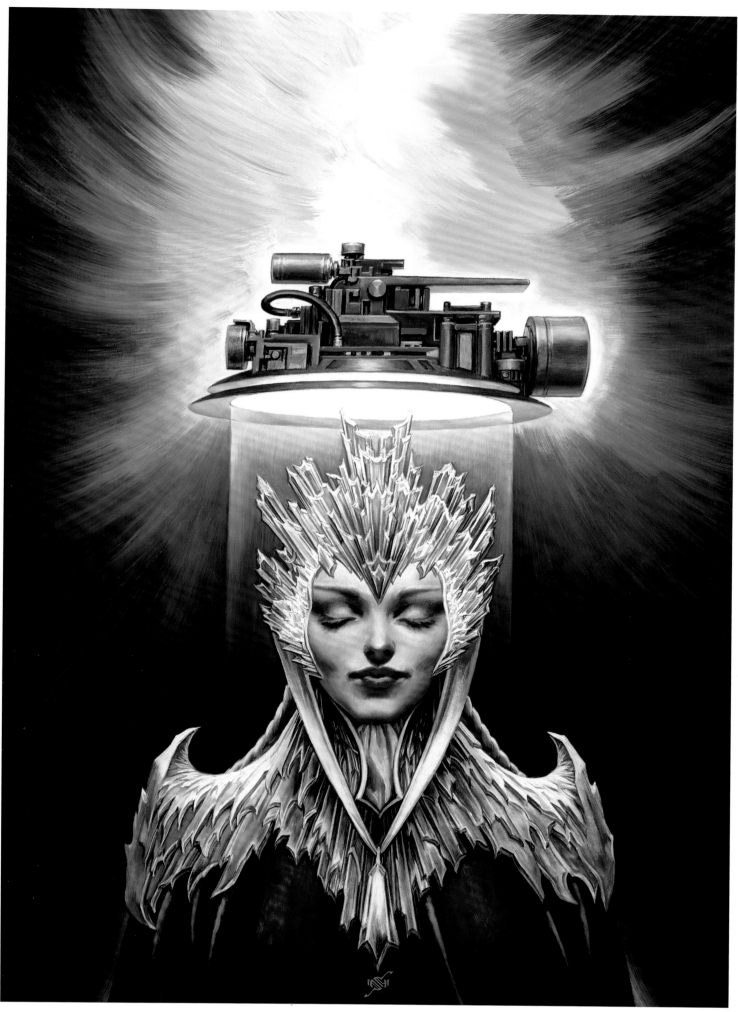

Above: The Ice Queen

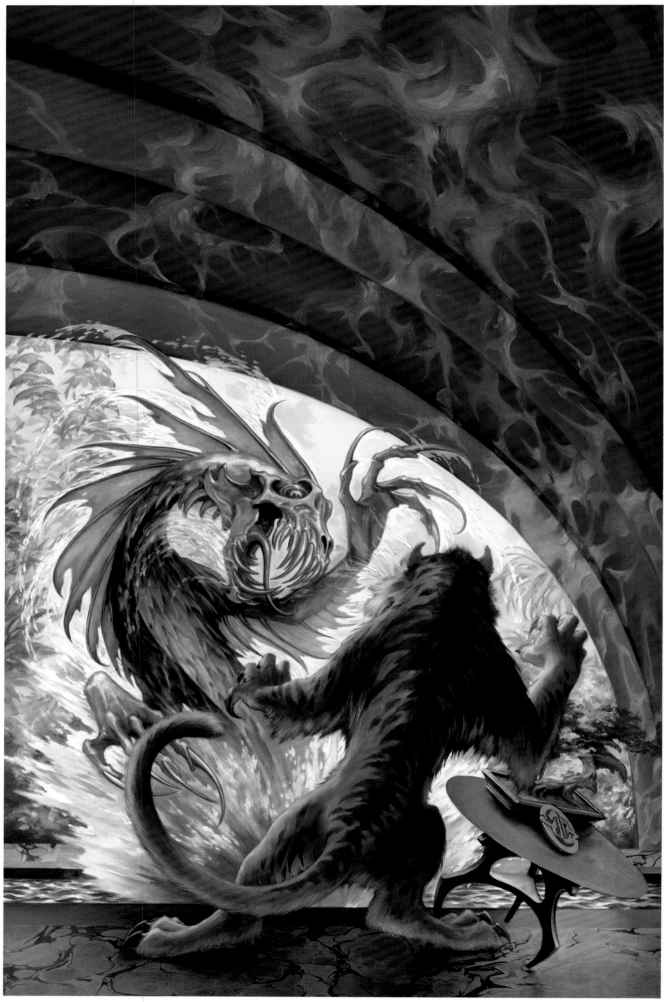

Abovet: Destiny's Forge

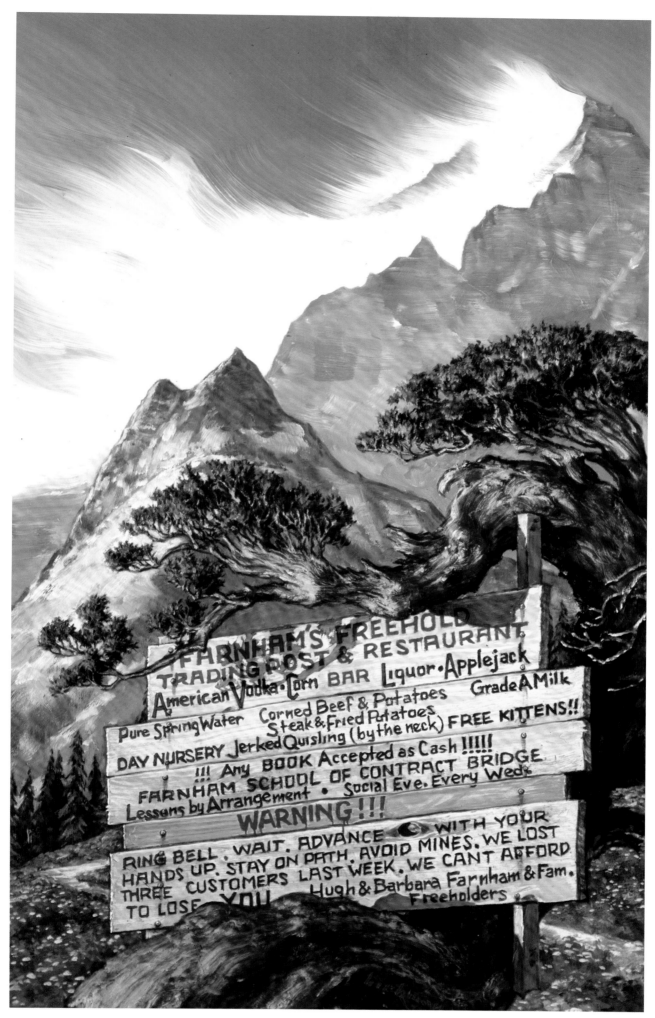

Above: Farnham's Freehold

CLASSICS

S ome of the most persistent and appealing themes or images have come to me from older sources, from early legend, like the Mabinogion, or the Arthurian legends, or St. George and his Teutonic counterpart Siegfried. All the heroes and monsters are probably archetypal, the sort of recurring images or themes that C.G. Jung has identified as appearing in every culture, in all ages, along with gods and goddesses, devils and demons, and other such pests.

Since all mythology is constantly evolving, and consequently in a state of development (Siegfried originally was an overgrown lout who beat a blacksmith to death, and had to leave home—a far cry from the Wagnerian version), more modern writing has provided a considerable upgrade to contemporary mythology. This has resulted in a much wider scope for persistent images to manifest from, to buzz around in my psyche, demanding to at least be drawn, if not painted. At the earliest would be the Egyptian and Greek myths, working up through Celtic and Germanic and Norse, to arrive at the 'moderns': H. Ryder Haggard, A. Merritt, Edgar Rice Burroughs, H.G. Wells, Jules Verne, Clark Ashton Smith. H.P. Lovecraft, Harlan Ellison, Neal Stephenson, Tim Powers and William Gibson. All have provided a vast backlog of imagery for my psychic traffic-control pattern to handle.

Left: Ghost Quartet

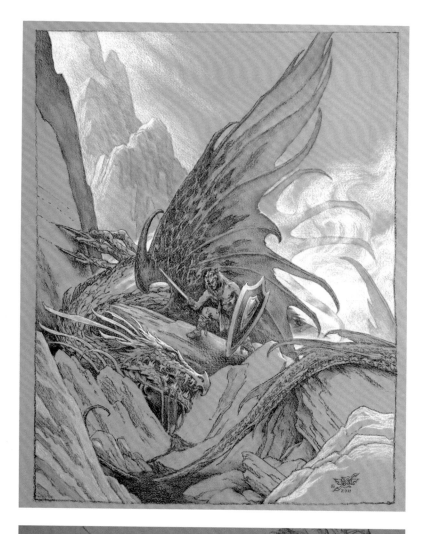

SIEGFRIED AND THE DRAGON'S BLOOD

(far left) - As myth-cycles tend to develop over time to meet the needs of each succeeding age, all mythology can be viewed as works-in-progress. This is certainly true of the Siegfried legend—in its earlier forms from the Middle Ages, he is just an obnoxious muscle-bound teenage lout, the disgrace of the Wulfungs.

My own favorite version of his story would be the more Wagnerian form, where the influence of classical mythology, preserved by the Irish Christian monasteries, had made itself felt in the form of higher powers and their dysfunctional workings in the affairs of mortals—in this case, Wotan and all the Norse pantheon, are working their particular agendas through human agencies. At this stage, Siegfried has been fitted into the Achilles archetype of classical Greek legend: after slaying the dragon with a sword and shield of his own forging, Siegfried becomes invulnerable by bathing in the dragon's blood, except for a spot on his shoulder where a linden leaf has fallen. This spot, untouched by the enchanted blood of the dragon, is the means of his later death by treachery.

I was inspired to paint this scene after watching Fritz Lang's 1927 film *Siegfried*, a magnificent thing to see, with the notable exception of the dragon—with all the scores of brilliant paintings and illustrations of dragons he must have seen, what *could* he have been thinking?

Technical notes: This painting was done on a large 24 x 36 pre-stretched oil-primed linen canvas. The drawing was projected onto the canvas, and lined in directly with oil color, using mars violet. The monochrome underpainting was finished in the same color, using the tonal charcoal drawing I had started with as a guide. The color was then added over this, using W&N Artist's Painting Medium.

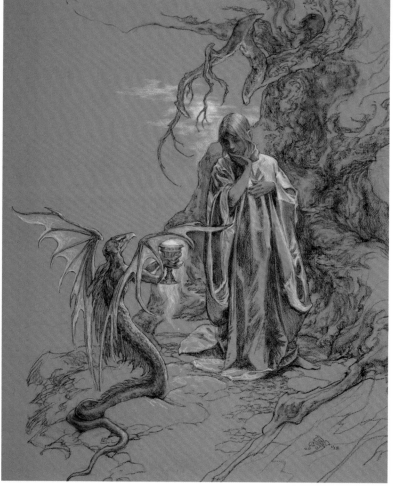

Left: The Libation

NADA THE LILLY (right) - This is another scene from the pen of the immortal H. Ryder Haggard, and the single most challenging commission I have ever received. To begin with, this book is one of the greatest epic fantasies in the English Language, so there was a lot to live up to. Also, it was to form part of a collection in the company of some of the best artists in the business. This wasn't easy, as the only Zulus I had ever seen were the members of Ladysmith Black Mambazo—very charming gentlemen, but not, as you might say, in the heroic mold.

I did all the research I needed, including location, costume, and weapons, and did the best I could. The most salient aspect I formed of the African landscape is the intensity of its character. I painted most of the picture with a palette knife, the surest way on Earth of ensuring character. The garments and gear were authentic down to the bindings on the spear points.

My thanks to Howard and Jane Frank for selecting me for the commission, and for their tact, patience, and useful suggestions during the whole processes.

Technical notes: Oil on canvas over a mars violet underpainting, with Venice turpentine varnish medium over this.

THUVIA, MAID OF MARS (far right) - Wearying as the word *homage* is getting to be, you could charitably regard this scene from the book by Edgar Rice Burroughs as perhaps a tribute to the wonderful fantasy paintings of Roy G. Krenkel Jr.—the very same artist who introduced Frank Frazetta to the world of book cover illustration, thereby doing the world a great service.

As fantasy writing goes these days, the Barsoomian books are getting to be a bit creaky (remember, the first one was written in 1912; Thuvia was 1920). Nevertheless, they provide a solid basis for a wealth of romantic imagery, as well as a golden invitation to learn anatomy, due to the universal nudity of all creatures on Barsoom. Naturally, I was all for this as a young reader, and I was happy to accept this scene for a commission painting when my friend and client Mr. Richard Lee suggested it.

I felt the composition would lend itself to a round format, echoing as it does the signature round double moons of Barsoom. And though a trifle awkward to do justice to in an art book layout, round paintings do look striking hanging on the wall in a collection.

Technical notes: This was painted on pre-primed fine-weave cotton canvas stretched over a 3/4-inch birch plywood disc, 24 inches in diameter (a standard size for circular frames, an important consideration). Interestingly enough, I discovered that it was much easier to stretch a canvas evenly on a round stretcher, than on a square or rectangular one. I used mars violet for my underpainting, done over a refined charcoal drawing on the canvas. It was painted with the Venice turpentine medium, using my color sketch as a guide.

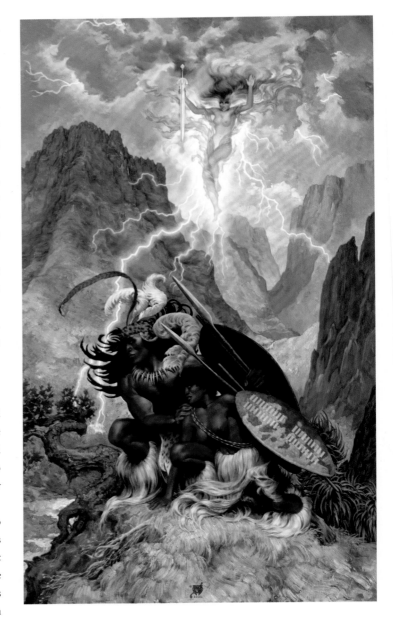

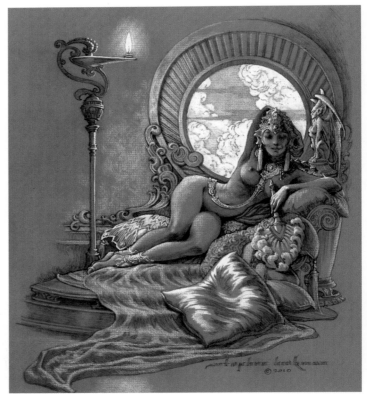

Right: Silver Cloud

128

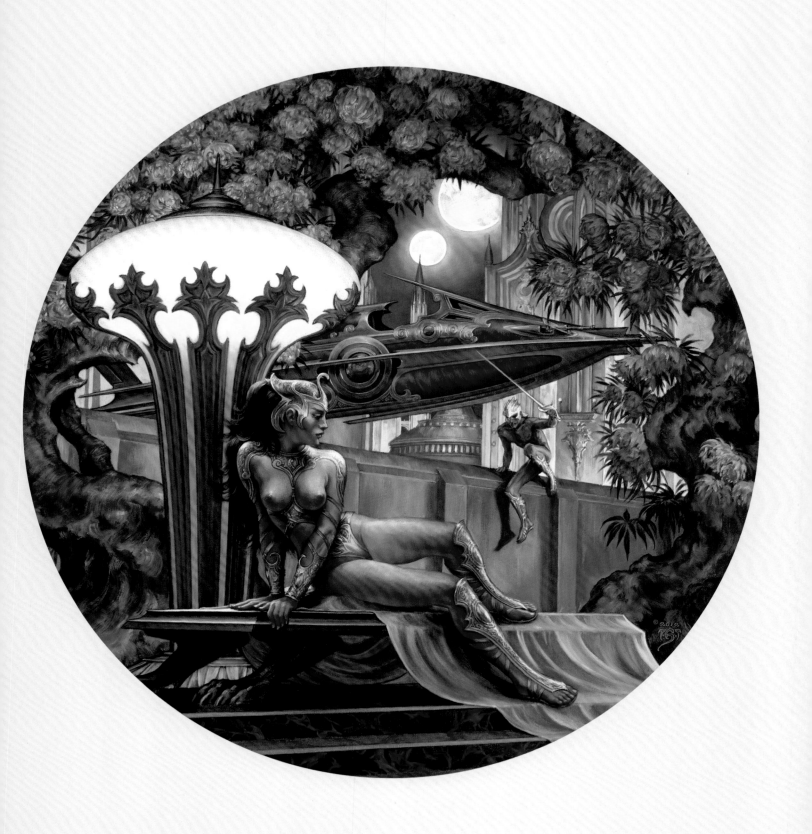

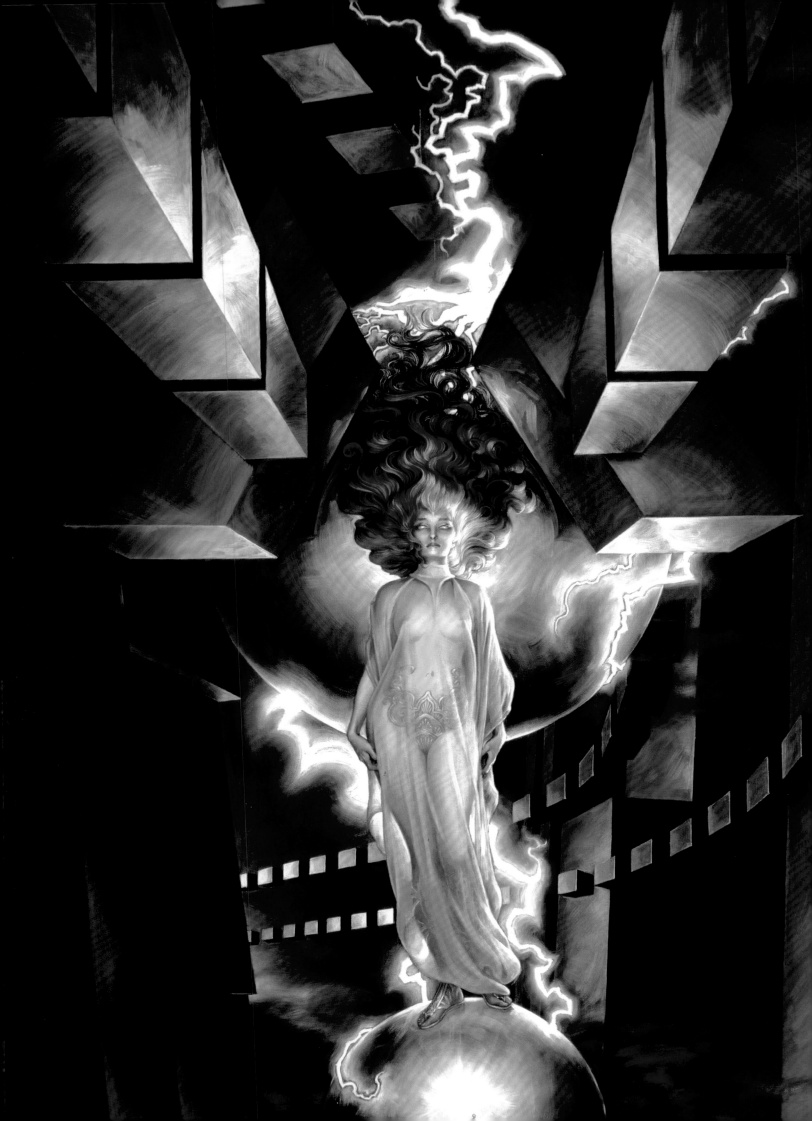

NORHALLA OF THE LIGHTNINGS *(left)* - Here is a scene I read that I couldn't resist, from *The Metal Monster*, by A. Merritt. Merritt is underrated as an epic fantasist; his prose is ecstatic to the point of being hard to follow in places, but when you figure out what's going on it's startlingly visual. Incredibly, this book was written in 1919.

The scene shows the otherworldly goddess figure, Norhalla, who had been raised as a child by the incredible sentient metal creatures that surround her.

I started this for the fantasy art exhibit at the New Britain Museums of Art, the first show I know of at a major museum. The show was vastly more popular than the curators imagined; so many people came they were worried about structural damage to the museum building, and have never hosted another show of imaginative realism.

I worked on this picture sporadically since 1980 until I finished it in 2002, as the cover for *Weird Tales*. I might just as well have saved myself the trouble—when I saw the cover I realized the publishers had allowed the printers to deliver the cover printed without the blue plate. On a blue painting, you'll notice.

Technical notes: Oil on canvas over an acrylic polychrome underpainting. Modified Liquin medium.

Above: Into the Maelstrom

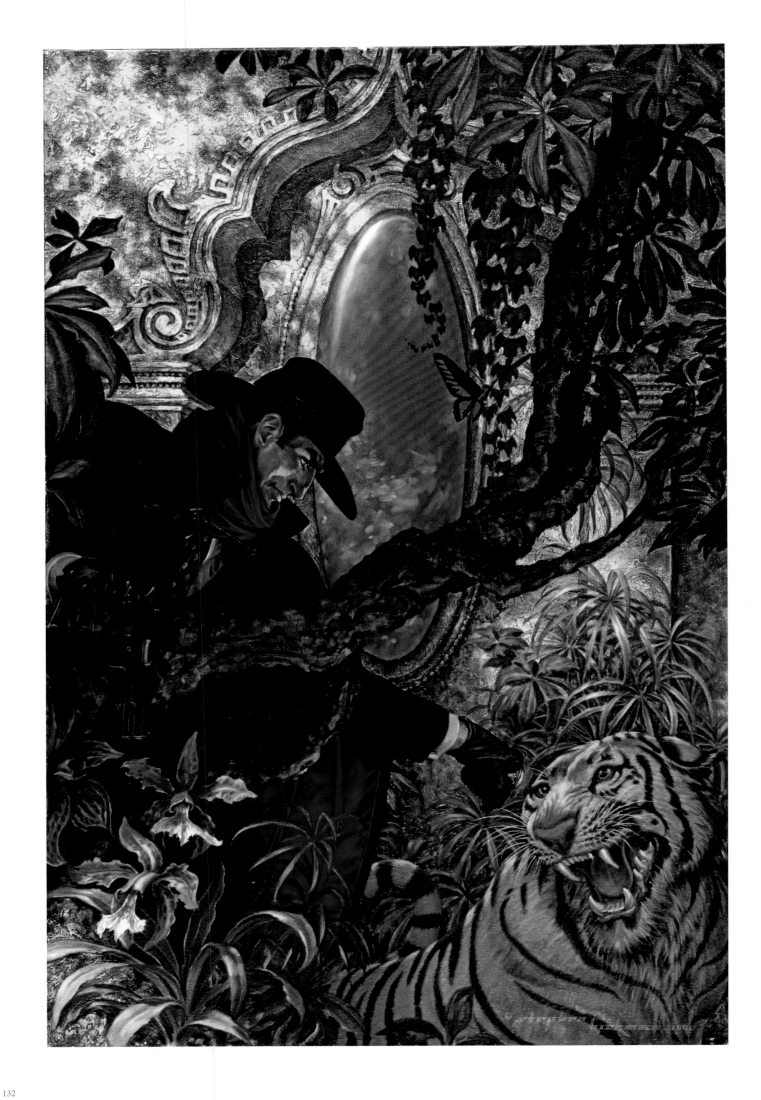

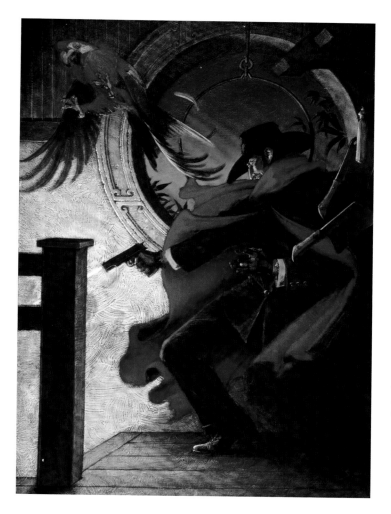

THE SHADOW (left) - I just had the greatest time doing this

painting—the Shadow has always been a dark hero who has fascinated me, so I was looking forward to doing a painting of him. When this commission came along, I had just finished an elaborate and frustrating painting, and in therapeutic contrast, this painting went like a breeze.

To capture the motion of the cape, I hung a blanket over my shoulders, and worked out the gesture and motion in reverse, so that I could watch what the improvised cape did in a mirror.

When I had my drawing, the way I wanted it, I textured a canvas with a ratty old trim-brush that I had found in the basement of our apartment. I softened up the hardened bristles with a hammer, and got to work with my trusty can of Sani-Flat, keeping in mind that the brightest light source in the painting would be the muzzle-flash from the Shadow's .45 Model 1911 Colt automatic.

The next step was to project the sketch onto the canvas, lining in the drawing directly in oil color. Then I painted this standing at my easel, rather than sitting, because standing tends to give an immediacy to a painting, and eliminates the over-worked quality that can ruin an otherwise good picture. I love the way this turned out—every once in a while things just fall into place...

Technical Notes: The painting was done in oil color over an ivory-tinted canvas, pre-textured with Sani-Flat. I did the monochrome underpainting for this one using a color called brown madder alizirin, a color from the Windsor and Newton color list. The medium I used was probably the good old linseed-oil/stand-oil/turpentine standby.

THE SHADOW AND THE TIGER (far left) - The most

fascinating thing about a character like the Shadow is that you would be hard put to figure out a setting where he wouldn't fit in somehow. Maybe not in an igloo north of the arctic circle, for instance; at least not during the six-month-long daytime. But during the long nighttime, with the auroral fires flaming overhead...see? There he is!

Here we see the Shadow hypnotizing a white tiger with the power of his fire-opal girasol ring. This is a setting I dreamed up as the cover for one of the two *The Shadow Strikes* covers I did for DC Comics. Sumatra is no stretch of the imagination for the Shadow—didn't he learn to cloud men's minds from the sages of the mysterious East? That was before television took over the job for him, you understand.

I think it was this painting that marked my decision to use nothing but oil color in my illustration work: up to this time, roughly half of my covers, particularly SF covers, were done in acrylic. I had just finished up an acrylic cover, and when I blocked in the Shadow's face in this painting, I realized

that it was done. I didn't have to re-do it forty-two times and still not have it look right. Nuts to acrylic. I realize there are artists who can use this medium brilliantly, but for me it's like my fellow artist Ragan Reeves once called it: "liquid linoleum."

Things to note here: tiger's faces (and cats in general) are hard to paint convincingly—this one about drove me to distraction, because of course I didn't have a model, and the only picture I could find remotely like what I wanted was a black leopard. In fact, the only objects in the painting I had models for were the .45 Colt and the opal in the wall—that was about 23 mm long, but at least I could study it for a while and see what the light bouncing around inside of it was doing.

Technical Notes: This is an oil painting on canvas, about 18 x 24 inches, done over a white gesso ground. I textured the weathered stucco-work in the wall using gummy Sani-Flat and a palette knife—it was too dried-up to put on with a brush: I still can't figure out how I did that. This was painted with the Liquin/linseed-oil combination.

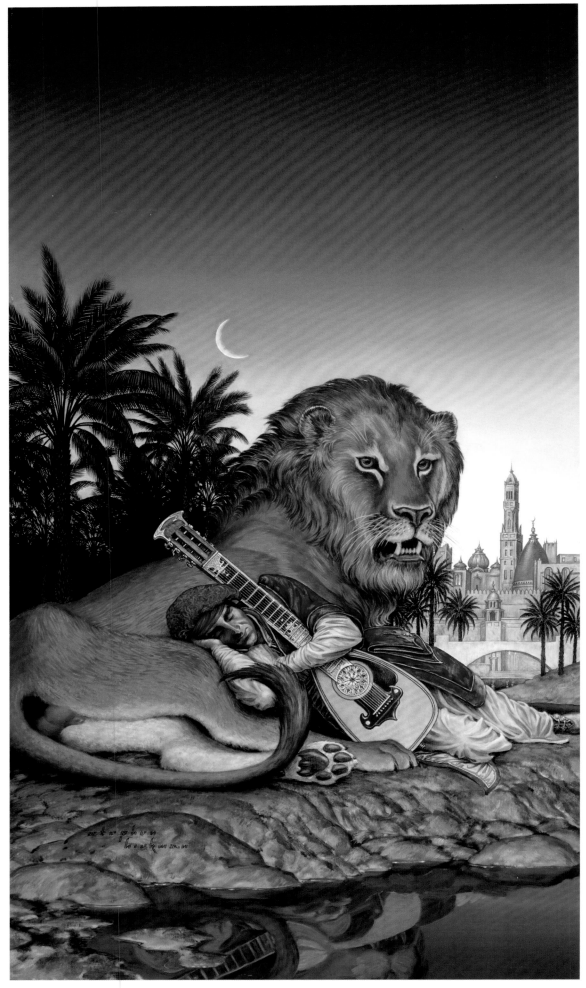

Above: Heroic Visions II

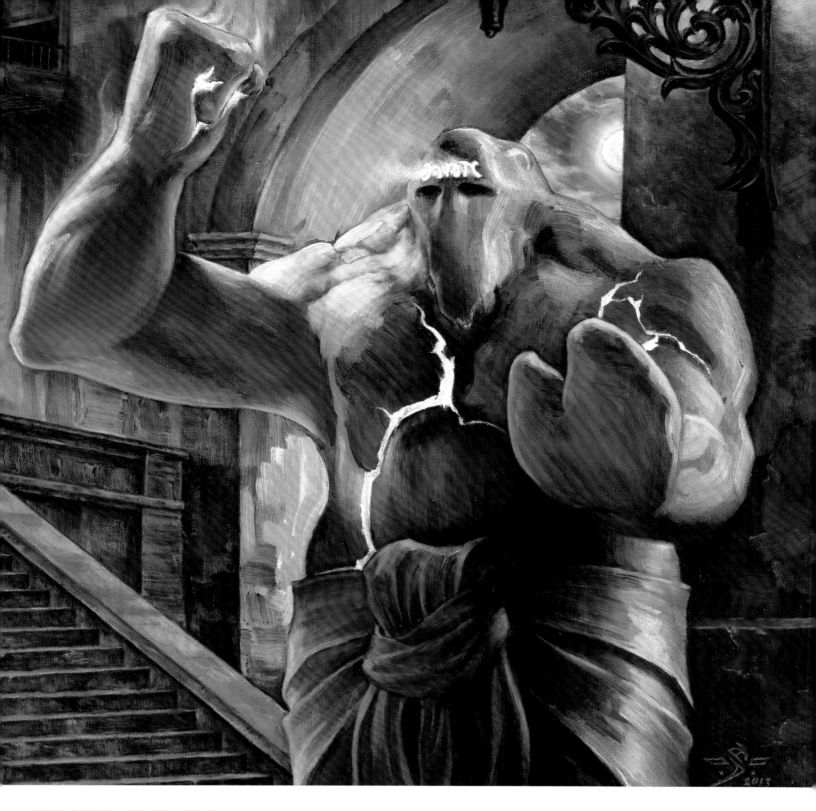

THE GOLEM OF PRAGUE - I had the opportunity to do this painting, the idea for which had been buzzing around in my imagination for some weeks, when my good friend Travis Louie invited me to be a part of an exhibition he was curating for New York City's Last Rites Gallery. The Golem idea was a bit lateral for the zombie-themed show, but it did extend the dramatic range of the interpretive nature of the exhibit. There were some brilliant interpretations in this remarkable show, and I felt privileged to be in it.

Ever since I first saw a picture of the Golem in *Famous Monsters of Filmland* Magazine, I had been wondering about this massive creature with the glowing eyes and the steel-riveted belt. But it was the inspired use of the Golem-symbol in Michael Chabon's novel *The Amazing Adventures of Kavalier & Clay* that sparked my interest most recently. So I read up on the

Golem in the Wikipedia entry, and found the wealth of atmosphere and richness of setting I was hoping for; that determined the form that this version of the Golem assumed. My favorite version of the Golem had the word 'truth' (EMET) inscribed in Hebrew on his forehead, and so that is how I painted it, glowing with the blue fire of righteousness.

Technical notes: I wanted to try a much more loose and brushy approach with this painting, so I first trowelled on a mixture of raw umber and white on my canvas, and painted my projected sketch directly into the wet paint. To get the distinct brushwork that I wanted, I had to really load the paint on—so to make sure all this dried in time for the show, I used straight Liquin, which has powerful drying properties.

THE TREASURE OF DAGON *(right)* - As I mentioned before, I've been completely fascinated by deep-sea divers since I was in kindergarten—I wore the pages in our Encyclopaedia Britannica thin by constantly re-reading the entry about divers.

This scene is developed from a sketch I did some time back. I had decided to incorporate a Lovecraftian theme some 20 years before Lovecraft and the tentacle thing came into vogue. Working from some photos I took of a copper-and-bronze Mk.-V Sieb diving helmet and rig in the Naval Museum in Washington DC, I took pains to get the details just right. Also of great assistance was the folder of reference material mailed to me by my friend David Merriman, a model maker in Virginia Beach, VA, who was rated as Ship's Husbandry Diver when he was in the U. S. Navy—much obliged, David!

Technical notes: This was painted on an oil-primed canvas intended for another painting ---as with oil-primed surfaces, I projected my drawing onto the canvas and lined in the painting using mars violet oil color, and finished up the underpainting in the same color. The finished painting was done using the Venice turpentine medium.

CTHULHU STATUETTE *(above)* - This was originally done as a photographic prop for a cover on *The Tales of the Cthulhu Mythos,* a series of the earliest short stories by Robert E. Howard, from the time when he first started corresponding with H.P. Lovecraft.

Jim Baen may have had a reputation as a difficult art editor to work with at times, but to his everlasting credit, he was willing to try anything once. In this case it was the use of a photo of an actual sculpture done specifically for the cover. I was delighted that he gave me the OK and got started.

The statuette was done in four days from the time I had finished the sketches I had used to talk to Jim into this loopy scheme. Unfortunately, the photos I had made of the finished piece didn't turn out to be usable. Jim told me to paint a picture of the thing, so I did.

Later, Randy Bowen saw the painting in my previous art book, and read the commentary about there being an actual sculpture of Cthulhu. He contacted me about putting it into production, which he did, after I carefully added the wings, which incidentally took longer to do than the rest of the sculpture.

Technical notes: This was done in polyform sculpting compound, except for the wings, which I sculpted using epoxy putty for strength.

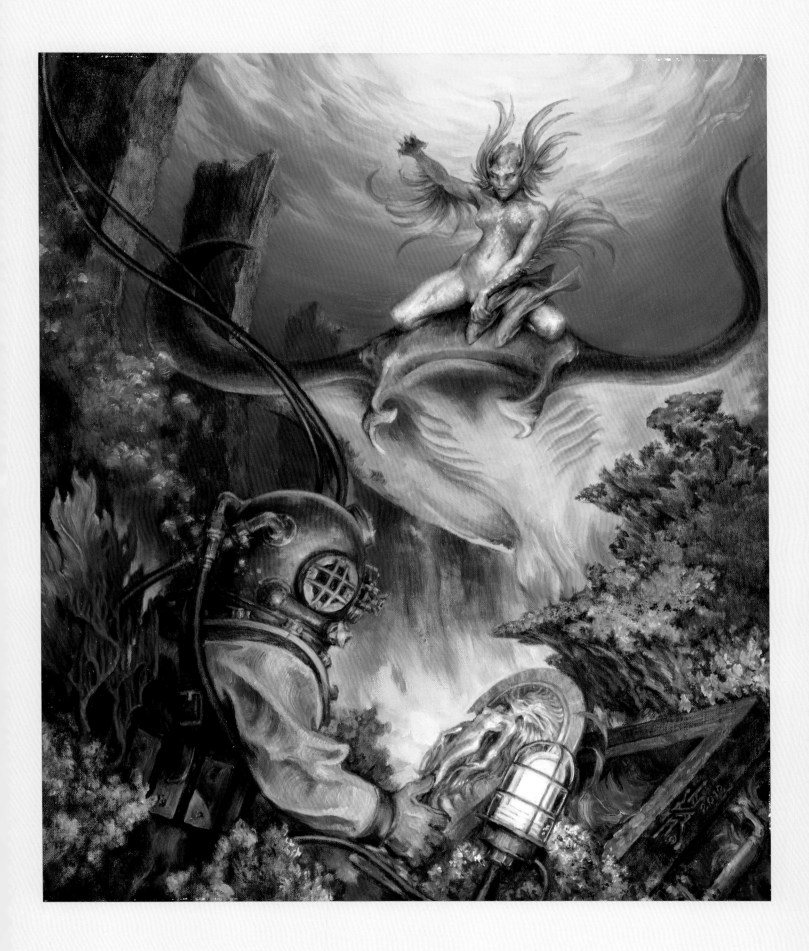

THE COLOUR OUT OF SPACE *(top right, far right)* - This cover, which I did for *The Magazine of H.P. Lovecraft,* represents the first deliberate excursion I made into cross-media (traditional/ digital) effects. I had Photoshop in mind from the beginning, as anyone who has read this story can readily imagine: if ever a story suggested hot-rodding the illustration in a computer, this is that story.

The problem is representing an alien color never seen on earth before...that's a twister, isn't it? How in the world do you go about suggesting a color that does not exist in our earthly spectrum?

What I did was to make a fairly pedestrian (for Lovecraft) painting on illustration board as an intermediate step, painting in the tree and foliage, with the well (as mentioned in the story), and Lovecraft's likeness wafting out of it: this was a stipulation by the magazine: Lovecraft's face somewhere on the cover.

Then I scanned the painting to make a digital image, and proceeded from there: first I distorted Lovecraft's face in such a way you could still recognize him. Then I got serious with the colors, using just about everything I knew of Photoshop, which, admittedly wasn't much at the time. But it was enough to give me about ten different versions of the cover.

I sent off three of these versions to the magazine, and would you believe it? They wanted to use the whimpy version I started off with in the first place. So this is the first time most people on the planet get to see the *fun* versions...

PORTRAIT BUST OF H.P. LOVECRAFT *(bottom right)* - For the most part, the projects I think are the most rewarding and successful get the best response from people, but this is a salient exception. I think this is the best sculpting I've done, but it seems to make people deeply uneasy, even people as tough as Harlan Ellison. Folks seem to love the Cthulhu statuette, but they're creeped out by this? Well, well...

This sculpture is the first thing I've done with the intention of producing an edition of castings. A completely finished piece, in other words.

I was working from good portrait stills made from the original negatives too, which were sent to me by the John Hay Library at Brown University in Providence, RI. I found I was having difficulty getting a likeness, until I got mad and did a caricature, and it immediately looked like H.P. Lovecraft.

The rest is history: everybody got weirded out. But in the John Hay Library, on exhibit with original hand-written Lovecraft manuscripts and my Cthulhu statuette, is a copy of this portrait bust.

Technical notes: Created in polyform sculpting compound.

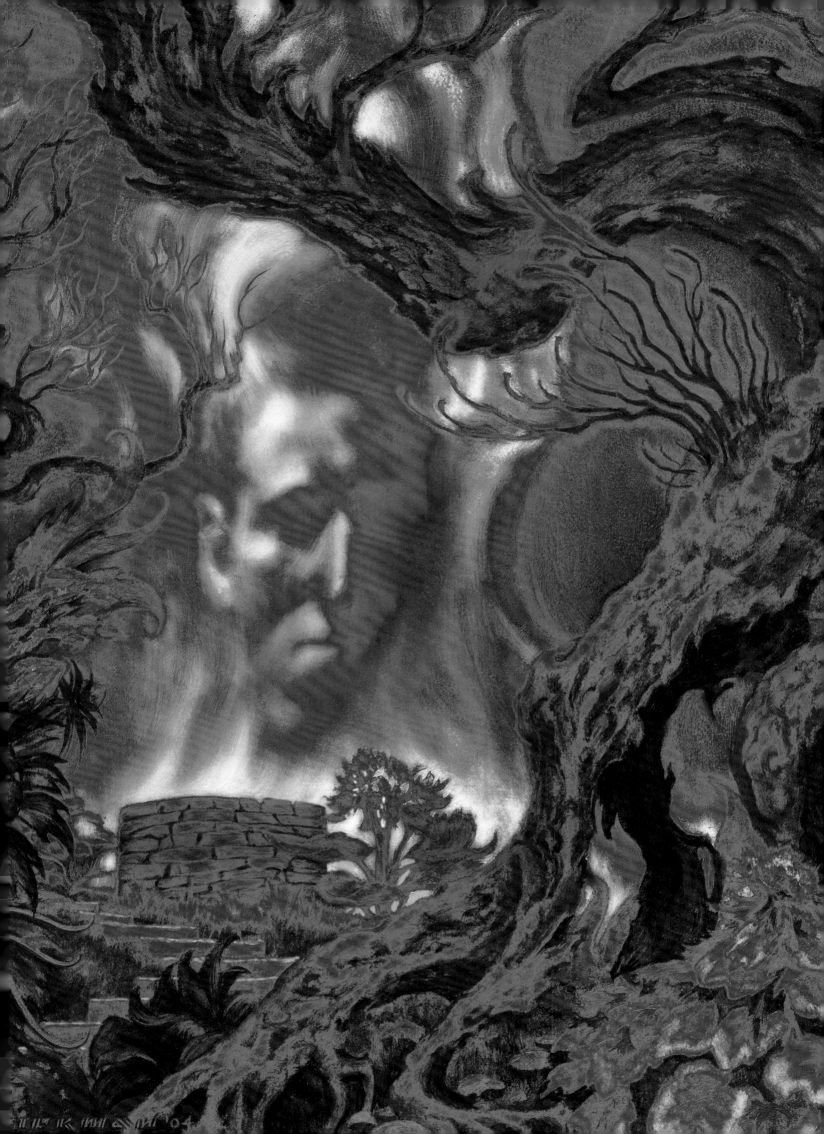

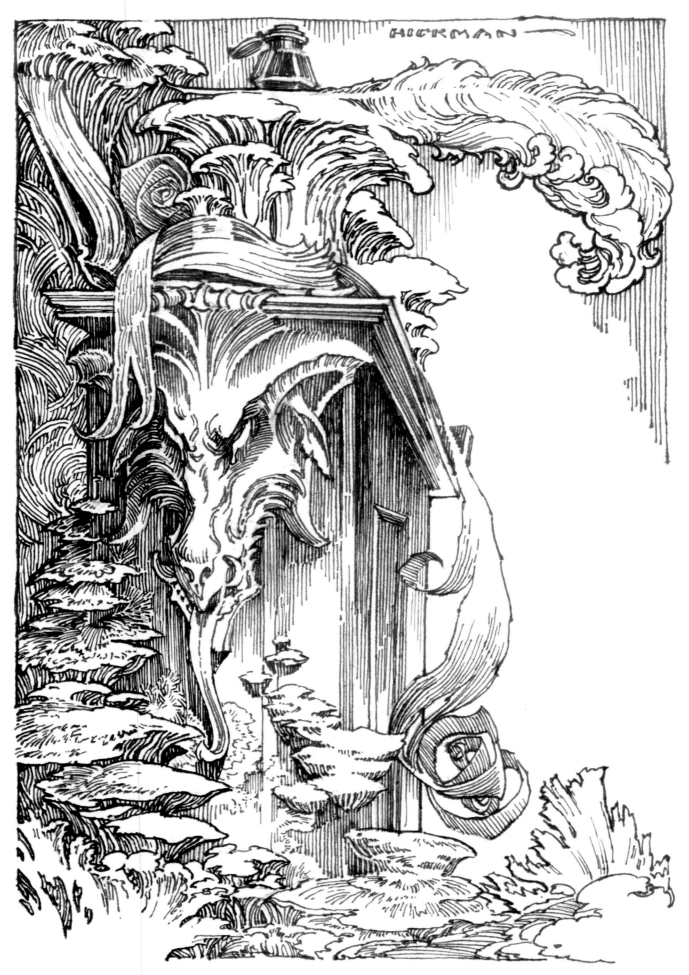

Above: Fungi from Yuggoth **Right:** The Temple

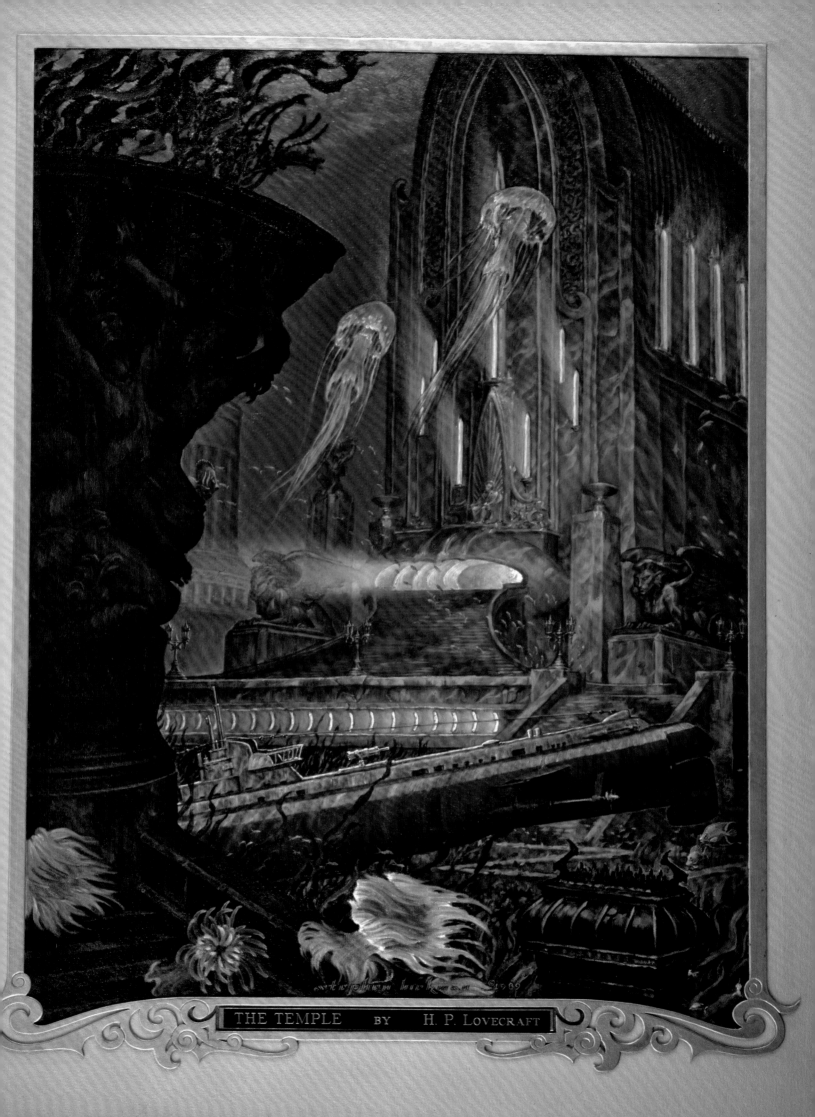

THE TEMPLE BY H. P. LOVECRAFT

THE SECRET ART OF PAINTING

Anyone can paint a picture, and generally everyone does at some point paint a picture, even if it's a paint-by-numbers—good fun, and doesn't the paint smell great? Actually, the secret of doing a good paint-by-numbers is to get yourself some decent brushes, so that you can actually keep the paint inside all those little spaces. So there's your first secret of painting right there.

But the Big Secret of Painting is just this: that there is no Big Secret, at least in the sense that there's nothing that will make your paintings wonderful as soon as you learn what it is. Anyone can paint a picture, but not everyone can paint a breathtaking, fascinating picture, and no artist can do that every time. Of course it is a matter of personal taste what constitutes a great painting, but what it comes down to is the idea behind the painting: the artistic vision is the essence of a good painting.

So if there is a Secret Art to painting, it will lie in this artistic vision, that elusive something that is beyond words to describe, which makes one painting better or worse than another. Imagination, or inspiration, call it anything that you choose, because your vision will be unique, different from any other artist's. At least it had better be, as mature artists who base their work on another's style are beneath contempt: what would you think of someone who followed you around, listening to everything you said, and then repeating it to others as if the words were their own?

The definition of the work that I like to do, and that I like to look at, is one that the Count Leo Tolstoy came up with: that of art as communication—the artist is expressing their insights and feelings to the viewer (or reader, or listener). There are other definitions of painting and art, generally associated with a type of art I find pretentious and intellectually arrogant. My advice to non-artists is: if you don't happen to like a painting, or if you don't understand it, the painting has failed, and not your understanding of it. Always be suspicious of any work of art that seems to require an explanation.

As an artist, then, what is it that you have to say to the viewer? As I see it, that is the one single important question: do you have anything to say? It can be simple or complex, subtle or overwhelming, reassuring or strange. For my own personal work I try to paint elegant and dreamlike stuff, because I feel that beauty is the most challenging and worthy aspect to try and capture.

I don't regard myself as a natural talent, but I do have a lot to say, and I've worked hard to learn how to say it as effectively as I can. Given that Biblical grain of mustard seed worth of talent, which is what I started with, you can accomplish some surprising things as long as you keep your priorities straight, and concentrate on the important stuff—good ideas being at the top of the list. That's were all the hard work is channeled—digging deeper for the inner vision, the inspiration. Like anything that people do, the harder you work at something, the better you will get at it.

As Salvador Dali said, no masterpiece was ever created by a lazy artist.

But at the same time, keep in mind what Phillip Marlowe told the receptionist: 'Somebody put in a lot of work on that one, but hard work is no substitute for talent." In other words, art is not all just mindless toil, otherwise, every poem ever written would read like *The Gleaners*... very tedious.

Which brings us to the second item on the List of Priorities, which is: paint what you are most fascinated with. It doesn't really matter what you paint, it's more about how you use the imagery that you choose. This says a lot about you as an artist, and here is where the real subliminal poetry of your painting has a chance to speak. In my opinion, the worst mistake an artist can make is to paint what you think that people will want to see. If you happen to want to see that as well, fine, but the average viewer can immediately sense the insincerity in a picture, and, even if they can't put it into words, will not respond to the picture.

I like the Far Eastern take on artistic accomplishment: that the artist's technique should be so perfected as to be invisible to the viewer. Though Western art is more concerned with the expression of the individual, rather than the representation of ideal forms, there is still a valid point here: it is a mistake to let your facility with your craft stand in the way of what you have to say. Being able to render objects in a spectacularly realistic manner is great if you are using that to put across a worthwhile message. Otherwise you're just a slave to your subject and technique. Just learn to do what you do until it is second nature.

A great way to think of ideas is to start by writing a list of all the things you are most interested in. After that, you're pretty much on your own, except that the third item of the List could well be: don't waste time. It's all up to you, after all. As the man said, if you want to stand in the spotlight, you've got to be willing to climb the ladder to change the bulb.

> ## "NO MASTERPIECE WAS EVER CREATED BY A LAZY ARTIST"
>
> — SALVADOR DALI

A WORD OR SEVERAL ABOUT THE TECHNICAL NOTES - First of all, my notes should not be taken as an instruction to do exactly what I'm doing—I happen to think this a good way to do paintings, but a good way is never the only good way to do something. Also, as you'll see from the individual notes, some paintings are done differently from others. So take what you can use, and don't worry about the rest of it.

Color selection: in high school, we painted everything in five colors—red, yellow, blue, black, and white. You really do a lot of color mixing just using primaries like that. I fondly remember the great moment when yellow ochre was added to our color selection. So, what did I learn from that? Well, while you can paint a picture with primary colors, 'specialty' colors like yellow ochre are great time-saving pre-mixtures of these basic colors.

However, when it comes to selecting from the bewildering selection of time-saving mixtures that you find in art stores and catalogs, you come to a problem here: how do you select from among the literally hundreds of shades to avoid duplication or overlap that you get from the confusing brand names?

The way I solved this is by using the color selection that I found in the back of *Norman Rockwell, Illustrator* (Watson Guptill Publications), where he describes his procedures. I simply put all these colors on my palette every time for every painting, until I learned how to use them. This is a better system than getting colors that have cool names like Aureolin, and figuring out at random how to use them, trust me (I still have my ancient tube of Aureolin). The colors I have found most useful are:

Alizirin Crimson, Vermillion Hue, Cadmium Red Deep, Burnt Umber, Burnt Sienna, Raw Umber, Yellow Ochre, Cadmium Orange, Cadmium Yelow Pale, Lemon Yellow Hue, a white mixed from Zinc White and Titanium White (like Weber's Permalba); this takes care of the warm tones, arranged in my case starting from the upper left corner of my palette and ending with the white in the upper right-hand corner (but remember I'm left-handed; check Rockwell's book for right-handed, not much different).

The cool colors are Terre Verte, Viridian, Cobalt Blue, Cerulean Blue, Untramarine Blue, and instead of black I use a mixture of Pthalocyanine Green and Alizirin Crimson.

You will need to know several things about each of the oil colors you choose. First, what the colors look like, both in their pure states and mixed with white; second, how transparent or opaque they are; third, their natural drying rates; and fourth, their toxicity levels.

And—just like Norman Rockwell says in his book—you can mix most of the colors you will conceivably need in a painting using three of the colors from this mixture. I found this to be literally true, but you have to learn to gray your colors using color complements—a complement is a color's opposite on the color wheel.

Finally, what Rockwell says about using bristle brushes to give character to brushwork in oil color is also true. It's also best to use a larger brush than you think you need for a particular passage.

A BRIEF WORD ABOUT PAINTING MEDIUMS —a medium is what you mix with your oil colors to make sure they don't take forever to dry, and to give certain characteristics to the dry paint film, such as gloss or matte finish, and degree of transparency, and the character to the surface (smooth or full of brush-marks). A medium is generally a resin of some sort, mixed with oil, and thinned with a solvent to make it workable. The three mediums that I've mentioned most often in this book are the Venice Turpentine medium, the Damar medium, and Liquin: the first is a mixture of equal parts of Venice Turpentine, sun-thickened linseed oil, and turpentine. The second is made of equal parts of Damar gum solution (different from Damar varnish, much heavier), linseed oil, and turpentine. The third, Liquin, is a made by Windsor and Newton, and is a synthetic-resin mixture with excellent drying characteristics and great durability. I generally mix in some refined linseed oil to slow down the drying time considerably. I don't have a mixing ratio, just experiment for yourself and see what works best for you.

ACKNOWLEGEMENTS

First off, I'd like to thank Ron and Judith Miller.
Ron for his endless patience in showing me how
Photoshop works; and to Judith,
for her celestial cooking and hospitality.

And then I'd like to thank Arnie and Cathy Fenner for
their encouragement and advice in the putting together of
this art book project.

Thanks also to Robert Hansen-Strum for his photographic
competence, and taste in music. Robert took many of the
digital and photographic images in this book.

And to my brother Lance, for being to coolest guy
on earth. And thanks to my Bohemian friend
Fiona Campbell, for providing two of the best titles
for paintings in this book.

And to my wife Victoria, and my daughters Aurora and
Zara, who have helped me in more ways than they will ever
realize. My love and gratitude, forever and always.